THE AHMANSON GIFTS

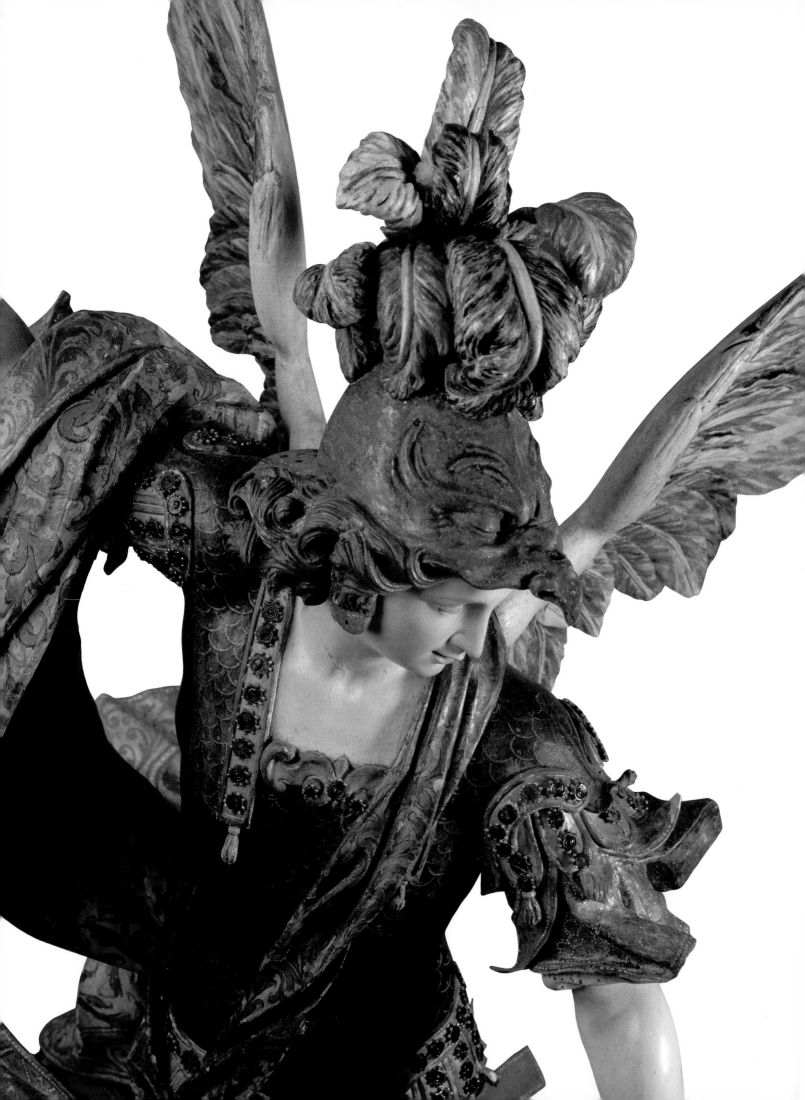

THE AHMANSON GIFTS

European Masterpieces in the Collection of the Los Angeles County Museum of Art

PHILIP CONISBEE MARY L. LEVKOFF RICHARD RAND

Los Angeles County Museum of Art

Published by the Los Angeles County
Museum of Art, 5905 Wilshire Boulevard,
Los Angeles, California 90036.

Editor: Gregory A. Dobie
Designer: Robin Weiss
Photographers: Peter Brenner, Barbara Lyter,
and Steve Oliver
Typesetter: Andresen Typographics, Tucson,
Arizona
Printer: Nissha Printing Co., Ltd., Kyoto,
Japan

COVER:
Philippe de Champaigne
Saint Augustine (detail)
Cat. no. 46

FRONTISPIECE:
Circle of Domenico Antonio Vaccaro
Saint Michael Casting Satan into Hell (detail)
Cat. no. 24

**Library of Congress
Cataloging-in-Publication Data**

Los Angeles County Museum of Art.
 The Ahmanson gifts : European
masterpieces in the collection of the Los
Angeles County Museum of Art / Philip
Conisbee, Mary L. Levkoff, Richard Rand.
 p. cm.
 Includes bibliographical references and
index.
 ISBN 0-87587-160-7 (pbk.)
 1. Painting, European—Catalogs.
2. Painting, Modern—Europe—Catalogs.
3. Ahmanson Foundation—Art
collections—Catalogs. 4. H. F. Ahmanson
& Company—Art collections—Catalogs.
5. Painting—Private collections—
California—Los Angeles—Catalogs.
6. Los Angeles County Museum of Art—
Catalogs.
 I. Conisbee, Philip. II. Levkoff, Mary L.,
1953– . III. Rand, Richard. IV. Title.
ND454.L6 1991
759.94′074′79494—dc20 91-18247
 CIP

CONTENTS

FOREWORD

Art has never been created in a social and economic vacuum. Few of the works published in this catalogue would have come into existence without the informed patronage of either individuals or institutions (whether secular or religious) from the fifteenth century through the early twentieth century. Most of these pieces were produced for the privileged, in whose exclusive preserve they normally remained. But the public art museum, that noble creation of enlightened nineteenth-century philanthropy, has made art available to a wide audience. While the context for these works has radically changed, the enterprise of the modern museum also requires informed patronage. It necessitates considerable efforts of thought, will, and generosity to bring fine artworks into the public domain, especially in these days of upwardly spiraling prices and strong international competition. The Los Angeles County Museum of Art has been extremely fortunate in receiving such enlightened support from The Ahmanson Foundation, several members of the Ahmanson family, and H. F. Ahmanson and Company, all of whom have been consistently and magnanimously generous to the museum's Department of European Painting and Sculpture during the last twenty years.

While the focus of the catalogue is the remarkable group of European old master paintings and sculptures that has come to constitute by far the major concentration of Ahmanson gifts to the museum, their other donations to the Departments of Far Eastern Art, Indian and Southeast Asian Art, and Prints and Drawings should also be acknowledged. It should be mentioned as well that before the Ahmanson benefactors turned their attention to the museum's collections with such good effect, Howard F. Ahmanson provided the major funding for the building in which the same collections are housed and which bears the Ahmanson name. This benefaction is discussed in more detail in the introduction.

The purpose of this volume is to celebrate twenty years of Ahmanson gifts by publishing them all in full color, together with scholarly entries that present the current state of knowledge about each piece. While it should be borne in mind that the works discussed are complemented by the many other gifts and purchases that make up the European collection as a whole, the quality of the Ahmanson gifts is consistently outstanding. Among them are several truly great masterpieces of European art.

The catalogue is meant to be both a handy reference work for the art historian and an enjoyable guide for museum visitors. It fulfills an important part of the educational mission of the museum and is a just tribute to the outstanding generosity of The Ahmanson Foundation, the Ahmanson family, and H. F. Ahmanson and Company.

Earl A. Powell III
Director

EDITORIAL NOTE AND ACKNOWLEDGMENTS

Authorship of this catalogue was divided between the three members of the Department of European Painting and Sculpture: Mary L. Levkoff, assistant curator of sculpture, Richard Rand, assistant curator of painting, and myself. The entries for which we are each responsible are signed with our initials. Richard Rand deserves a special acknowledgment for taking on many additional administrative chores.

A wide range of artists from the fifteenth century to the early twentieth century is represented in the Ahmanson gifts to the department during the last twenty years. This eclecticism, which reflects the ultimate goals of balance and comprehensiveness for the collection, means that within a total to date of fifty-two gifts there are no obvious stylistic or national groupings. Therefore the catalogue is arranged in chronological order by date of acquisition, which at least gives some sense of how the collection has developed. The reader should be reminded that the Ahmanson presentations need to be seen against the background of the growth of the collection as a whole during this period. A good idea of the overall holdings can be had from the museum's 1987 publication, *European Painting and Sculpture in the Los Angeles County Museum of Art: An Illustrated Summary Catalogue*, which is complete up to 1986.

Many scholars have contributed directly or indirectly to this catalogue. In writing it, we occasionally have had to stray rather far from our personal areas of expertise. In such cases our reliance on the research of others has become proportionally greater. We do not pretend to have said the last word about any of these artworks; rather, we present the current state of knowledge. We hope that this celebratory volume will be read not only by fellow art historians and curators but also by a wider audience. The cited literature on each work is selective, although it provides more than enough leads for the curious reader to take his or her own investigations further.

The scholars on whose previously published studies we have relied are specifically acknowledged at the beginning of each entry. Others, sometimes anonymous, have contributed information to our files. A special acknowledgment must go to Burton Frederickson, senior curator for research at the J. Paul Getty Museum and director of the Getty Provenance Index, who some years ago did much research on the earlier acquisitions in this catalogue, research that remains unpublished in our files. Of course any shortcomings are entirely our own. We are also pleased to acknowledge the invaluable support of our colleagues here at the museum, who photographed, edited, designed, and otherwise assisted in the production of this catalogue. We are especially grateful to Peter Brenner, Martin Chapman, Bruce Davis, Gregory A. Dobie, Julie Johnston, Mitch Tuchman, Robin Weiss, and Alison Zucrow. Others we would like to thank are Trudi Casamassima, Mary Alice Cline, Sandy Davis, Carol Dowd, Peter Fusco (former curator of European sculpture and decorative arts), Scott Schaefer (former curator of European painting and sculpture), and Lee Walcott.

Philip Conisbee
Curator of European Painting and Sculpture

A MODEL OF INFORMED PATRONAGE

Howard F. Ahmanson and the Ahmanson Gallery (photograph by Richard Gross from the *Los Angeles Times* special edition of March 28, 1965, on the opening of the Los Angeles County Museum of Art)

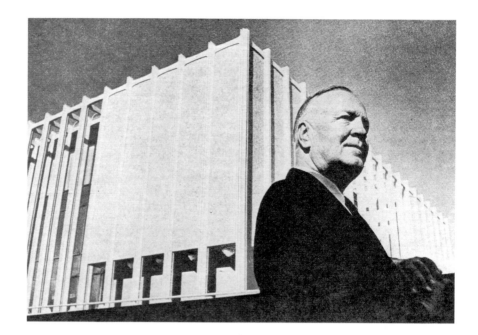

The Ahmanson name has been continuously linked with that of the Los Angeles County Museum of Art since the mid-1960s, when the museum was established as an independent entity and moved west from Exposition Park to its present Hancock Park site. A substantial donation made possible the building of the Ahmanson Gallery, now known as the Ahmanson Building, which was designed by William L. Pereira and Associates. This structure housed all of the permanent collection when the new institution opened its doors in March of 1965. The museum has enjoyed twenty-five years of spectacular growth since then, but the Ahmanson Building, which itself was expanded in 1983 with an addition funded in part by a major lead gift from The Ahmanson Foundation, remains a significant monument to those auspicious beginnings.

Howard F. Ahmanson (1906–68), a graduate of the University of Southern California (USC), was the creator of a great financial empire, controlled by H. F. Ahmanson and Company, a holding company, which revolved around his Los Angeles-based Home Savings and Loan Association, the largest institution of its kind in the United States. In addition Mr. Ahmanson had a number of collateral enterprises: the Ahmanson Bank and Trust Company, the National American Insurance Company of Omaha, and the Southern Counties Title Insurance Company of Los Angeles, along with other affiliated firms.

As one of the community's most public-spirited citizens, Mr. Ahmanson was deeply concerned about the cultural life of Los Angeles and Southern California and in 1967 suggested that the region needed a cultural master plan: "We have to find

out how many art galleries we're going to need, how many symphony orchestras and theaters. There is a growing enthusiasm about culture, and we're going to have more leisure for culture." Mr. Ahmanson matched his words and his ambitions with deeds and through a variety of significant benefactions to museums, libraries, and the performing arts did much to stimulate the cultural life of the most dramatically expanding community in the country. He also gave generously of his time and his counsel as a member of the board of trustees of the Los Angeles County Museum of Art, the California Museum Foundation, the California Museum of Science and Industry, and USC; as a member of the board of governors of the Otis Art Institute and the Performing Arts Council of the Music Center; and as a trustee of the John F. Kennedy Center for the Performing Arts in Washington, D.C. In addition to the Ahmanson Building at the museum the Ahmanson name was given to the Ahmanson Theatre at the Music Center and, in the sphere of medicine, to the Ahmanson Center for Biological Research at USC. Most recently, in 1986, a building was named for Mr. Ahmanson at the California Museum of Science and Industry.

The importance of Howard F. Ahmanson to the early development of the museum cannot be exaggerated. He was a prime mover in securing the support of the County Board of Supervisors for the concept of an art museum and in encouraging them to make available the site in Hancock Park. When fund-raising began, although Edward W. Carter, Sidney Brody, and Kathryn Gates led the campaign, it was the two-million-dollar gift from Mr. Ahmanson for the Ahmanson Gallery that convinced the board of the museum that it could raise sufficient funds and got the campaign off to a successful start.

Mr. Ahmanson was a noted collector of art, and a number of important works from his personal and corporate collections have been given to the museum by H. F. Ahmanson and Company, his first wife, Dorothy G. Sullivan, and their son, Howard F. Ahmanson, Jr. These gifts and their provenances are duly recorded in the catalogue. Mention should be made here of the masterpiece acquired by Mr. Ahmanson in 1959, Rembrandt's *The Raising of Lazarus*, which was given to the museum in 1972 in Mr. Ahmanson's memory by H. F. Ahmanson and Company, a gift that instigated the Ahmanson donations of old master paintings, whose twentieth anniversary is celebrated with the present publication.

Support for cultural activities of various kinds has come mainly through The Ahmanson Foundation, which was incorporated in 1952 as an independent body in California with funds provided by Howard F. Ahmanson and Dorothy G. Sullivan. Other donors include William H. Ahmanson and Robert H. Ahmanson, both nephews. While the Ahmanson name is displayed with justifiable pride on several of the most prestigious cultural buildings in Los Angeles, this is but a small measure of Ahmanson philanthropy in the cultural and educational life of this area. The Ahmanson Foundation has given wide support, primarily in Southern California (with major emphasis on Los Angeles County), to the arts and humanities, education, medicine and health, and a broad range of social welfare programs. The president of The Ahmanson Foundation since 1974 has been Robert H. Ahmanson. During his term of service support for the acquisition of European paintings and sculptures of the very highest quality by the Los Angeles County Museum of Art has been especially generous. It is no exaggeration, nor a slight to the museum's many

other generous benefactors, to say that the combined efforts of H. F. Ahmanson and Company, the Ahmanson family, and, above all, The Ahmanson Foundation have resulted in the museum now displaying one of the very finest collections of European old masters to be seen in America. They form a part, albeit a very significant one, of a major collection of European paintings and sculptures, the ultimate goal for which is the representation of the significant artistic movements from the Middle Ages to the end of the nineteenth century.

If The Ahmanson Foundation has been especially generous to the museum in supporting such acquisitions for the edification and enjoyment of the ever-growing public, this should be seen as a significant part of much broader cultural and educational programs of support, which are referred to above. To limit the discussion here to education and culture, but not to forget important contributions to health, medicine, and social services, The Ahmanson Foundation has extended its philanthropy to almost every important museum, library, educational and cultural foundation, and performing arts organization in the Los Angeles area for buildings, galleries, endowments, scholarships, and library, archive, and art acquisitions.

It is virtually impossible in a brief introduction to make even a representative selection from the thousands of grants made by The Ahmanson Foundation since the mid-1970s, but all the major museums have been the recipients of funding for building programs of one kind or another. Major grants for visual and performing arts structures have gone to Pepperdine University, USC, Scripps College, the Music Center, and the Orange County Center for the Performing Arts, while the construction and expansion of libraries has been assisted at USC, the University of California at Los Angeles (UCLA), California Lutheran College, and the University of San Diego, to name only the larger projects. Support for library acquisitions has ranged from grants to the Los Angeles Public Library to replace materials lost in a devastating arson fire in 1986 to major and continuing funding of collections of international prestige and scholarly importance such as the Huntington Library and Art Gallery and the UCLA Biomedical Library. An especially distinguished project has been to help the Department of Special Collections in the UCLA University Research Library to build its holdings of early Italian Renaissance printing, especially the works of the humanist scholar, teacher, printer, and publisher, Aldus Manutius. The first fascicle of the scholarly Ahmanson-Murphy Aldine Collection catalogue appeared in 1989, with Ahmanson Foundation support. Thus The Ahmanson Foundation is playing a significant role in making the libraries of Los Angeles collectively into one of the great bibliographical centers of the world. There have also been many grants in support of institutional academic scholarships, performances, and cultural broadcasting.

The model patronage outlined above has made a significant impact on the cultural life of Southern California. The present catalogue is a record of one of the most consistent acts of Ahmanson generosity to a cultural institution.

Philip Conisbee

CATALOGUE

Several Ahmanson gifts on view in the
Ahmanson Building, 1991

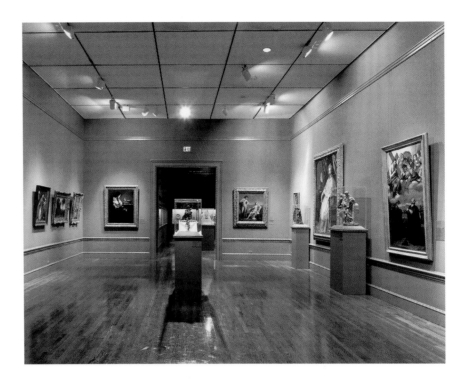

Note to the Reader

*The entries are arranged in chronological order by date of acquisition, beginning with
Rembrandt's* The Raising of Lazarus *(M.72.67.2), acquired in 1972, and ending with
Troyon's* View at La Ferté-Saint-Aubin, near Orléans *(M.91.36), acquired in 1991 (the first
two numerals in the accession number indicate the year of acquisition). Dimensions for paintings
are given as height by width; for sculptures, height by width by depth. The Select Literature
section of each entry lists particular sources where the museum's artwork is specifically
mentioned; general references to these sources in the text take the place of specific citations.
Notes are utilized, however, when greater specificity is desired.*

The Raising of Lazarus

REMBRANDT HARMENSZ VAN RIJN
Dutch, 1606–69

c. 1630

Oil on panel

37 15/16 x 32 in. (96.4 x 81.3 cm)

Gift of H. F. Ahmanson and Company in memory of Howard F. Ahmanson

M.72.67.2

PROVENANCE:

Probably Amsterdam, collection of the artist, until 1656.

Possibly Amsterdam, Johannes de Renialme, by 1657.

Possibly Amsterdam, Abraham Fabritius, by 1670.

Possibly Amsterdam, Pieter le Moine, by 1674.

Possibly Middleburg, David Grenier sale, 18 August 1712, no. 96.

Possibly Amsterdam, sale, 4 June 1727, no. 2.

Amsterdam, Philippus Joseph de Jariges sale, 14 October 1772, no. 24.

Leipzig, Gottfried Winckler II, until 1795.

Leipzig, Gottfried Winckler III.

St. Petersburg and Geneva, Jean François André Duval, by 1812.

London, Duval sale, 12–13 May 1846, no. 116.

Paris, Comte de Morny sale, 24 May 1852, no. 17.

Paris, Jules Beer sale, 29 May 1913, no. 52.

Paris, Charles Sedelmeyer (dealer), 1913.

Paris, Vicomte de Brimon.

Paris, Charles Sedelmeyer (dealer), 1920.

London, R. Langton Douglas (dealer), by 1932.

Shanzmüle, Solothurn, Switzerland, Madame Dubi-Müller (on extended loan to the Rijksmuseum, Amsterdam), 1932–59.

Los Angeles, Howard F. Ahmanson, 1959–72.

SELECT LITERATURE:

Abraham Bredius, *Rembrandt: The Complete Edition of the Paintings*, 3d ed., revised by Horst Gerson (London: Phaidon Press, 1969), 454, 604, no. 538.

Wolfgang Stechow, "Rembrandt's Representations of the 'Raising of Lazarus,'" *Los Angeles County Museum of Art Bulletin* 19, no. 2 (1973): 6–11.

Stichting Foundation Rembrandt Research Project, *A Corpus of Rembrandt Paintings: Volume 1, 1625–1631* (The Hague: Martinus Nijhoff Publishers, 1982), 293–308, no. A30.

Gary Schwartz, *Rembrandt: His Life, His Paintings* (New York: Viking, 1985), 82, 84–87.

This wholly autograph painting is a key picture from Rembrandt's early period in Leiden, when he set up his own studio and became an independent master. It was through dramatic depictions of such New Testament subjects as this one that Rembrandt was first recognized as a painter of exceptional genius.

The eleventh chapter of John tells the story of Lazarus of Bethany, who was the brother of Mary Magdalene and Martha. When Jesus heard that Lazarus was sick, he went to see him, only to find that Lazarus had been dead for four days. Jesus nevertheless ordered the tomb opened and, invoking the power of God, resurrected the dead man. Rembrandt's painting shows the most dramatic moment of the story,

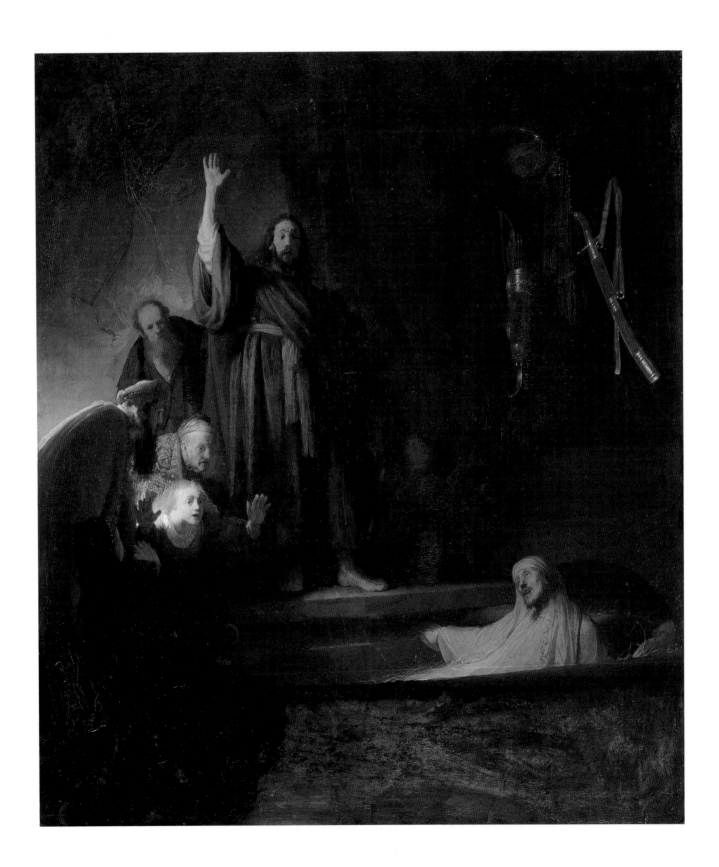

when Christ cries out, "Lazarus, come forth," and Lazarus, still bound in his burial shroud, lifts his head from the stone tomb. As prescribed in the biblical text, the scene is set in a gloomy cave, lit only by the light that filters in from the entrance at left. The penumbral composition reveals itself gradually: only after the eye records the triangular positioning of the commanding Christ, the amazed Mary, and the rising Lazarus do other details emerge. At the lower left the shadowy figure of Martha, dressed in mourning clothes, faints back in awe; at the top right a sword in its sheath, a bow and quiver, and a turban hang on the craggy cave wall; and just to the right of Christ's firmly planted left foot a half-visible group of spectators presses forward.

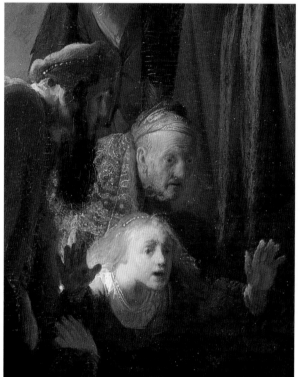

Detail

These localized areas of visual interest, separated by passages of shadow, interact dynamically, guiding the viewer's eye through the composition in a deliberate sequence. Rembrandt utilized this strategy in a number of pictures painted during his early years in Leiden. The most celebrated of this type is *Judas Returning the Thirty Pieces of Silver* (private collection, England), which is signed and dated 1629. In composition and lighting it is closely related to the museum's panel. Both paintings share details such as the motif of armor hanging on the wall. Based on these similarities, most scholars date *The Raising of Lazarus* to shortly thereafter, about 1630.

Rembrandt was born in Leiden, a university town and leading textile production center. His early biographer, Jan Orlers, relates that at a young age Rembrandt was enrolled in the local Latin School but later withdrew and entered the studio of Jacob van Swanenburg, a noted Leiden painter. Rembrandt trained with him for three years before moving to Amsterdam, where he was apprenticed to Pieter Lastman in the fall of 1622. Lastman's *Hagar and the Angel* (cat. no. 37) embodies the sort of clear-headed, meticulously realized composition that Rembrandt would have emulated at this early stage. About six months later he returned to his hometown and established his own studio.

In the ensuing years Rembrandt painted a number of historical subjects in the style of Lastman but in the latter part of the decade was drawn to the painters of the Utrecht school, such as Gerrit van Honthorst and Hendrick Terbrugghen, both of whom had recently returned from Italy. These artists had been much impressed by the innovative paintings of Caravaggio, and Rembrandt adopted their dramatic use of light and shade and the focused expressive effect of their compositions. A fine example of this type of painting is his *Hannah and Simeon in the Temple* (Kunsthalle, Hamburg), datable to 1627–28, which was painted for Frederick Hendrik, the Prince of Orange. This new tenebrist style would be completely realized in *The Raising of Lazarus*.

During this period Rembrandt became a successful local painter and took on his first students, the most important of whom was Gerard Dou. The organization of Rembrandt's studio at this time is unclear, but it is generally thought that he shared a workshop with another up-and-coming painter, Jan Lievens; indeed the styles of the two artists in these years are remarkably alike, a situation that has sometimes

Jan Lievens, *The Raising of Lazarus*, 1631, oil on
canvas, 41¼ x 44¾ in. (104.8 x 113.7 cm), the
Royal Pavilion Art Gallery and Museum,
Brighton.

led to confusion in attributions. The relationship between the two evidently was
quite productive, for at the end of the decade both were singled out for praise by
Constantijn Huygens, an important connoisseur and secretary to the Prince of
Orange. In a revealing passage in his memoirs, written in 1629 or 1630, Huygens
directly compares the art of Lievens and Rembrandt, admiring especially Lievens's
abilities as a portraitist while lauding Rembrandt for his mastery of visual expression
and authentic emotion.

Rembrandt's *The Raising of Lazarus* presents an instructive example of Huygens's
comparison, since Lievens too painted a version of the subject, which is signed
and dated 1631 (fig. 1a). In fact the theme occupied both artists for a time; during
the early 1630s Rembrandt made a drawing of the story (fig. 1b), and Lievens and
Rembrandt each produced a print (figs. 1c and 1d). Apparently stimulated by each
other's creativity, the artists experimented with several possible interpretations of
the subject, responding and reacting to the progress the other was making. Encour-
aged by Huygens, the relationship of the two painters turned into a friendly rivalry.

The exact connection between these five depictions of Lazarus has vexed scholars,
as has the sticky question of who made the initial work. Except for Lievens's paint-
ing the only other of the works that is dated is Rembrandt's drawing, which is in-
scribed 1630. Rembrandt subsequently modified this sketch, changing the subject to
show the Entombment of Christ, but underneath the alterations one can still make
out the original composition. It follows quite closely the main structure and elements
of Lievens's etching, to such an extent that it can be characterized as a rather free
copy of the latter. Since Lievens's etching certainly followed his painting of 1631
(reversing the composition in the process), the chronological puzzle is solved only
if the date on Rembrandt's drawing is viewed with skepticism. This hypothesis is

advanced by Gary Schwartz, who places Rembrandt's painting first, dating it to late 1630; Lievens's painting of 1631 second; Lievens's etching third; and Rembrandt's drawing, with an incorrect date of 1630, fourth. Rembrandt's etching undoubtedly was not finished until the artist had moved to Amsterdam in 1632; the print is signed "RHL van Ryn f," a form the artist used only after his move from Leiden.

More recently Peter Schatborn has postulated that Lievens started his painting in late 1630, making the print before the painting was completed; this etching was then copied by Rembrandt in his drawing of later that year. Lievens then completed his painting in early 1631, dating it at that time. This hypothesis differs only marginally from the opinion of the Rembrandt Research Project, which believes that all the images were developed over a period of time, probably simultaneously, and that the discrepancy in dates results from the different periods in which the works were finished.[1]

Whatever the exact sequence and despite the agreement of most scholars that Rembrandt's painting initiated the *Lazarus* series, one should not exclude the possibility that Rembrandt responded to what Lievens was doing. After all Rembrandt admired his colleague's etching enough to make a drawing of it. The general similarities in composition between Rembrandt's and Lievens's paintings (in contrast with Rembrandt's radical rearrangement of the composition in his etching) indeed suggest that Rembrandt's painting followed Lievens's painting and etching. In fact the genesis of *The Raising of Lazarus* presented something of a struggle for Rembrandt: laboratory analysis reveals a number of changes and false starts, testifying to the pains he took to resolve the structure of the picture. The decisive alterations in composition, figures, and gestures are signs that the painter, still unsure of his abilities, labored in his quest for maximum expressive effect.

It can be argued, however, that Lievens clearly responded to Rembrandt's picture by emulating the brooding atmosphere of the cave. One might say he took deliberate notice of Huygens's appreciative comments regarding Rembrandt's expressive use of mood and gesture by utilizing the compositional strategies and provocative lighting effects at which his rival was so adept. He was not entirely successful; despite the dramatic contrast of light and shade and the miraculous tenor that pervades the scene, Lievens's painting is oddly disparate, the figures tiny and doll-like. Lazarus is represented only by a pair of ghostly hands reaching from the tomb. Rembrandt's Christ is monumental; his Lazarus is shown struggling to lift his revived bones from the grave. Huygens was correct when he wrote: "Rembrandt surpasses Lievens in the faculty of penetrating to the heart of his subject matter and bringing out its essence, and his works come across more vividly."[2]

As one of Christ's most spectacular miracles, the Raising of Lazarus understandably was a very popular subject in the history of art; representations of it date from as early as the third century. For Christians the event was viewed as a prefiguration of the Resurrection of Christ as well as a prelude to the resurrection of the dead at the Last Judgment. In his painting Rembrandt makes subtle visual references to these dogmatic parallels: Mary's outstretched hands, dramatically backlit, allude to the Crucifixion, while Christ's triumphant stance on the lid of Lazarus's tomb recalls images of his own Resurrection.

Rembrandt's interpretation of the event is markedly different from those of his

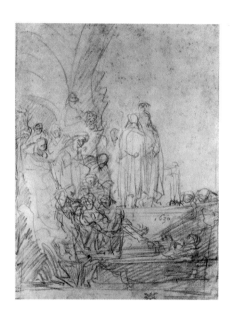

FIG. 1b
Rembrandt Harmensz van Rijn, *Entombment of Christ*, 1630, red chalk, 11¼ x 8⅛ in. (28.6 x 20.6 cm), British Museum, London.

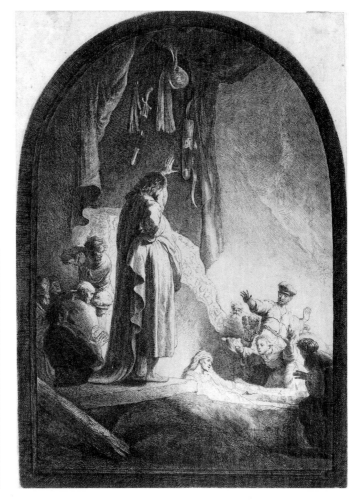

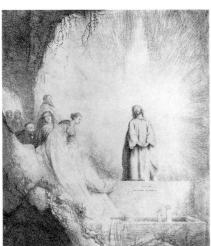

FIG. 1c
Jan Lievens, *The Raising of Lazarus*, c. 1631, etching, 14 x 12¼ in. (35.6 x 31.1 cm), Los Angeles County Museum of Art, lent by the Engel Family Collection (L.84.9.119).

FIG. 1d
Rembrandt Harmensz van Rijn, *The Raising of Lazarus*, c. 1632, etching and burin, 14⅝ x 10³⁄₁₆ in. (37.1 x 25.9 cm), Los Angeles County Museum of Art, lent by the Engel Family Collection (L.84.9.84).

immediate predecessors, such as Jan Tengnagel and Lastman, whose straightforward presentations, placed in the brightly lit landscape outside the tomb, appear pedantic by comparison.[3] Rembrandt instead took as his starting point the clammy recesses of the cave, a setting that allowed him to exploit fully the mysterious effects of filtered light and murky shadows; his version is not so much a transcription of the event, with all the appropriate participants present, as an evocation of mood and atmosphere. He imagined how such a wonderful but grisly miracle must have appeared to those present and attempted to communicate the onlookers' sense of fear and awe. The reaction of Christ indicates his own amazement at the powers in his possession.

This interpretation of Christ, emphasizing his human characteristics transformed by faith, breaks with the iconographic tradition established by Italian artists such as Sebastiano del Piombo and continued in the North principally by Rubens.[4] These artists, rooted in Catholic dogma, imagined a robust and athletic Christ, in full command of his powers, a hero of unmistakable divine provenance. The Protestant Rembrandt, by contrast, stressed the humility of Jesus, whose divinity was mysterious and of supernatural origin, understandable only through the faith of his believers. It was a vision of the saviour shared by Lievens, whose Christ is even more earthbound and insubstantial, but who is transformed by a heavenly radiance. The

Notes

1. Peter Schatborn, "Notes on Early Rembrandt Drawings," *Master Drawings* 27, no. 2 (Summer 1989): 124; Rembrandt Research Project, 300–306. Martin Royalton-Kisch, in an unpublished manuscript, has recently suggested that on the basis of style the British Museum drawing should be dated to c. 1635, when Rembrandt was making numerous studies after other artists. Rembrandt presumably predated the drawing to indicate when Lievens conceived the composition. The author is grateful to Mr. Kisch for his assistance.

2. Schwartz, 74.

3. A 1615 painting by Tengnagel is in the Statens Museum for Kunst, Copenhagen; a 1622 painting by Lastman is in the Mauritshuis, The Hague.

4. See *The Raising of Lazarus* by Sebastiano, 1519, National Gallery, London. A painting of about 1620 by Rubens (formerly Kaiser-Friedrich Museum, Berlin) was destroyed in 1945.

5. Rembrandt reinterpreted the subject once again in an etching of 1642. In addition a copy of the Los Angeles painting is in the Art Institute of Chicago (1970.1010).

6. Walter L. Strauss and Marjon van der Meulen, *The Rembrandt Documents* (New York: Abaris Books, Inc., 1979), 353, nos. 38, 42.

undercurrent of spiritual intensity running through these paintings forms a pictorial corollary to Christ's dictum to Martha immediately before the Raising of Lazarus: "I am the resurrection, and the life: he that believeth in me, though he were dead, yet shall he live."

How much Rembrandt's personal religious sentiment resonates in his painting is unknown, but at this youthful stage in his life he had not cemented his Christian beliefs nor the particular compositional strategies of which the *Raising* is a stellar example. This was made clear when Rembrandt reinterpreted the figure of Christ in his etching of c. 1632, where Jesus takes on the stature and power of the Italianate model, and his flowing hair and active draperies assume a Rubenesque dynamism. The brash move of turning the principal figure away from the picture plane, showing only Christ's profile, might appear idiosyncratic (and was rarely repeated by Rembrandt), but it testifies to his keen desire to create something bold in emulation of Rubens.[5] It is no accident that the etching dates from about the same time as Rembrandt's *Passion* series of 1633–39 (Munich, Alte Pinakothek), which was painted for the Prince of Orange in direct rivalry with Rubens. These different interpretations of the Raising of Lazarus signal the experimental character of Rembrandt's art in these heady early years, when, boosted by the encouraging words of Huygens, he explored a variety of stylistic and iconographic options.

It is unclear for whom Rembrandt might have painted *The Raising of Lazarus*; in seventeenth-century Holland, Calvinist strictures against icons precluded the use of religious paintings in churches. There was, however, an active market for such works among private collectors. Unfortunately the provenance of the Los Angeles picture is traceable for certain only from the late eighteenth century. It is probable that Rembrandt painted it for himself and never intended to sell it. In fact an inventory of Rembrandt's effects drawn up in 1656 records a *Raising of Lazarus* by Rembrandt and one by Lievens hanging in the antechamber of the artist's residence in Amsterdam.[6] The descriptions of these pictures are not precise enough to ascertain whether they were the paintings discussed here, but the hypothesis is attractive; it certainly would have been appropriate for Rembrandt to hold on to two paintings that played such an important role in his development as an artist and that were the fruit of the creative rivalry he shared with Lievens.

RR

An Artist in His Studio

DAVID TENIERS THE YOUNGER

Flemish, 1610–90

and

JAN DAVIDSZ DE HEEM

Dutch, 1606–84

1643

Oil on oak panel

19 x 25¼ in. (48.3 x 64.1 cm)

Signed at lower left center: H. D. Teniers; at lower right center: J. D. Heem f Ao 1643

Gift of H. F. Ahmanson and Company in memory of Howard F. Ahmanson

M.72.67.1

PROVENANCE:

Amsterdam, Pieter de Smeth van Alpen sale, 1–2 August 1810.

Amsterdam, Anna Maria Hogguer sale, 18–21 August 1817.

Paris, Madame Le Rouge sale, 27 April 1818, no. 58.

Paris, Comte de Morny.

Paris, Charles Sedelmeyer (dealer), 1894–95.

Brussels, Simeon del Monte, by 1928–59.

London, sale, Sotheby's, 24 June 1959, no. 59.

Los Angeles, Howard F. Ahmanson, 1959–72.

SELECT LITERATURE:

Jane P. Davidson, *David Teniers the Younger* (Boulder, Colorado: Westview Press, 1979), 25, 57, 60, 77, pl. 5.

David Teniers the Younger was born in Antwerp, where he reportedly trained with his father, David Teniers the Elder, a minor painter and art dealer. In 1632 the son joined the Antwerp guild and soon after met the painter Adriaen Brouwer, who had recently returned from Holland (Brouwer's compositions of tavern interiors and low-life genre scenes had a decisive and lasting influence on Teniers's oeuvre). Teniers was an associate of Rubens and Jan Brueghel I, whose daughter he married in 1637.

An immensely productive artist, whose paintings were often copied and imitated, Teniers is best known for his genre scenes, usually set in guardrooms or taverns. He painted still lifes, portraits, and religious pictures as well. In addition he was an important landscape painter in the Dutch manner. His penchant for bawdy images of lower-class and military life did not preclude his association with the most exalted of clients and protectors. He enjoyed, for example, the patronage of Antoon Triest, the bishop of Ghent, and around 1651 he moved to Brussels, where he became court painter to Archduke Leopold Wilhelm. Teniers also served Leopold as caretaker of his art collection, preserving a semblance of its richness in several encyclopedic paintings of the *kunstkamer*. Leopold's successor, Don Juan of Austria, ennobled the artist in 1658.

An Artist in His Studio was painted in 1643, when Teniers was at the height of his powers. The artist's debt to Brouwer in this interior scene is considerable, especially in the planarity of the composition and such details as the old woman peering

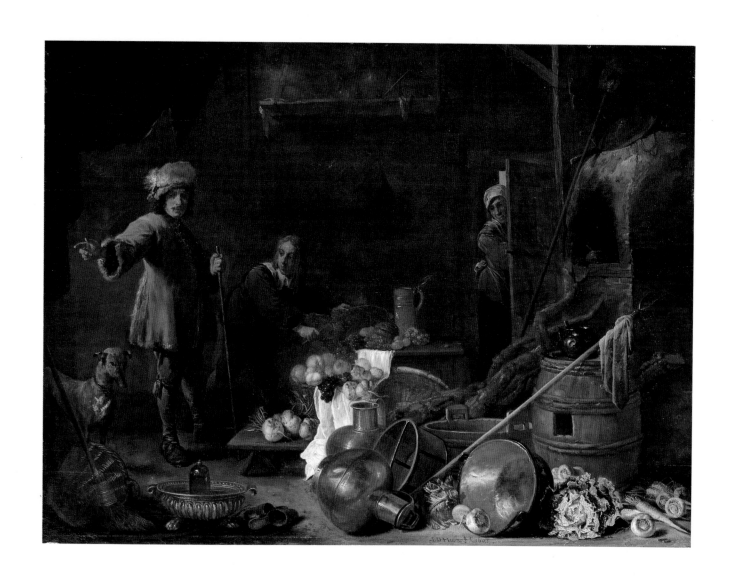

through the half-open door. Teniers's precise and smooth brushstrokes, however, owe little to Brouwer's typically rough and heavy application of paint. The arrangement of the principal elements, moreover, recalls numerous works by Teniers from the 1640s, such as the *Guardroom with the Deliverance of Saint Peter* (Metropolitan Museum of Art, New York), which is datable to 1645–47. In both pictures figures are grouped around a table at the center, an oven or fireplace is placed to one side, and a wedge of either military accoutrements or kitchen bric-a-brac fills a corner of the foreground.

In the Los Angeles picture this *repoussoir* device, which heightens the sense of three-dimensional space, plays a more prominent role than usual. The fruit and vegetables on the wooden table and the cluttered kitchen ware in the lower right corner fill much of the foreground. These objects were painted by Jan Davidsz de Heem, who signed his name and dated the picture at the lower right center edge, just below the copper pot. Teniers, whose own signature appears to the right of the discarded shoes, often collaborated with other artists, especially later in his career, but this painting is a rare instance of Teniers working with de Heem, the premier still-life painter of the seventeenth century. The deft touch of de Heem's brush is here in full power, capturing, for instance, the reflection off the copper jugs and the translucency of the grapes. The still-life elements can be compared with those in his *Still Life with Oysters and Grapes* (cat. no. 39).

The subject matter of *An Artist in His Studio* is difficult to determine at first. The work was previously titled *Kitchen Interior*, no doubt owing to the presence of the oven and the profusion of foodstuffs and culinary equipment. The drapery at the upper left, however, which partially obstructs the light from a hidden window, suggests the orchestrated space of a studio. The man at the left, dressed in a fur-lined coat and hat and holding a maulstick, is clearly an artist and has in fact been identified as Teniers; he directs the actions of the servant in the center, who seems to be arranging a still life, evidently the subject of the picture the artist is painting.[1] The motif is similar to Jan Vermeer's famous *Artist's Studio* (Kunsthistorisches Museum, Vienna), which includes the artist, his subject, and the curtain that controls the fall of light. But the dank and humble studio of Teniers's painting, with its unseemly chaos of objects and food, shares little of the dignity and hushed reverence of Vermeer's working space. Painted prior to Teniers's exalted status as court painter to Leopold, *An Artist in His Studio* draws attention more to the artist as craftsman, working with his hands, than to the poet-painter celebrated in Vermeer's picture.

RR

Notes
1. Davidson, 57.

Saint Francis's Vision of the Musical Angel

MORAZZONE (PIER FRANCESCO MAZZUCCHELLI)
Italian (Lombardy), 1573–1626

c. 1611
Oil on canvas
46½ x 62 in. (118.1 x 157.5 cm)
Gift of The Ahmanson Foundation
M.73.6

PROVENANCE:
Italy, private collection.
New York, Frederick Mont (dealer).

SELECT LITERATURE:
Roberto Longhi, "Codicilli alle 'Schede lombarde' di Marco Valsecchi," *Paragone* 21, no. 243 (May 1970): 37–38, pl. 31.

In the anonymous fourteenth-century *The Little Flowers of Saint Francis of Assisi*, which was the most widely consulted life of the saint in the sixteenth and seventeenth centuries, it is recounted how he retired to a cell or cave in a rocky wilderness to pray and do penance by fasting and mortifying his body:

> *Finally . . . Saint Francis being much weakened in body through his sharp abstinence, and through the assaults of the devil, and desiring to comfort the body with the spiritual food of the soul, began to think on the immeasurable glory and joy of the blessed in the life eternal; and therewithal began to pray God to grant him the grace of tasting a little of that joy. And as he continued in this thought, suddenly there appeared unto him an Angel with exceeding great splendour, having a viol in his left hand and in his right the bow; and as Saint Francis stood all amazed at the sight of him, the Angel drew the bow once across the viol; and straightway Saint Francis was ware of such sweet melody that his soul melted away for very sweetness and was lifted up above all bodily feeling; insomuch that, as he afterwards told his companions, he doubted that, if the Angel had drawn the bow a second time across the strings, his mind would have left his body for the all too utter sweetness thereof.*[1]

This scene of angelic consolation for the penitent suffering of Saint Francis was not treated by artists in medieval and Renaissance times, but it became a popular subject in Counter-Reformation Italy. Exemplary of the Counter-Reformation revival of interest in the saints of earlier eras was the claim of the seventeenth-century Franciscan scholar Luke Wadding that he had established the date that the musical angel had appeared to Saint Francis in Rieti. Wadding claimed the year was 1225, one after the saint had received the stigmata on Mount Alverna and one before his death in 1226. The most celebrated representation of this event was Agostino Carracci's print of 1595 (*Saint Francis Consoled by the Musical Angel*, fig. 3a), which was adapted from a slightly earlier print by his friend and colleague Francesco Vanni. In these two works it is established that Saint Francis is in a remote, rocky place with only a simple cup for drinking and roots to eat; the knotted cord is his scourge. The crucifix he embraces indicates that he has been contemplating the sufferings of Christ, but it also carries a message of eternal spiritual life. The nearby skull is a

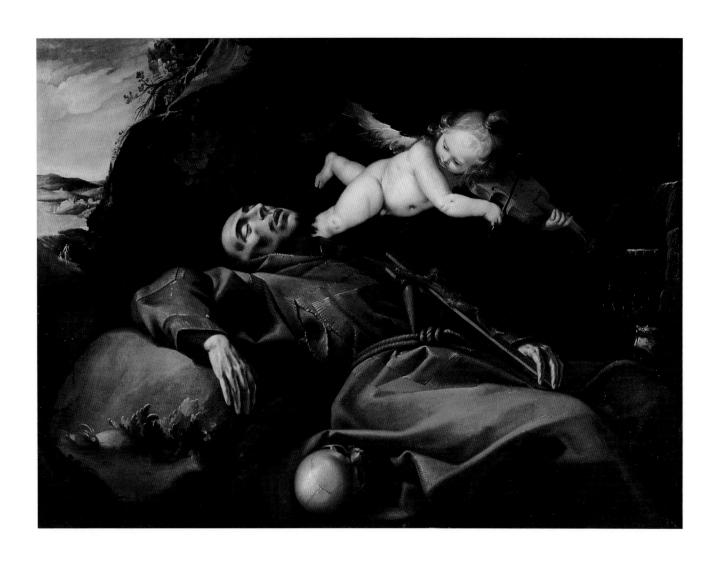

reminder of the mortality of the flesh. The saint has fainted in ecstasy, "lifted up above all bodily feeling," a respite provided by the angel's "sweet melody."

All of these elements are present in Morazzone's picture, albeit with some variations: there is no cup, just a nearby stream for drinking water, and the roots are still growing on the hillside. The painting is much larger than Carracci's print, giving the figure of Saint Francis a powerful, looming presence. It is a dark work, typical of the Lombard school in the late sixteenth and early seventeenth centuries, colored mainly with austere browns, grays, and creams. There is an eerie, spiritual light, however, still reminiscent, almost a century after his death, of Leonardo da Vinci, who had such a potent influence on Lombard painting.

The provenance for *Saint Francis's Vision of the Musical Angel* is sketchy. It cannot be traced before its acquisition by Frederick Mont, when it bore an attribution to the Spanish painter Francisco Ribalta. In 1970 Roberto Longhi attributed it to Morazzone and dated it to about 1611. He compared the piece with Morazzone's *Magdalen*, which was installed in the Cappella della Maddalena in San Vittore, Varese,

Fig. 3a
Agostino Carracci (after Francesco Vanni), *Saint Francis Consoled by the Musical Angel*, 1595, engraving, 13⁷⁄₁₆ x 12⅛ in. (34.2 x 30.8 cm), National Gallery of Art, Washington, D.C., Ailsa Mellon Bruce Fund.

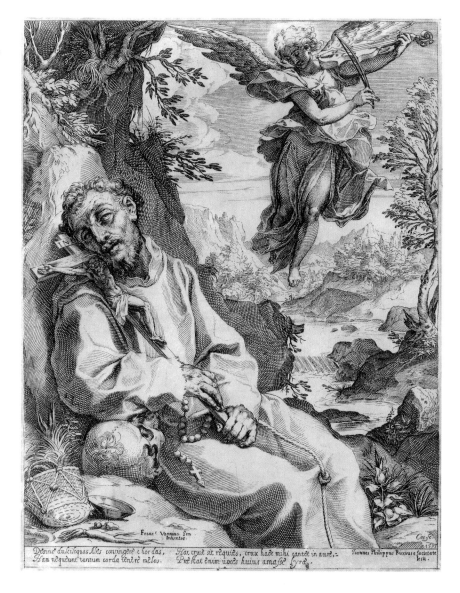

Notes

1. *The Little Flowers of Saint Francis of Assisi*, trans. T. W. Arnold (London: J. M. Dent & Sons, 1898), 184–85.

2. For information on the *Magdalen* see *Il seicento lombardo*, exh. cat. (Milan: Palazzo Reale, 1973), 2:47, no. 103, pl. 118.

3. Mariagrazia Brunori, "Considerazioni sul primo tempo di Francesco Del Cairo," *Bollettino d'Arte* 49, no. 3 (July–September 1964): 236, fig. 1.

4. Mina Gregori, letter to author, 25 October 1989.

5. *Il Morazzone*, exh. cat. (Milan: Bramante, 1962), 186.

in 1611.[2] The schematic landscape setting, treatment of draperies, small angels, and use of light are indeed generally comparable in the two works, so the attribution seems quite reasonable.

Several scholars have questioned this attribution in recent years, however. All agree that the painting is from Lombardy or Piedmont, from the circle of Morazzone, and that it is of good quality. The most frequent alternative attribution has been Francesco del Cairo, a follower of Morazzone who worked mainly in Milan. This suggestion rests primarily on similarities between the museum's painting and Cairo's *Dream of Elijah* (church of Sant'Antonio Abate, Milan), which probably dates from the early 1630s.[3] To the present writer these similarities are more compositional than stylistic; the reclining figures of Elijah and Saint Francis are similar, but the Morazzone does not have the almost mystical intensity of light and expression that is typical of Cairo's works. Of course if the museum's painting is a much earlier work by Cairo, it could be argued that he was still trying out Morazzone-like ideas, but corroborating evidence of this is lacking. More recently Mina Gregori has reiterated her opinion that the Los Angeles painting is by a Piedmontese follower of Morazzone, not Cairo. Indeed if a Morazzone follower or pupil is being discussed, it is all too easy to go to a famous name like Cairo. For Gregori the angel in the museum's picture recalls painters such as Isidoro Bianchi or Stefano Montalto, but she still leaves the question open.[4] Gregori draws attention to another version of the museum's painting in the sacristy of San Tommaso, Turin, a work to which she first referred in 1962.[5]

Whoever painted it, *Saint Francis's Vision of the Musical Angel* is an excellent example of religious art in Lombardy and Piedmont during the early seventeenth century. The unusual way in which the saint has swooned into the landscape perhaps suggests knowledge of Caravaggio's early *Stigmatization of Saint Francis* (Wadsworth Atheneum, Hartford), as does the dark landscape setting and the eerily breaking light. Subsidiary figures of shepherds in Caravaggio's painting are echoed in the tiny background figures, possibly Tobias and the Angel, who appear in the Morazzone, but their identification is uncertain and also inconsistent with the life of Saint Francis. Longhi suggested that the distant hill town seen in the glimmering light is Varese, but this seems fanciful.

Morazzone, along with his Lombard colleagues Tanzio da Varallo (cat. no. 19) and Cerano, was profoundly influenced by the art of Gaudenzio Ferrari, his Lombard forerunner, and studied in Rome from 1592 to 1598, where he was certainly aware of Caravaggio's innovative realism and exaggerated chiaroscuro. Although he draws stylistically from the Carracci and Caravaggio, Morazzone's interpretation of Saint Francis's ecstasy has considerable originality of composition and mood. The painting is permeated by a gentle restfulness, as the saint gains a welcome relief from his mental and physical anguish.

PC

Holy Family

FRA BARTOLOMMEO (BACCIO DELLA PORTA)
Italian (Florence), 1472–1517

c. 1497
Oil on canvas
59⁷⁄₁₆ x 35¹⁵⁄₁₆ in. (151.0 x 91.3 cm)
Gift of The Ahmanson Foundation
M.73.83

PROVENANCE:

Florence, Ferdinand Panciatichi Ximemes d'Aragona, by 1857.

Florence, Mariana Panciatichi.

Florence, Charles Fairfax Murray (dealer).

Rome and Florence, Count Alessandro Contini-Bonacossi, until 1969.

New York, Eugene Thaw (dealer), 1969–73.

London, Thomas Agnew and Sons (dealer).

SELECT LITERATURE:

Bernard Berenson, *Italian Pictures of the Renaissance: Florentine School* (London: Phaidon Press, 1963), 1:23.

Everett Fahy, "The Earliest Works of Fra Bartolommeo," *The Art Bulletin* 51, no. 2 (June 1969): 148–49, fig. 20.

Everett Fahy, "A 'Holy Family' by Fra Bartolommeo," *Los Angeles County Museum of Art Bulletin* 20, no. 2 (1974): 8–17.

This *Holy Family* was first published as a work by Mariotto Albertinelli, but when the painting was exhibited in Florence in 1940, it was declared by leading scholars to be unquestionably by Fra Bartolommeo.[1] The confusion regarding works by Bartolommeo and Albertinelli has since been clarified by Everett Fahy, who firmly established that the *Annunciation* in the Cathedral of Volterra (fig. 4a), dated 1497, is by Bartolommeo and not Albertinelli, as had hitherto been claimed.[2] This is significant for the Los Angeles painting (which was done after the Volterra work), for, as Fahy recognized, the Madonna in the *Annunciation* is duplicated in the *Holy Family*.[3] Mary's stance, the position of her left hand and head, and the fall of her draperies are the same in both paintings. The artist varied only the position of the Virgin's right hand, which in the museum's painting holds the head of the Christ Child, and the mantle, which covers her head in the *Holy Family* but rests on her shoulders in the *Annunciation*. It is clear the artist used the same cartoon for the Madonna in each picture.

The museum's work conforms to the traditional portrayal of the Holy Family as established in the 1490s, principally by Raphael and Leonardo da Vinci. Bartolommeo absorbed the innovations of these masters through his teacher Cosimo Rosselli, a follower of Leonardo. Bartolommeo subsequently studied with the fashionable painter Domenico Ghirlandaio, in whose studio he met Albertinelli. Around 1492 the two young artists set up a workshop together, collaborating occasionally on paintings such as the fresco of the *Last Judgment* in Santa Maria Nuova in Florence.

Sometime around 1500 Bartolommeo gave up painting to become a monk, entering the Dominican monastery at Prato. By 1504 he was back in Florence, however, where he established a flourishing studio. Aside from brief visits to Venice in 1508 and Rome in 1514, he spent the majority of his career in his native Florence, where he was the principal exponent of the High Renaissance style. All his extant

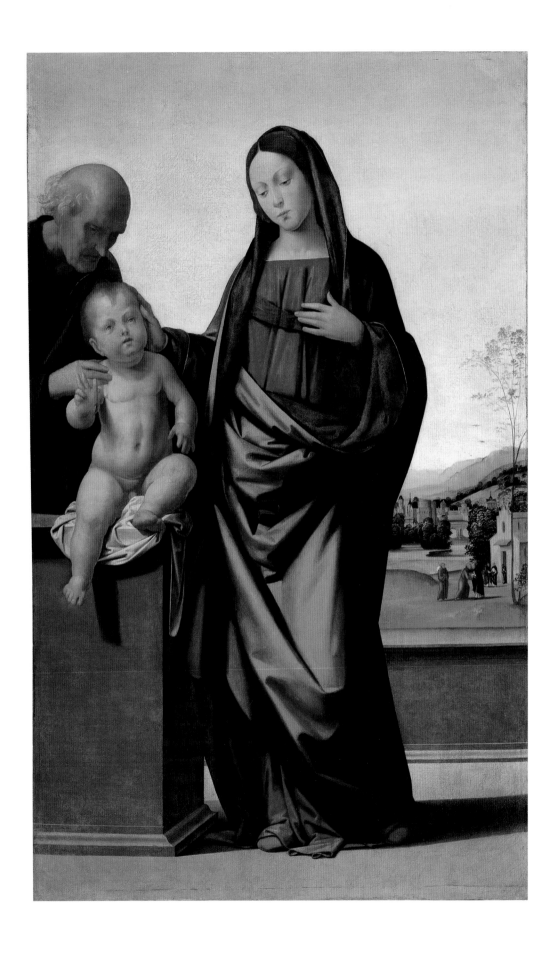

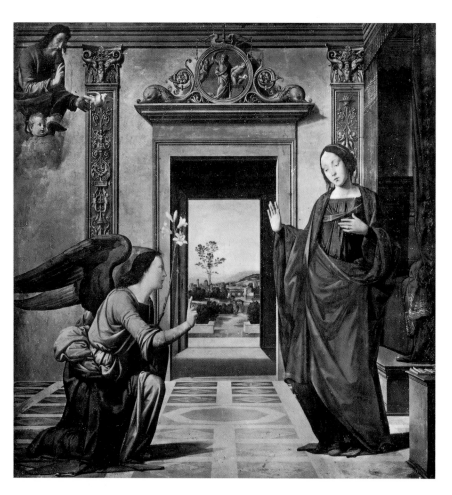

FIG. 4a
Fra Bartolommeo, *Annunciation*, 1497, tempera and oil on panel, 69⁵⁄₁₆ x 66¹⁵⁄₁₆ in. (176.0 x 170.0 cm), Cathedral, Volterra. Photo: Alinari/ Art Resource.

paintings are religious in subject matter.

Bartolommeo's art, also like that of Raphael and Leonardo, ultimately drew its inspiration from nature, although it was a nature filtered through the idealizing conventions suitable to the subject matter. As an heir to the artistic innovations of the fifteenth century, Bartolommeo represented nature in its perfect state, purged of the accidents and particulars of real life but nevertheless rendered with complete understanding of anatomical structure and optical phenomena. His figures betray no hint of individuality; instead they conform to ideal types, as befits their heavenly provenance. In the *Holy Family* the Virgin's elegant proportions are matched by the perfect oval of her face and the graceful fall of her draperies; her movements are restrained and measured as she gently caresses the head of the robust and active Christ Child. Joseph is more a paradigm of benign old age than a portrait of wrinkled flesh.

Notes

1. *Mostra del cinquecento toscano in Palazzo Strozzi*, exh. cat. (Florence: Palazzo Strozzi, 1940), 22, no. 3. Ludovico Borgo, in his doctoral dissertation, still maintains the attribution to Albertinelli. See Ludovico Borgo, "The Works of Mariotto Albertinelli" (Ph.D. diss., Harvard University, 1968), 78–83, 200–202, no. 4, fig. 5. The dissertation was published by Garland Publishing, New York, in 1976.

2. Everett Fahy, "The Beginnings of Fra Bartolommeo," *The Burlington Magazine* 108, no. 762 (September 1966): 459–60.

3. Fahy, "The Earliest Works of Fra Bartolommeo," 148–49. The landscapes in both paintings are extremely similar as well.

4. Ibid., 149.

The limpid landscape stretching beyond the parapet at the right side of the *Holy Family* balances both natural observation and artistic idealization. The gentle valley, with its town hugging the banks of a river, is suffused with a clear, even light. The hills dissolve into the distance as the rich earth tones of the foreground recede into the silvery blues of the far-off mountains. Nature, however, is organized by Bartolommeo into a series of overlapping planes, clearly divided between a foreground, middle ground, and background. At the extreme right the reedlike tree, a bird's nest nestled in its branches, closes off the composition, providing a frail counterpoint to the statuesque Virgin.

In fifteenth-century Florence the vast majority of altarpieces were square, or nearly so, and usually painted on wood panels. The oddly vertical proportions of the museum's composition and the fact that it was painted on canvas suggested to Fahy that the picture served originally as a processional banner used by a confraternity dedicated to the Virgin.[4] This might explain the unusual placement of the Madonna in the center. Although an attractive hypothesis, there are few processional banners from this period with which to compare the *Holy Family*, and the painting may seem too elaborate and too well-preserved to have served such a purpose.

In the middle distance of the landscape the artist painted the facade of a convent, before which Saints Francis and Dominic embrace. This scene refers to a well-known dream of Dominic, in which the Madonna tells Christ that the two friars will lead the struggle against the vices of pride, avarice, and lust. This story clearly had special significance for Bartolommeo, for he depicted it at other times in his career (it also appears in a drawing in the Staatliche Museen, Berlin, and a fresco in the Convent of the Maddalena, near Florence). No doubt the artist, who became a Dominican monk himself, felt drawn to the life of the founder of the order. Bartolommeo's fascination with Dominican imagery had a more particular and timely relevance, however: its inclusion here is undoubtedly an homage to the charismatic sermons of the reformist Dominican friar, Girolamo Savonarola, who led from his pulpit a populist challenge to the rule of the Medici family and who became, for a time, the de facto dictator of Florence. Bartolommeo, before joining the Dominican order, was an intimate disciple of Savonarola and painted a portrait of the friar, whose fanatical diatribes against luxury and idolatry must have made the legendary dream of Saint Dominic intensely vivid in Bartolommeo's mind. The painter was provoked, along with other artists, to destroy some of his works in the great bonfires Savonarola orchestrated in the Piazza della Signoria as a means of ridding Florentine society of the idolatrous icons and extravagant items that corrupted it. Savonarola was eventually hanged as a heretic in 1498, soon after Bartolommeo painted the *Holy Family*. Fittingly the artist later became the principal painter at the church of San Marco, Savonarola's former seat of power.

RR

Portrait of a Man (Pieter Tjarck) **FRANS HALS**
Dutch, 1581/85–1666

c. 1635–38
Oil on canvas
33⁹/₁₆ x 27½ in. (85.2 x 69.9 cm)
Gift of The Ahmanson Foundation
M.74.31

PROVENANCE:

Brussels, Comte d'Oultremont.

Paris, sale, Hôtel Drouot, 27 June 1889, no. 3.

Paris, Arnold and Tripp (dealer), 1889.

London and Bawdsey Manor, Suffolk, Sir William Cuthbert Quilter, 1889/90–1911, then by descent, until 1937.

New York, Knoedler (dealer), 1937.

Nassau, Bahamas, Sir Harry Oakes, 1937–43.

Nassau, Lady Oakes, 1943–74.

London, sale, Christie's, 29 June 1973, no. 104 (bought in).

London, P. & D. Colnaghi & Co. Ltd. (dealer).

SELECT LITERATURE:

Wilhelm von Bode and M. J. Binder, *Frans Hals: His Life and Work*, trans. M. W. Brockwell (Berlin and London: Photographische Gesellschaft, 1914), 2:57, no. 178, pl. 110.

N. S. Trivas, *The Paintings of Frans Hals* (New York: Oxford University Press, 1941), 46–47, no. 65, pl. 88.

Seymour Slive, *Frans Hals* (London: Phaidon Press, 1970, 1974), 1:122, 2: plates 176–77, 3:59–60, no. 108.

Claus Grimm, *Frans Hals: The Complete Work* (New York: Abrams, 1990), 283, no. 92.

The identity of the sitter in this magnificent portrait has sometimes been questioned, but there seems to be no reason to doubt the veracity of its traditional identification. The painting first appeared at a Parisian auction in 1889 as a "Portrait de Messire Pierre Tiarck." An old label on the back of the panel bears an inscription, probably from the eighteenth century, which reads: "Messire Pierre Tiarck / fils de Théodore et de / Mademoiselle Gertrude / Worp." In the 1889 sale the painting was paired with a Hals portrait of a woman, which is now in the National Gallery, London (fig. 5a).[1] It too bears an inscription, apparently by the same hand, which describes the woman as "Mademoiselle Marie Larp fille / de Nicolas Larp et de / Mademoiselle de / Wanemburg." Research in the Haarlem archives reveals several references to a Maria (or Maritgen) Claesdr Larp, who in 1634 married a Pieter Dircksz Tjarck, whose occupation was listed as *verwer* (a dyer of silk and cloth). It would appear completely reasonable to assume that the French inscriptions on the backs of the two paintings were translations of the names of the sitters, taken either from old Dutch labels that have since been lost or based on some other form of information.

The portrayal of the sitters offers internal evidence that the two works were painted as pendants. The pictures are nearly identical in size, and in each the sitters are placed within painted frames and lit from the left. Within these points of similarity, however, Hals varied the gestures and forms of the two sitters, contrasting the man's bent wrist, his hand dangling a rose, with the woman's tense, open hand held up to her breast. The dark, oval silhouette of his wide-brimmed hat mirrors the glowing white expanse of her huge ruff.

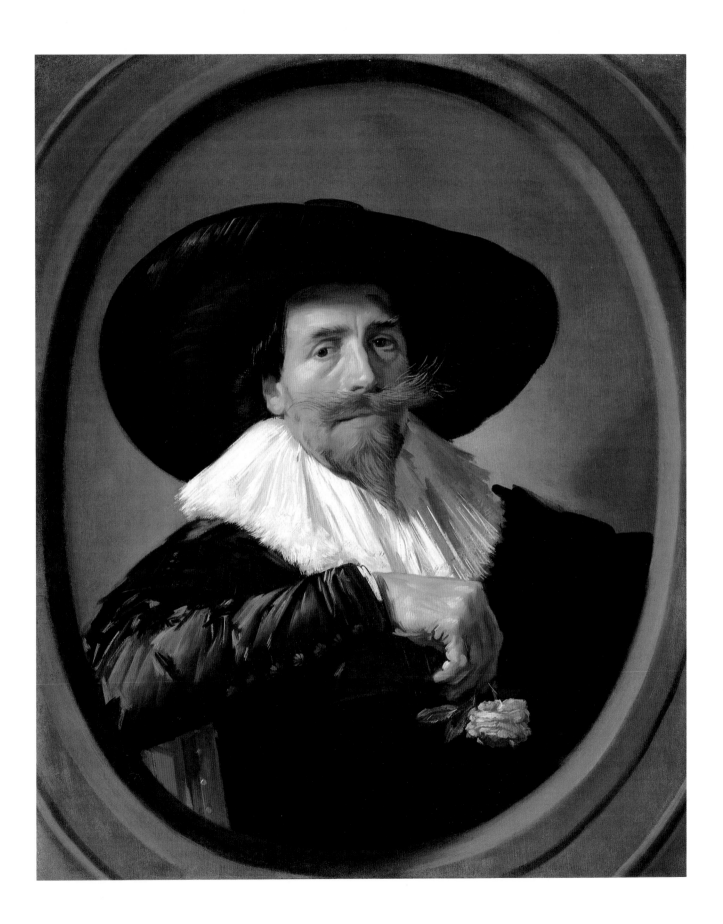

In traditional fashion Tjarck and Larp are distinguished one from another by the way the artist reveals their personalities. The husband, with his tilted hat and air of bravado, challenges the viewer through the simulated frame surrounding the composition. As if interrupted, he turns toward the spectator, leaning his arm across the back of a chair. This was an artistic device Hals invented and was to use in many of his male portraits, notably in *Isaac Abrahamsz Massa* (Toronto, Art Gallery of Ontario), wherein the sitter dangles a sprig of holly in the foreground of the painting as he leans over the back of a chair.[2] The effect is of a fleeting moment captured in paint, of a dynamism and spontaneity that is contained in the very brushwork itself, with its flashes of highlight and quickness of touch. This transient, even casual, treatment of a portrait was a characteristic remarked upon by the artist's early biographer, Arnold Houbraken, who wrote of "the boldness and vivacity with which his brush caught the natural likeness of human beings."[3]

Next to Tjarck, Larp is all reticence. In contrast with the sheer physical presence of her husband, she seems to cower in her simulated frame. Her arm does not cross the line between painted and real space but in fact pushes back the torso, exuding a sense of shyness or humility in the presence of the viewer. Unlike her husband, who has suddenly turned in his chair, Larp already faces the picture plane; there is no sense of movement or dynamism in her prim deportment.

Hals adapted his technique in each portrait to reinforce the sitters' different characters. For his portrayal of Tjarck, Hals loaded his brush with paint, deftly describing the textures of the silken doublet and the linen ruff, the gleam of flesh and the stiff moustache. Tjarck's hand and the rose it holds were painted with a startling palpability: they appear to break through the picture plane and enter the space of the viewer. When he created Larp's portrait, however, Hals reined in his characteristic bravura handling of paint, restraining his technique in keeping with the puritan demeanor of his subject. Any insight Hals might have had into her personality appears subsumed within a concentrated articulation of her apparel: the precise lace cuff, embroidered dress, and millstone ruff. Larp shrinks into her clothing, exuding none of the self-assurance of Tjarck.

The subtle differences in technique and expression between the two portraits are consistent with Hals's pendant portraits painted in the 1630s. Other examples include the *Portrait of a Man* and *Portrait of a Woman*, datable to the early 1630s, in the Staatliche Museen in Berlin, and a portrait pair in the Royal Collection of Sweden, dated 1638.[4] These last two are closely related to the Tjarck portrait and its pendant in the inclusion of simulated frames around the sitters. Apparently Hals first experimented with this trompe l'oeil device in the early 1630s but abandoned the trick by the beginning of the next decade.

Based on the style, treatment of the characters of the sitters, and the employment of the simulated frame, most scholars date the *Portrait of a Man (Pieter Tjarck)* and its pendant to the mid-1630s. The fact that Tjarck wedded Larp in 1634 offers the possibility that the pictures were painted to celebrate their marriage. Tjarck's rose can be understood not as a *vanitas* symbol, a reminder of the transience and brevity of human existence, as it might in a still life, but as the flower of Venus, a symbol of love perfectly appropriate in the context of marriage. In effect the portraits record the offering of love between the man and woman, a ritual the viewer evidently has

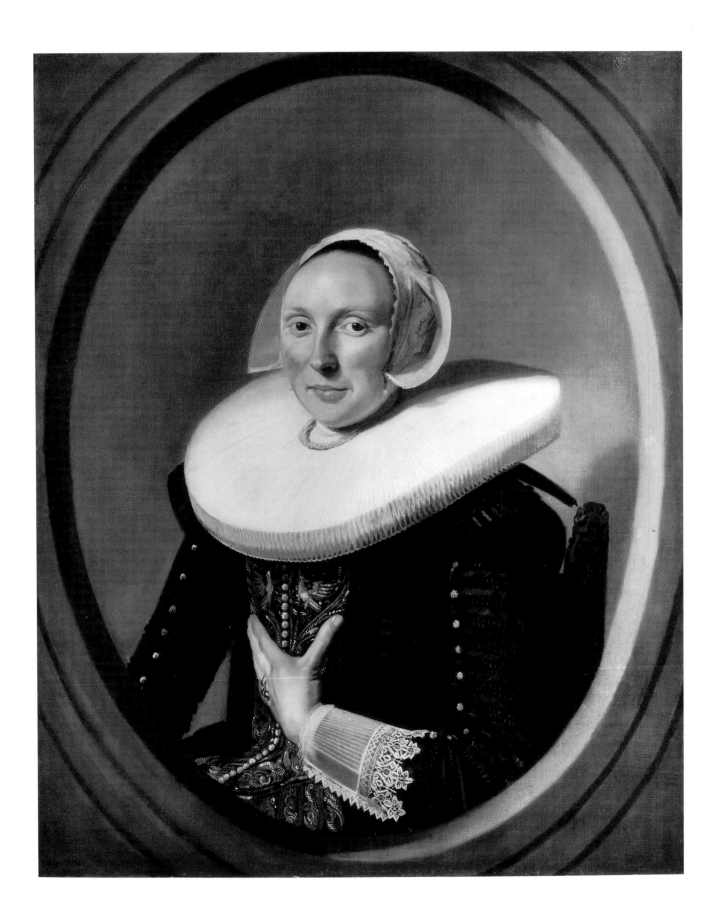

Notes

1. Slive, 2: pl. 181, 3:61–62, no. 112.

2. Ibid., 2: pl. 64, 3:25–26, no. 42.

3. Houbraken's *Life of Frans Hals* is printed in *Frans Hals*, exh. cat. (London: Royal Academy of Arts, 1989), 17–18.

4. Slive, 2: plates 150–51, 3:53, nos. 88–89; 2: plates 182–83, 3:62, nos. 113–14.

5. Ibid., 2: plates 290–91, 3:97–99, nos. 188–89.

interrupted. Hals was to again use the theme of an offered rose to unite pendant portraits of a husband and wife in *Stephanus Geraerdts* (Antwerp, Royal Museum of Fine Arts) and *Isabella Coymans* (Paris, Rothschild Collection), both dated c. 1650.[5]

Little is known of Tjarck or Larp other than the fact that they had one son, Nicolaes Pietersz Tjarck, and that Larp was listed in the archives as a widow in 1646. She remarried in 1648, was widowed again in 1653, and died in 1675. Tjarck's profession as a silk dyer suggests that the couple might have been Mennonite, as were most of the cloth merchants in Haarlem. Larp's rather elaborate costume, however, would have been unacceptably ostentatious to that religious sect.

Hals is considered today as one of the greatest Dutch artists of the seventeenth century and perhaps its greatest portraitist, after Rembrandt. He was, however, virtually unknown outside Haarlem in his own time and was "rediscovered" only in the nineteenth century, when Dutch art as a whole was reappraised by French critics and artists. As a result of his obscurity very little is known of his life. He was born in the first half of the 1580s in Antwerp, but later that decade his family moved to Haarlem. There he probably studied with Carel van Mander, but he did not become a member of the artists' guild until 1610. Hals joined *De Wijngaardranken*, one of Haarlem's drama and poetry societies, in 1616.

The entirety of Hals's career was spent in Haarlem, where he received numerous portrait commissions from various militia companies as well as leading citizens of the city. The great majority of his oeuvre consists of portraits, although he did paint genre scenes and several religious pictures. Despite great productivity Hals was continually in debt, and he died in poverty in 1666.

RR

PAOLO VERONESE (PAOLO CALIARI)
Italian (Venice), 1528–88

Allegory of Navigation with a Cross-Staff: Averroës

1557

Oil on canvas

80⁷⁄₁₆ x 46 in. (204.3 x 116.8 cm)

Gift of The Ahmanson Foundation

M.74.99.2

Allegory of Navigation with an Astrolabe: Ptolemy

1557

Oil on canvas

80½ x 46 in. (204.5 x 116.8 cm)

Gift of The Ahmanson Foundation

M.74.99.1

PROVENANCE:

Scotland, John Campbell, Earl of Ormelie.

Possibly Langton (near Duns), Berwickshire, Scotland, the Honorable Robert Baillie-Hamilton, then by descent to his wife, Mary Gavin Pringle, the niece of John Campbell, until 1911.

Newport, Rhode Island, Robert Goelet, until 1947.

Newport, Rhode Island, Salve Regina College.

London, sale, Sotheby's, 12 December 1973, no. 13.

London, Thomas Agnew and Sons (dealer).

SELECT LITERATURE:

Terisio Pignatti, *Veronese* (Venice: Alfieri, 1976), 1:75–76, 127–28, nos. 136–37, 2: plates 387–92.

W. R. Rearick, *The Art of Paolo Veronese 1528–1588*, exh. cat. (Washington, D.C.: National Gallery of Art, 1988), 60–62, cat. nos. 22–23.

These two paintings by Veronese are part of a set of four, the third of which, the *Allegory of Sculpture*, slightly cut down, is in a private collection in Switzerland. The fourth, the *Astronomer with an Astrolabe Globe*, is missing. The appearance of the complete set is known through four larger copies, now in the Musée des Beaux-Arts, Chartres, which were made later in the sixteenth century (the copies of the *Allegory of Sculpture* and the *Astronomer* are illustrated as figs. 6–7a and 6–7b).

In the *Allegory of Sculpture* a female figure is accompanied by a putto who carries her attributes of modeling tools and a clay statuette. Each of the three male allegorical figures in the other paintings carries a scientific instrument for celestial calculation. At the time of their acquisition in 1974 the museum's paintings were tentatively and quite reasonably known as *Allegory of Navigation with a Linear Astrolabe* and *Allegory of Navigation with a Flat Astrolabe*.

The four paintings do not make a very convincing self-contained set in terms of their subject matter and are probably the first and only completed parts of a larger suite of decorative allegories. Although the attributes of navigational devices cannot easily be linked to specific individuals by iconographic tradition, the three male figures clearly are meant to represent mythical or historical astronomers.

Professor W. R. Rearick, to whose scholarship this entry is indebted, has suggested that the three men be associated with the ancient astronomers Averroës (cat. no. 6), Ptolemy (cat. no. 7), and Zoroaster (fig. 6–7b) by analogy with the

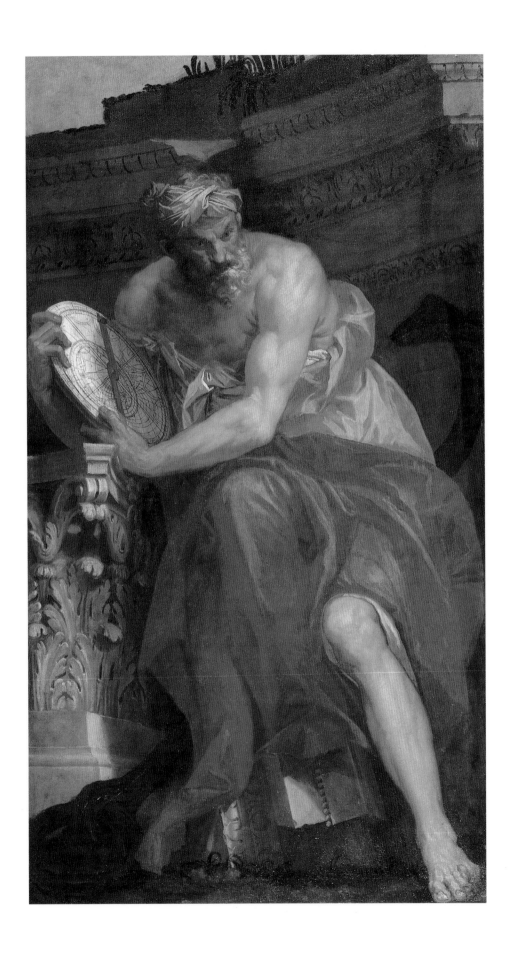

attributes assigned to these sages in a woodcut illustration for Daniele Barbaro's edition of Vitruvius, which was published in Venice in 1556 by Marcolini. These attributions are fitting considering that the paintings were conceived as part of the decoration of a library.

Between August 1556 and February 1557 the long ceiling of Jacopo Sansovino's great Libreria at Saint Mark's in Venice was decorated with twenty-one paintings that followed an elaborate iconographical program. The works were commissioned in sets of three from seven different artists. Veronese was one of these painters; in February 1557 Titian awarded him a gold chain as the best artist in the scheme. The walls of the main hall of the Libreria remained undecorated, as did those of the antechamber. Rearick has convincingly suggested that early in 1557 a decision was made to complete the decoration of the main hall with more allegorical paintings placed along the walls below the completed ceiling. Veronese executed the first four paintings and planned another (there is a preparatory drawing for a standing philosopher in the Royal Library, Windsor Castle), while a further painting was commissioned from Giuseppe Porta Salviati. Rearick argues that these first paintings were soon perceived to be too small in scale for the grand spaces of the hall and that their settings of antique architectural ruins with open skies did not harmonize with Sansovino's architecture. In about 1559 this first scheme was abandoned and a second one initiated. This new plan, begun by Battista Franco, Andrea Schiavone, Veronese, and his brother Benedetto, was completed by Tintoretto in 1570–71. These decorations subsequently underwent many vicissitudes; the present arrangement dates from 1929. Meanwhile, Veronese's original paintings of 1557 were probably moved to the antechamber, where four such paintings (presumably the Chartres copies) were identified by Boschini in 1674.[1] Most likely Veronese's originals were sold off when the antechamber was remodeled by Scamozzi in 1597 and replaced in the new antechamber by the four copies now at Chartres.

The museum's works can well be imagined in an architectural setting and are clearly meant to be viewed from slightly below. Averroës looks up, no doubt originally toward one of the allegorical ceiling paintings in the Libreria, while Ptolemy looks down into the room. The figures assume mannerist contrapposto poses and are slightly top-heavy to allow for the effect of perspective when seen from below. They have the rich surface texture associated with Venetian painting of the sixteenth century, which helps give the figures a powerful physical presence. The

FIG. 6–7a
Copy after Veronese, *Allegory of Sculpture*, c. 1597, oil on canvas, 87⅛ x 56⅛ in. (221.9 x 142.6 cm), Musée des Beaux-Arts, Chartres.

first painting is richer and more saturated in color, with contrasting red and green and a silvery white, while the second is more somber and tonal. While Venetian painters were aligned traditionally with the painterly effects of *colore*, and Veronese was no exception, his Libreria decorations, in their strong modeling of form and in the artist's understanding of anatomy and the force of a bold outline, betray his interest in the *disegno* (drawing) of Michelangelo and the Florentine/Roman school. *Averroës* and *Ptolemy* are among Veronese's grandest and most mature figures, decorative yet substantial in their physical and intellectual weight.

Veronese was the greatest decorative painter of the Venetian school in the sixteenth century. Born in Verona, where he had his first artistic training, he traveled to Venice sometime between 1545 and 1550. Although Verona was under the sway of the coloristic traditions of nearby Venice, it was also close to influences from Giulio Romano in Mantua and Parmigianino in Parma. On Veronese's arrival in Venice, however, it was above all the rich and festive color of Titian that impressed the young artist. Although he produced many beautiful and moving easel pictures and altarpieces, it was as a decorator on a grand scale in the churches and palaces of Venice that Veronese had his greatest successes. In 1553 he was working in the Ducal Palace, in the Sala del Consiglio dei Dieci, and then in the Sala dei Dieci, important commissions that show he was well regarded. By the late 1550s he had begun work on his greatest surviving decorative ensemble, the interior of the church of San Sebastiano, which was to occupy him on and off for the next twenty years.

The canvases for the Libreria date from this first decade of Veronese's activity in Venice. At the end of the 1550s he executed his most delightful secular decorations, the painted interiors of the Villa Barbaro, newly completed by Palladio in the foothills of the Alps at Maser. Veronese's decorations became increasingly sumptuous and colorful. The most celebrated in his day and today are the *Marriage Feast at Cana* (Louvre, Paris), painted in 1562–63 for the refectory of the Venetian church of San Giorgio Maggiore, and the *Feast in the House of Levi* (Accademia, Venice), painted in 1573 for the refectory of Santi Giovanni e Paolo. With their ornate scenography and colorful casts of festive diners, they have come to typify Venetian painting at its most glamorous. Veronese's earlier works, such as *Averroës* and *Ptolemy*, have more *gravitas* and are closer in mood to the earlier Roman and Tuscan influences of Michelangelo and Giulio Romano.

PC

Fig. 6–7b
Copy after Veronese, *Astronomer with an Astrolabe Globe*, c. 1597, oil on canvas, 87⅜ x 56⅛ in. (221.9 x 142.6 cm), Musée des Beaux-Arts, Chartres.

Notes

1. Marco Boschini, *Le ricche minere della pittura veneziana* (Venice: F. Nicolini, 1674), 69.

Portrait of Jean-Sylvain Bailly

AUGUSTIN PAJOU
French, 1730–1809

1791

Patinated plaster on painted wood socle and plinth

29¾ x 19½ x 11 in. (75.6 x 49.5 x 27.9 cm) with socle and plinth

Inscribed on right shoulder truncation: Par Pajou Citoyen de La Ville de Paris. 1791; painted on front of plinth: SI TROMPANT NOS DOULEURS D'UN PERE QUI N'EST PLUS / CETTE ARGILE À NOS YEUX SAIT RETRACER L'IMAGE, / DANS NOS CŒURS AFFLIGÉS, OU VIVRONT SES VERTUS, / NOTRE AMOUR LUI CONSACRE UN PLUS DURABLE HOMAGE. (While this clay can deceive our sorrow for a father who has died / by re-creating his image before our eyes, / It is in our suffering hearts, where his virtues survive, / that our love accords to him a more lasting homage.)

Gift of The Ahmanson Foundation

M.75.101

PROVENANCE:

The family of the sitter.

Monsieur Wolff.

Pierre Decourcelle.

His daughter.

Paris, sale, Galerie Charpentier, 30 May 1951.

Ader Collection.

Madame Jacques Loste.

Monte Carlo, Black-Nadeau Gallery (dealer).

SELECT LITERATURE:

Stanislas Lami, *Dictionnaire des sculpteurs de l'école française au dix-huitième siècle* (Paris: Honoré Champion, 1911), 2:221.

Henri Stein, *Augustin Pajou* (Paris: Librairie Centrale des Beaux-Arts, 1912), 72–75, 416.

France in the Eighteenth Century, exh. cat. (London: Royal Academy of Arts, Winter 1968), 138, no. 814, fig. 349.

"L.A. County Art Museum Acquisitions," *National Sculpture Review* 27, no. 1 (Spring 1978): 16.

Geneviève Bresc-Bautier, *Sculpture française–XVIIIe siècle*, École du Louvre notices d'histoire de l'art, no. 3 (Paris: Éditions de la Réunion des musées nationaux, 1980), under no. 46.

Jean-Sylvain Bailly (1736–93), whose literary career was surpassed by his studies in astronomy and its history, was elected to the French Academy of the Sciences at the age of twenty-seven. He calculated the orbit of Halley's comet, wrote two books about the moons of Jupiter, and published three volumes on ancient, Eastern, and modern astronomy. As the events of the French Revolution unfolded, he was drawn into political life and was elected deputy from Paris to the Estates-General. On July 15, 1789, he became mayor of Paris. Pajou no doubt modeled this portrait before Bailly was driven from office in November 1791, when the populace turned against him.

Pajou, descendant of a family of sculptors, studied under Jean-Baptiste Lemoyne and won, in 1748, the first Grand Prix de Sculpture. After spending four years at the French Academy in Rome (1752–56), he returned to Paris to embark on what would become one of the most illustrious careers of any French sculptor in the second half of the eighteenth century.

In 1768 Pajou was awarded the commission for all of the sculptured ornament of the Opera at the château of Versailles. This ambitious undertaking involved the decoration of the exterior of the building, the sculpture for its foyer, and a multitude of reliefs and panels for all of the loges of the interior. The Opera was to be ready in just two years, in time for the marriage of the Dauphin Louis to Marie Antoinette of

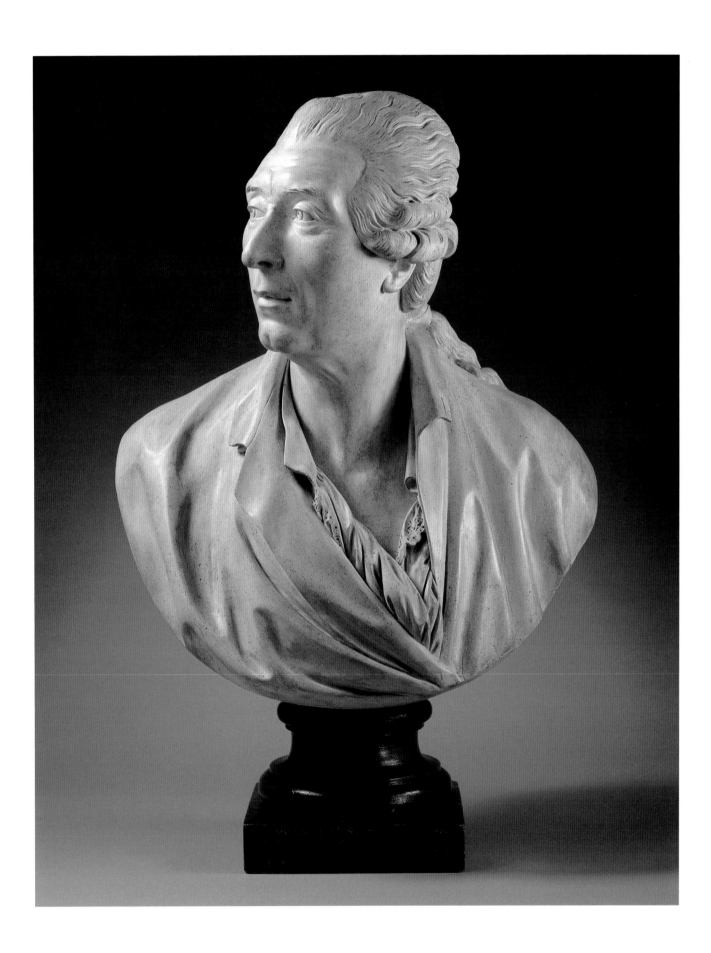

Austria. Pajou oversaw a team of practitioners who worked incessantly to complete the project by 1770. By then he had become the preferred portraitist of Madame du Barry and, after his nomination as *sculpteur du roi*, was made responsible from 1777 to 1784 for the official portraits of Louis XVI.

Pajou's appointment as curator of the collection of antiquities in the Louvre (also in 1777) helped him to survive professionally during the Revolution. He was asked to serve on the Revolutionary Committee on the Conservation of Works of Art, which ostensibly decided the fate of works of art during a period of methodical, widespread destruction of human life and historic monuments. In 1795, together with Claude Dejoux, Jean-Antoine Houdon, Pierre Julien, Jean-Guillaume Moitte, and Philippe-Laurent Roland, Pajou was nominated to the Institut de France, which had just been established.

The upheaval caused by the Revolution and its subsequent reversals affected all levels of society. Although the Revolutionary government endeavored to maintain its own support of the arts, France's sculptors suffered professionally as their aristocratic patrons were executed or fled the country. Virtually overnight, royal patronage had been brought to an end. The number of major commissions, in particular funerary monuments (vilified because of what was seen as their aristocratic character), was greatly reduced. In these adverse conditions the portrait bust, which had always provided sculptors with a basic means of livelihood, took on a proportionally greater significance as a category of sculpture.

Throughout his career Pajou had been recognized for his excellence as a portraitist. Indeed two of his earliest known works are portraits of his teacher Lemoyne (1758, bronze, Louvre, Paris; 1759, terra-cotta, Musée des Beaux-Arts, Nantes). In these his portrait style is already purified, direct, and purged of trivial details.

Unlike Houdon, who enlivened his portraits with a flickering charm, Pajou developed a more reticent idiom. In contrast with Houdon's treatment of Bailly's portrait (c. 1790, terra-cotta, Lindenau Museum, Altenburg), Pajou gave a gloss of idealization to the features and further neutralized the details of contemporary costume. By tilting the head back so that the focused gaze was slightly askance and by showing the lips barely parted, the artist conveyed the intellectual vitality of his subject. Bailly had been described by Mérard de Saint-Just as "serious, with an imposing air, perhaps even a little severe, but never austere."[1] This portrait, expressing the lively rationalism of the Enlightenment, captures the skepticism of an astronomer elected mayor of Paris. The open collar of the shirt, which contributed to the sense of candor of the sitter, suggests in retrospect the poignant vulnerability of this man of science, guillotined in 1793.

MLL

Notes
1. Stein, 72–73.

Landscape with Dunes

JACOB ISAACKSZ VAN RUISDAEL
Dutch, 1628/29–82

1649
Oil on oak panel
20⅝ x 26⅝ in. (52.4 x 67.6 cm)
Signed at lower left: Ruisdael 1649
Gift of Dorothy G. Sullivan
M.75.138

PROVENANCE:

Brighton, Lady Page Turner.
Paris, sale, Maurice Kahn, 9 June 1911, no. 58.
Paris, Charles Sedelmeyer (dealer).
Amsterdam, J. Goudstikker (dealer).
Almelo, Ten Cate Collection.
Munich, Julius Böhler (dealer), by 1958.
Los Angeles, Howard F. Ahmanson.
Los Angeles, Dorothy G. Sullivan, until 1975.

SELECT LITERATURE:

Jakob Rosenberg, *Jacob van Ruisdael* (Berlin: Cassirer, 1928), 105, no. 523a.

Dutch artists of the seventeenth century can properly be credited with the invention of landscape painting in its pure form. Previously the natural world had served primarily as background to subject pictures; these artists, in their closely observed renderings of the countryside, sea, and townscape, elevated landscape to an important genre of its own. Jacob van Ruisdael is generally considered its greatest practitioner during a period when this type of painting flourished. Born in 1628 or 1629 in Haarlem, he was the son of art dealer and occasional landscape painter Isaack Jacobsz van Ruysdael. Ruisdael's own artistic talents were manifested at an early age, and he was probably trained by his uncle, the prominent landscape painter Salomon van Ruysdael. Jacob joined the Haarlem guild of Saint Luke in 1648.

Early in his career Ruisdael made several trips in the Netherlands; in 1651 he traveled with Nicolaes Berchem, his friend and fellow landscape painter, to Westphalia. By 1657 Ruisdael had settled in Amsterdam, where he would spend the remainder of his life. He was a prolific painter of dunelands, forests, rivers, and fields and also a producer of etchings and drawings. An influential and often imitated artist, Ruisdael frequently collaborated on paintings with Berchem, Adriaen van de Velde, and Philips Wouwerman. His most important pupil was Meindert Hobbema.

Landscape with Dunes, which is signed and dated 1649, is a fine example of the kind of rugged, agitated landscape in which Ruisdael specialized early in his career. The artist chose as his site a rough country lane that winds through the landscape, bordered on the left by a meandering stream and on the right by grassy dunes. The bend in the road curves high at right, creating a dynamic balance with the lowland at left. Just off center Ruisdael placed a pair of twisted oaks, their intertwined limbs silhouetted against the stormy sky. Nestled in the folds of the land is a steep-roofed house, perhaps the destination of the mother and child who hurry along the path in the right middle ground. In the field at left a number of sheep lie in the path of the approaching storm, their presence half hidden by deep shadow.

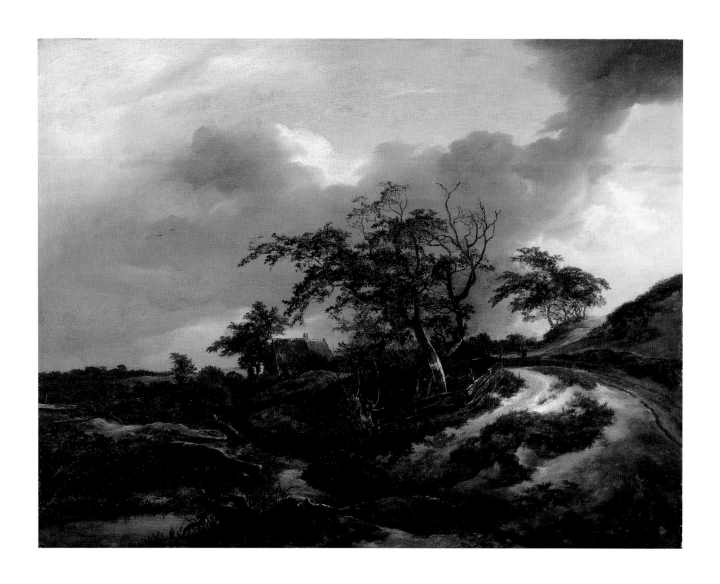

Notes

1. Seymour Slive and H. R. Hoetink, *Jacob van Ruisdael*, exh. cat. (The Hague/New York: Mauritshuis/Abbeville, 1981), 36–37, no. 5 and fig. 10.

The particular motif of *Landscape with Dunes* was apparently a favored one with Ruisdael. There exist several drawings and etchings that repeat the principal elements of the picture, and in its composition and mood the panel is a variation on several paintings that date from the late 1640s, such as the *Dune Landscape near Haarlem*, dated 1647 (on loan to the Kunstmuseum, Düsseldorf), and the landscape known as *Le Buisson* (Louvre, Paris).[1] The focus of both of these pictures, like the Los Angeles one, is the tangled mass of trees in the center, and both include a stream on the left and a rutted path sharply struck by sunlight on the right. The Düsseldorf and Paris versions, however, feature a distant view of Haarlem at left, with the spire of Saint Bavo prominent on the horizon. In the Los Angeles panel no such specificity of locale is apparent. Rather, Ruisdael chose to focus on those elemental forces of nature that make for such a dramatic composition.

In *Landscape with Dunes* the great, gray band of rain-soaked clouds runs the length of the picture, the agitated, dancing brushwork utilized by Ruisdael filling the air with the heavy moisture and chill of the approaching storm. The ground is composed of a series of curves and twists: the path, the gnarled logs that litter the foreground, the undulating creek, the weather-beaten fence. The central trees, their peeling bark rendered in a thick impasto, are strangely anthropomorphic, seemingly struggling as much against each other as with the wind that tears at them.

In such stormy landscapes Ruisdael's vision of nature is one of internal movement and dynamism, a vivid contrast with the placid calm that pervades other Dutch landscapes, such as *Forest Clearing with Cattle* by Philips Koninck and Adriaen van de Velde (cat. no. 41). Signs of man's industry or culture are negligible in the Ruisdael, and there is no sense of the sylvan compatibility of the human and natural that pervades the work by the other two artists. In fact the solitary mother and her child flee nature in the *Landscape with Dunes* as they hasten their progress along the windswept road, eager to find shelter in the face of the threatening storm.

RR

Magdalen with
the Smoking Flame

GEORGES DE LA TOUR
French, 1593–1652

c. 1638–40
Oil on canvas
46¹/₁₆ x 36⅛ in. (117.0 x 91.8 cm)
Signed at lower right: G DelaTour
Gift of The Ahmanson Foundation
M.77.73

PROVENANCE:

France, La Haye family.
Paris, Simone La Haye, c. 1943–77.

SELECT LITERATURE:

Pierre Rosenberg and François Macé de L'Épinay, *Georges de La Tour: Vie et oeuvre* (Fribourg: Office du Livre, 1973), 132–33, no. 32.

Jacques Thuillier, *L'opera completa di Georges de La Tour* (Milan: Rizzoli, 1973), 93, no. 38.

Benedict Nicolson and Christopher Wright, *Georges de La Tour* (London: Phaidon Press, 1974), 174, no. 27, pl. 49.

Pierre Rosenberg, *France in the Golden Age: Seventeenth-Century French Paintings in American Collections*, exh. cat. (New York: Metropolitan Museum of Art, 1982), 354, no. 12.

Pierre Rosenberg, "France in the Golden Age: A Postscript," *Metropolitan Museum Journal* 17 (1984): 41, fig. 23.

Georges de La Tour was the greatest tenebrist painter working in seventeenth-century France. Indeed since his "rediscovery" early in this century he is ranked second only to Caravaggio, the artist who in Rome and Naples at the very beginning of the seventeenth century effectively invented tenebrism, as a master at painting in this dramatic style, with its bold contrasts of light and shade.

La Tour was born in Vic-sur-Seille in 1593, a time when the duchy of Lorraine was still independent from France. Nothing is known for certain about his training as an artist, but contemporary documents show that he spent most of his working life at Lunéville, Lorraine's administrative center. In 1623 and 1624 he sold paintings to Duke Henri II. In 1639 he was in Paris, where Louis XIII conferred on him the title of *peintre ordinaire du roi*. In this year he offered the ruler a painting of *Saint Sebastian Mourned by Irene* (the original is lost, but there are good replicas in the Louvre, Paris, and the Staatliche Museen, Berlin). Between 1644 and 1651 La Tour received important commissions for paintings destined for the Maréchal de la Ferté, governor of Lorraine.

Among the unresolved questions regarding La Tour's training is whether or not he went to Italy. If so he possibly journeyed to Rome during the second decade of the century, where he would have been one of a large international community of artists under the sway of Caravaggio's influential dramatic style, even though the master had died in 1610. To the present writer, however, there is nothing in La Tour's manner to suggest direct exposure to Caravaggio's art nor to the rather down-to-

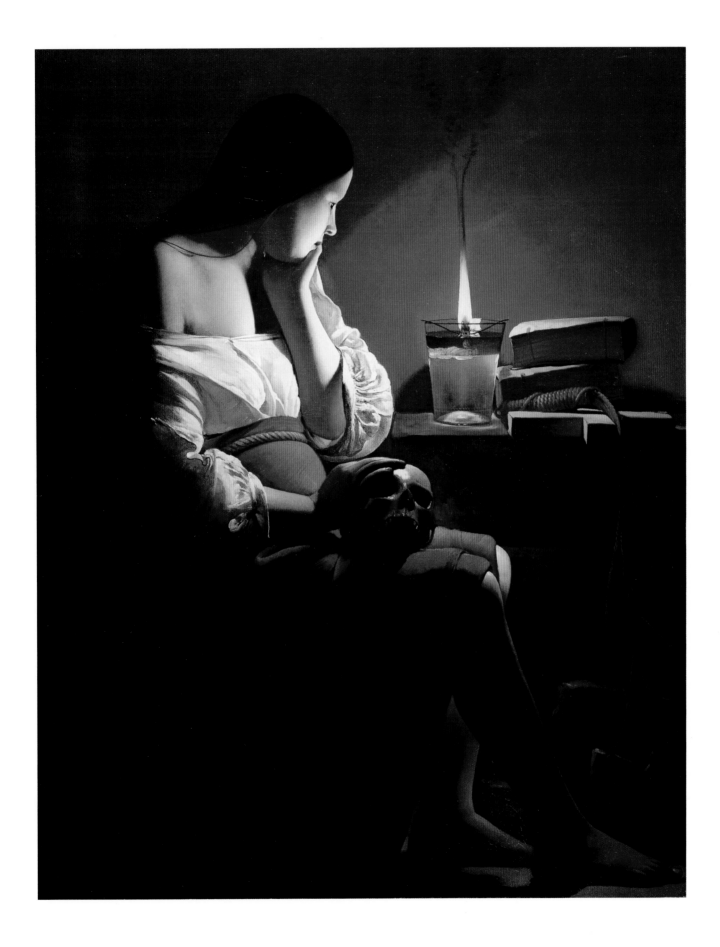

earth work of his immediate followers in Italy. It is just as likely that he traveled in the Low Countries, especially to the southern, Dutch, Catholic city of Utrecht, the most important center of Caravaggesque painting north of the Alps, where he might have seen the work of artists such as Dirck van Baburen, Gerrit van Honthorst, and Hendrick Terbrugghen, all of whom had studied in Rome. This is a matter that can never be resolved by stylistic comparisons alone: until a document is found, the issue of La Tour's travels north or south must remain an open question.

There is a general consensus among scholars that in the early to mid-1630s La Tour developed his own celebrated tenebrist manner, in which his strong effects of chiaroscuro are created by artificial light sources in dark and normally nighttime settings. This is long after he was likely to have been exposed to any direct experience of Caravaggio or his immediate followers. Indeed relative to the Caravaggesque painting that was going on in Italy and Utrecht during the first twenty years of the century, La Tour's effects of light are especially studied and subtle, while his forms are smooth and have a personal refinement of design and execution that is almost mannered. His three surviving dated works, *The Payment of Dues* (1634, Lvov Museum), the *Repentant Saint Peter* (1645, Cleveland Museum of Art), and the *Denial of Saint Peter* (1650, Musée des Beaux-Arts, Nantes), show how La Tour's tenebrist works become progressively more simplified in form.

Within these three fixed points of reference it is generally accepted that the *Magdalen with the Smoking Flame* dates to the late 1630s, after *The Payment of Dues*, with its complex disposition of the six participants and ambitious light effects, but before the grand and simplified monumentality of the *Repentant Saint Peter*. Before this tenebrist period La Tour seems to have concentrated on his daylight scenes, which have a greater sense of observed reality than the later works and are more often genre subjects. However, his religious subjects were always to be close to genre in treatment.

Magdalen with the Smoking Flame is one of the artist's finest nocturnal scenes. It depicts a subject that was especially popular in Catholic Europe during the Counter-Reformation in the seventeenth century. If Protestant reformers decried both the Catholic adoration of saints and the use of images as aids to devotion, the Catholic Church responded by asserting both traditions even more firmly. Images of the penitent Magdalen were particularly favored, because she appealed to both rich and poor alike in her rejection of the blandishments of the material world in favor of the spiritual life as a follower of Christ. Although there is no justification for such an identification in the Scriptures, the Magdalen came to be seen traditionally as a courtesan who, upon her conversion to Christianity, rejected her former life of sin and materialism and became one of Christ's most ardent followers. Her apocryphal story is told in Jacobus de Voragine's compendium of the saints' lives, *The Golden Legend*, compiled in the thirteenth century and still the standard source for her life in the seventeenth century. He relates that her great love and the intensity of her conversion won her a special place in Christ's heart.

La Tour shows the Magdalen in her retreat from the world, as she sits alone in a dark and austere interior. She is no longer dressed in her elaborate courtesan's costume but wears plain, homespun clothes, her skirt supported by a simple cord.

Her hair is undressed, not decked with jewels; her feet are bare in humility. On the table is a knotted scourge used in the mortification of the flesh, a plain wooden cross, and two books, which suggest she has been contemplating the suffering of Christ and studying devotional texts. On her lap she cradles a skull, symbol of the mortality of the flesh. Mary's attention is concentrated above all on the steady

Detail

glow of the flame rising from the simple oil lamp on the table. Her contemplation of this light is the subject of the painting; her fixed gaze also directs the viewer's attention. The light not only illuminates the salient features of the Magdalen's ascetic surroundings but is also spiritual, representing truth and religious faith. La Tour does not stress her penance, her devotion to prayer as a means of salvation, nor her ultimate heavenly glory. Rather he emphasizes her spiritual enlightenment. Moreover her own faith will burn with the ardor of this flame. Voragine writes that the Magdalen is to be interpreted as a "light-giver, or enlightened." More than penance or heavenly glory she chose the way of inward contemplation in her converted life and became "enlightened with the light of perfect knowledge in her mind." She is called light-giver "because therein she drank avidly that which afterward [i.e., when she went on later in life as an active disciple of Christ] she poured out in abundance; therein she received the light, with which afterward she enlightened others."[1]

La Tour brilliantly deploys the light of the oil lamp to simplify his composition, repress the extraneous detail, and direct attention to the most meaningful features of his painting. For all the simplicity of its subject, it is a very beautiful work. The softness of the light creates an almost palpable atmosphere, and the artist has taken a sensuous delight in describing the different surfaces it reveals: the smooth, plump flesh of the young Magdalen, the creamy white of her blouse, the saturated red of her skirt, the various gleams given off by the surfaces of bone, vellum, and glass. This very high level of aesthetic accomplishment plays an important part in engaging the spectator's attention and also suggests something of the spiritual rapture being experienced by the Magdalen as she contemplates her recent understanding of what it means to follow Christ.

Because of the strong sense of observation in the painting, for example in the exquisite way La Tour describes the surfaces, volumes, and textures of the Magdalen's blouse or carefully renders the lamp, where the device that stops the wick from falling into the oil is shown clearly and where the black smoke rises so convincingly, it is reasonable to join the consensus that says this painting is among his first nocturnal works. The style is not as rarified and mannered as it became during the second half of the 1640s. The artist's observations still have a strong basis in reality, linking this painting with the more realistically observed daylight pictures that preceded it, such as the *Penitent Saint Jerome* (two versions, Musée des Beaux-Arts, Grenoble, and Nationalmuseum, Stockholm), *The Fortune Teller* (Metropolitan Museum of Art, New York), or *The Card Sharp* (two versions, Kimbell Art Museum, Fort Worth, and Louvre, Paris).

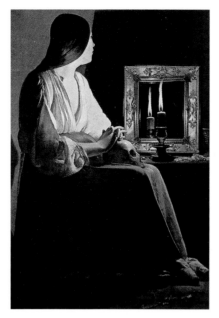

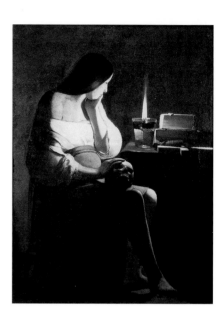

FIG. 10a
Georges de La Tour, *Repentant Magdalen*,
c. 1638–40, oil on canvas, 45¼ x 37¼ in.
(114.9 x 94.6 cm), National Gallery of Art,
Washington, D.C., Ailsa Mellon Bruce Fund
(1974.52.1 [2672]).

FIG. 10b
Georges de La Tour, *Magdalen with Two Flames*,
c. 1640–45, oil on canvas, 53⅝ x 36¾ in.
(136.2 x 93.3 cm), Metropolitan Museum of
Art, New York, gift of Mr. and Mrs. Charles
Wrightsman, 1978.

FIG. 10c
Georges de La Tour, *Magdalen with the Lamp*,
c. 1645–50, oil on canvas, 50⅜ x 37 in.
(128.0 x 94.0 cm), Louvre, Paris. Photo:
Cliché des Musées Nationaux.

Notes

1. Jacobus de Voragine, *The Golden Legend*
(c. 1275), trans. and ed. Granger Ryan and
Helmut Ripperger (*The Golden Legend of Jacobus
de Voragine*, pt. 2, London: Longmans, Green
and Co., 1941), 355.

The *Magdalen with the Smoking Flame* is probably La Tour's first image of this saint.
He repeated the subject three more times in autograph paintings. The *Repentant
Magdalen* (National Gallery of Art, Washington, D.C., fig. 10a) is a highly poetic work,
different in conception but similar in style to the Los Angeles painting. Its theme is
slightly altered: La Tour alludes more strongly to the transience of the flesh by
giving the skull such a prominent position, and the fact that the Magdalen is gazing
into the mirror, where the skull is reflected, serves to emphasize this aspect of the
subject. The *Magdalen with Two Flames* (Metropolitan Museum of Art, New York, fig.
10b) has more of the abstract quality of the mid-1640s and suggests more a rejection
of the world, as is indicated by the mirror of vanity and the discarded jewelry still
strewn on the table and floor. The *Magdalen with the Lamp* (Louvre, Paris, fig. 10c) is
a still later and more austere version of the Los Angeles picture, perhaps painted
in the mid- or even late 1640s. Besides the California painting, it is the only other
version that is signed. While the composition of objects on the table and the
positioning of Mary's feet are slightly different, it is the stiffer and more abstract
quality of the handling and overall design that are striking. For example, contrast
the treatment of the Magdalen's blouses in the Los Angeles and Paris works. The
condition of the Louvre's painting leaves much to be desired, in contrast with the
nearly perfect state of the *Magdalen with the Smoking Flame*.

Unfortunately it is not known for whom the Los Angeles painting was originally
made. Most likely it was done for a patron in Lunéville, but if dating it to the period
of about 1638–40 is correct, it cannot be ruled out that it may have been prepared
in Paris, where the artist was recorded in 1639. Whatever one's religious or philo-
sophical point of view, the *Magdalen with the Smoking Flame* remains a very moving
statement about the human condition and is one of the supreme masterpieces
of the Los Angeles County Museum of Art.

PC

Diana with a Stag and a Dog

JEAN-BAPTISTE TUBY I
Italian (naturalized French), 1635–1700

1687

Terra-cotta

10¼ x 16⅞ x 8¼ in. (26.0 x 42.9 x 21.0 cm)

Inscribed on base: Tubi fct 1687

Gift of The Ahmanson Foundation

M.78.77

PROVENANCE:

Paris, Alain Moatti (dealer).

SELECT LITERATURE:

"Principales acquisitions des musées en 1979," *La chronique des arts*, no. 1334, supplement to *Gazette des Beaux-Arts*, 6th period 95 (March 1980): 34, no. 178.

François Souchal, *French Sculptors of the Seventeenth and Eighteenth Centuries: The Reign of Louis XIV* (Oxford: Cassirer, 1987), 3:359–60, no. 69.

The Roman-born Jean-Baptiste Tuby is known to have been in Paris by 1660. His foreign nationality did not prevent him from being elected to the Royal Academy just three years later; indeed his naturalization in 1672 was at the order of Louis XIV. For nearly twenty years he served as *officier des bâtiments du roi* besides teaching at the Academy and establishing an atelier for bronze casting at the Gobelins. Tuby was a member of the inspired group of artists and architects who realized the splendid vision of Versailles. He also collaborated with Antoine Coysevox on the tombs of Jean-Baptiste Colbert and Jules Mazarin.

Throughout his life Tuby enjoyed a close relationship with Louis XIV's aesthetic factotum, the painter Charles Le Brun. It was Tuby who, following Le Brun's designs, executed the paradigmatic image of Versailles, the spectacular *Chariot of Apollo* for the Basin of Apollo at the head of the Grand Canal. He was further charged with producing various sculptures for the fountains and gardens of the château, in particular the large group called *Flora*. For the Water Parterre, a divided reflecting pool surrounded by personifications of France's rivers, he modeled *The Rhône* and *The Saône* (both 1687). Their composition and style bear directly on the terra-cotta *Diana with a Stag and a Dog*.

Although no large-scale version of the *Diana* is known, it may have been a project destined for the gardens of Versailles, where, in an elaborate sequence of fountains and sculptures, the symbolic identification of Louis XIV with the sun-god Apollo was played out. Apollo's twin sister was the moon-goddess Diana, who was also goddess of the hunt.

Notes

1. Guy Walton, letter to Peter Fusco, 1 September 1981. The Cabinet of Diana is one of two small pools also known as the Cabinets of the Animals.

2. *Antiquities, Works of Art and Important Renaissance Bronzes, Plaquettes and Limoges Enamels*, auc. cat. (London: Christie's, 8 July 1981), no. 355.

3. Paris, Ader Picard Tajan sale, 22 November 1987, no. 108. The work is inscribed "Th. R. esquisse p le Loiret. Fecit 1688" and measures 29.0 x 44.0 x 18.0 cm.

4. Guilhem Scherf, letter to author, 30 July 1990, citing Louvre archives.

The *Diana* might have been proposed for the Cabinet of Diana, a small pool that served as a transitional motif between the Water Parterre and the Basin of Latona (or, alternatively, the Baths of Apollo).[1] The representation of Diana in the traditional pose of a river goddess, reclining with her arm supported by an overturned urn spilling water, would have been especially appropriate in this location. Tuby's statuette unites the symbolism of water, the element that nourished and animated the formal gardens, with the goddess of the hunt. As hunting was a royal privilege (enjoyed especially in the woods surrounding the gardens), Diana had come to be ever more closely associated with the king of France.

The conflation of the two iconographic types, of Diana with a river goddess, already had a royal tradition in French art. In the iconographic program of François I's Fontainebleau the many representations of water nymphs held allusions to the hunt. The earliest known freestanding monumental French sculpture, the marble *Diana of Anet* (c. 1550, Louvre, Paris), was combined with aquatic imagery in the great fountain of the château of Anet. Indeed the composition of the *Diana of Anet* is so close to Tuby's *Diana* that it could easily be considered an inspiration for the terra-cotta, but the cool mannerism of the marble has nothing in common with the inviting, tender appeal of Tuby's statuette.

Tuby's activities in bronze casting at the Gobelins give more than passing interest to a bronze version of the Los Angeles *Diana* that was sold at auction in London in 1981.[2] The museum's sculpture should also be considered in relation to another terra-cotta of very similar size and format, *The Loiret*, by Thomas Regnaudin, which appeared in Paris in 1987.[3] The *Diana* may yet prove to be that which passed at auction in Paris on November 7, 1935 (Ader sale, no. 60): "Groupe en terre cuite: Diane couchée près d'un cerf et d'un chien," inscribed J. B. Tuby, measuring 43.5 cm.[4]

MLL

Bacchus and Ariadne

GUIDO RENI
Italian (Bologna), 1575–1642

c. 1619–20
Oil on canvas
38 x 34 in. (96.5 x 86.4 cm)
Gift of The Ahmanson Foundation
M.79.63

PROVENANCE:

Probably Bologna, Cesare Rinaldi.

Possibly Rome, Cardinal Pietro Ottoboni, by 1693.

Possibly Rome, Ottoboni sale, 1740.

London, sale, Hogard & Co., 8 March 1769.

England, Nathaniel Curzon, Lord Scarsdale, by 1769.

London, Thomas Agnew and Sons (dealer).

SELECT LITERATURE:

D. Stephen Pepper, " 'Bacchus and Ariadne' in the Los Angeles County Museum: The 'Scherzo' as Artistic Mode," *The Burlington Magazine* 125, no. 959 (February 1983): 68–75.

Richard Cocke, "Guido Reni's 'Bacchus and Ariadne,'" *The Burlington Magazine* 126, no. 970 (January 1984): 39.

D. Stephen Pepper, *Guido Reni: A Complete Catalogue of His Works with an Introductory Text* (New York: New York University Press, 1984), 238–39, no. 66, pl. 92.

Guido Reni 1575–1642, exh. cat. (Los Angeles: Los Angeles County Museum of Art, 1988), 218–19, no. 22.

Guido Reni, one of the most famous and influential painters in seventeenth-century Italy, remained an admired model of refined classicism throughout Europe until well into the nineteenth century. Reni, along with Domenichino (cat. no. 47), was a pupil of Flemish painter Denys Calvaert (who worked in Bologna) until the early 1590s, when he attended the academy founded by the brothers Annibale and Agostino Carracci and their cousin Ludovico Carracci.

During the 1580s and 1590s the Carracci changed the direction of Italian painting from the dominant complexity and sophisticated refinement of the mannerist style to a more solid and classical art based on the study of the masters of the High Renaissance, especially the idealism of Raphael, early style of Michelangelo, color of Titian and Veronese, and frank emotion of Correggio. They revived the practice of drawing constantly from life; an artist who went through their academy understood every way that the human figure could serve as a vehicle of physical, emotional, and moral expression. This study of the human form was tempered by constant references to the great models of ideal art of the past, notably the Renaissance artists mentioned above as well as antique sculpture. So great was the influence of the Carracci and that of their Bolognese and Roman followers that most of the subsequent major developments in figure painting in seventeenth-century Italy had this firm basis. The establishment of Annibale's studio in Rome, when he was called there to decorate the Farnese Gallery in 1595, secured his preeminent position.

Reni too went to Rome, where, in the early 1600s, he absorbed the radical, forceful, and dramatic tenebrist style of Caravaggio, a painter whose art was also deeply rooted in the study of nature. Although Reni flirted briefly with Caravaggio's

strong effects of light and shade and realistic rendering of surfaces (see especially Reni's *Crucifixion of Saint Peter* in the Vatican, begun in 1604 soon after his arrival in Rome), he was drawn more toward the idealizing classicism of the Carracci. In Bologna he had known Raphael's altarpiece of the *Ecstacy of Saint Cecilia* (Pinacoteca Nazionale, Bologna), which remained a model of perfection for him.

Reni soon became a highly successful and sought-after artist, so well did his art embody the seventeenth-century ideal of classical beauty. Working mainly in Rome and his native Bologna, he painted altarpieces, private devotional works, frescoes in churches and palaces, and important secular commissions, such as the *Labors of Hercules* (Louvre, Paris), done between 1617 and 1621 for the Gonzagas in Mantua.

Bacchus and Ariadne was painted at this most classical moment of Reni's career, when he was at the peak of his powers and reputation. Quite different from the vast scale and muscular heroism of the *Labors of Hercules*, it is a small and refined cabinet picture, clearly made for the delectation of a cultivated private patron, who would have been familiar with this celebrated story from ancient mythology (Ovid, *Ars Amatoria* 1:594–627; *Metamorphoses* 8:177–81). Reni shows the moment when Bacchus, wearing his traditional wreath of grapevines, encounters Ariadne, daughter of King Minos of Crete, abandoned on the shore of the island Naxos by Theseus, whose white-sailed ships can be seen disappearing over the horizon. Above her head, high in the sky, is a ring of stars alluding to Bacchus's pledge to render her name eternal by bearing her crown up to heaven, where it became the constellation Corona Borealis. The two figures are studiedly perfect in form, as befits ideal characters in an ancient myth. Sky and sea seem impossibly blue.

The only certainty about the provenance of this painting is that it was in the Scarsdale Collection at Kedleston Hall by 1769, where it remained until it came to Los Angeles via a London dealer in 1979.[1] Several copies or versions of the subject exist or existed (see Pepper 1984), but the museum's superb painting is the only surviving autograph one and is of the highest quality. It seems quite likely that it is the painting sold in London in 1769, as it is known that Sir Nathaniel Curzon, first Lord Scarsdale, was purchasing works of art for Kedleston at that period.[2] It also seems likely to the present writer that the museum's painting was in the collection of Cardinal Pietro Ottoboni and sold in 1740. Although the dimensions in the Ottoboni sale inventory, five by four *palmi* (113.0 x 90.2 cm), are a little larger, the painting could have been trimmed at a later date or measured in its frame.[3] Ottoboni was one of the great and discriminating collectors of his day, and both the quality and the sophisticated approach to the subject matter in *Bacchus and Ariadne* are up to his standards. However, a link cannot be established between Ottoboni and Scarsdale, any more than it can be proven that the painting's first owner was the Bolognese poet Cesare Rinaldi. But this last hypothesis, first cautiously proposed in 1983 by Stephen Pepper (to whose research this entry is indebted), seems convincing.

Rinaldo Ariosti, writing from Bologna to his master, the Duke of Modena, on February 21, 1627, mentions a *Bacchus and Ariadne* by Reni on the market, which then belonged to a certain Rinaldi. It is the only mention of such a picture in Reni's lifetime. The most likely candidate for its ownership is Cesare Rinaldi, a friend and correspondent of Reni's from at least 1613. He was one of a circle of sophisticated collectors and literati that included other Reni patrons in Bologna such as Luigi

Zambeccari, whose family commissioned Reni's celebrated *Samson Victorious* (Pinacoteca Nazionale, Bologna). Count Andrea Barbazzi, the agent who commissioned the *Labors of Hercules* for the Duke of Mantua, was also of the circle. Interestingly, Rinaldi already owned a painting of *Bacchus and Ariadne* (now lost) by Ludovico Carracci, which had inspired a poem by his Roman friend, poet and collector Giambattista Marino.

Bacchus and Ariadne has been the focus of some scholarly discussion about its probable meaning for the artist, its presumed first owner, and their cultivated circle in Bologna. Pepper (1983 and 1984) has suggested that the meaning in this and several other paintings lies in Reni's appropriation of the *scherzo* (a refined and learned jest), a category of literary rhetoric that, with some irony, suggests in the characters represented attitudes or behavior that is humorously inappropriate to their situations:

> The scene is a seduction, where Ariadne, a tear rolling down her cheek, turns away from Bacchus, but with her open hand clearly accepts his offer. Bacchus is even more comical, presenting himself as a substitute for the faithless Theseus, whose ships can be seen in the distance: his stance and attitude seem more appropriate to a public orator than to a suitor. The effect is to pull the rug out from under the characters, whose rhetoric is so formal as to be inappropriate to their actions.[4]

Professor Richard Cocke, however, rejects Pepper's arguments, claiming rather that Reni had carefully read the Ovidian source of the story of Bacchus and Ariadne and, master of classical idealism that he was, had concentrated their famous encounter on the shores of Naxos into the very essence of the tale, expressed by him in the two figures alone. It certainly is the classical counterpart to Titian's crowded and rambunctious *Bacchus and Ariadne* (National Gallery, London), which follows Ovid's *Ars Amatoria* more literally and is treated in a typically Venetian manner, full of color and movement, as Bacchus's lively train of inebriated followers dances through the landscape. Titian's painting was in Reni's day and is today one of the most famous interpretations of classical mythology in Western art. For Cocke, Reni, with brilliant economy, balances the distraught Ariadne—"He is gone, the faithless one; what will become of me?"—with the young god Bacchus, who presents himself to her even as the ships of Theseus disappear over the horizon—"Lo, here am I, a more faithful lover; have no fear." Cocke has also shown that Reni's two figures are based on classical statues well known in that time and relates this artistic practice of borrowing to Reni's stated position (as reported by his seventeenth-century biographer, Carlo Cesare Malvasia) that, far from being inspired by supernatural visions of beauty, his own idea of beauty was formed by years of hard work studying the classical ideals expressed in ancient sculpture. The present writer leans toward Cocke's interpretation, so seriously and carefully meditated does Reni's ideal of beauty appear to be. This is not to deny the artist a degree of wit. He very skillfully distills the story down to its basic elements but does not try to convince the viewer of the reality of the scene. Reni presents the fundamental idea of it, expressed through classical, rhetorical figures, while Titian, by contrast, seems to travel back to Ovid's ancient mythical world, making the observer experience it as real or at least believable and down-to-earth.

PC

Notes

1. A 1769 catalogue of the collection of Lord Scarsdale, Kedleston Hall, recorded the painting: "Music Room–West End, Guido, *Bacchus and Ariadne*." It was not noted by Horace Walpole when he went to see the works of art at Kedleston in 1768. However, an unspecified painting of about the same dimensions by Reni was noted in a manuscript inventory made in 1761. See Pepper, "'Bacchus and Ariadne,'" 71–72.

2. Pepper, "'Bacchus and Ariadne,'" 72.

3. Ibid., 71. Transcriptions of the relevant Ottoboni archival papers were supplied to the museum by Professor Edward J. Olszewski in February 1982 and are on file along with his helpful correspondence.

4. Pepper, "'Bacchus and Ariadne,'" 72.

Soap Bubbles

JEAN-SIMÉON CHARDIN
French, 1699–1779

c. 1733–34
Oil on canvas
23⅝ x 28¾ in. (60.0 x 73.0 cm)
Signed at lower left: J.S. chardin
Gift of The Ahmanson Foundation
M.79.251

PROVENANCE:

Possibly Paris, Baché, Brilliant, De Cossé, Quené sale, 22 April 1776, no. 81.

Possibly Paris, Duc de Rohan-Chabot sale, 23 May 1780, no. 26.

Possibly Paris, Claude-Henri Watelet sale, 12 June 1786, no. 10.

Possibly Paris, Dulac sale, 6 April 1810, no. 19.

Possibly Philippe de Kerhallet, 1912 (document on file in Département des Peintures, Louvre, Paris).

Paris, sale, Drouot, 18 June 1973, no. 90.

Paris, Claus Virch (dealer).

SELECT LITERATURE:

Pierre Rosenberg, *Chardin, 1699–1779*, exh. cat. (Cleveland: Cleveland Museum of Art, 1979), 209.

Pierre Rosenberg, *Tout l'oeuvre peint de Chardin* (Paris: Flammarion, 1983), 91, no. 97B.

Pierre Rosenberg, *Chardin: New Thoughts*, Franklin D. Murphy Lectures 1 (Kansas City: Spencer Museum of Art, 1983), 53–54, fig. 35.

Philip Conisbee, *Masterpiece in Focus: "Soap Bubbles" by Jean-Siméon Chardin*, exh. cat. (Los Angeles: Los Angeles County Museum of Art, 1990).

In 1749 Pierre-Jean Mariette, critic and connoisseur, wrote the earliest biography of Chardin. It relates that the artist, who had established a solid reputation as a painter of still lifes during the 1720s, was teased by a friend, portraitist Joseph Aved, for painting only the lowliest types of subjects and not attempting the more difficult human form. In response to Aved's taunt, Chardin turned to figure painting, making a few portraits of close acquaintances and scenes from everyday life. According to Mariette, Chardin's first effort at this type of painting was *Soap Bubbles*.

The museum's picture is one of several versions of the scene. Stylistically it is quite close to Chardin's *Lady Sealing a Letter* (Staatlichen Schlösser und Gärten, Schloss Charlottenburg, Berlin), which is dated 1733. In both cases the figures are quite large in relation to the picture space and are modeled boldly. The young man in *Soap Bubbles* may even be the same model as the youth helping to seal the letter in the Berlin picture. Charles-Nicholas Cochin, in a later biography written in 1779, said that Chardin's first genre paintings were *Woman Drawing Water from an Urn*, also dated 1733, and *The Washerwoman* (both Nationalmuseum, Stockholm). Whatever the order of the paintings, something that will probably never be known, 1733 does seem to be the most likely date for Chardin's turn from still life to human subjects, for both anecdotal evidence and the style of all the paintings concerned point to that date.

In 1728 Chardin had become a member of the Royal Academy, an institution to which he was to remain devoted throughout his life and in which he became an important officeholder. He may have wanted to elevate his art from lowly still life to the more respected depiction of the human figure not only because of Aved's friendly teasing but also to consolidate his position in academic circles. Indeed there

FIG. 13a
Jean-Siméon Chardin, *Soap Bubbles*, c. 1733–34,
oil on canvas, 24 x 24⅞ in. (61.0 x 63.2 cm),
Metropolitan Museum of Art, Catherine D.
Wentworth Fund, 1949 (49.24).

FIG. 13b
Jean-Siméon Chardin, *Soap Bubbles*, c. 1733–34,
oil on canvas, 36⅝ x 29⅜ in. (93.0 x 74.6 cm),
National Gallery of Art, Washington, D.C., gift
of Mrs. John W. Simpson, 1942 (1942.5.1
[552]).

is often more to Chardin's figure paintings than meets the eye. If on one level they seem like extensions of the homely and everyday world of his still lifes, on another they can have deeper meanings. *Soap Bubbles*, for example, could be just a scene the artist observed one day in passing, but it also belongs to a long iconographic tradition in European art, stretching back at least to the sixteenth century, wherein the bubble is an emblem of the transience of human life. The youth may be idling away his time blowing this bubble (when a version was exhibited at the Paris Salon in 1739, his occupation was described as "frivolous play"), but the painting has a serious mood. It is far from being a scene of carefree, youthful abandon.

Soap Bubbles exists in three versions: the Los Angeles picture, another horizontal one at the Metropolitan Museum of Art, New York (fig. 13a), and a larger, vertical picture at the National Gallery of Art, Washington, D.C. (fig. 13b). The New York and Washington paintings were extensively discussed by Pierre Rosenberg in his exhibition catalogue of 1979, and he included the Los Angeles one, which was acquired by the museum after the 1979 exhibition, in his published lecture of 1983 and catalogue of Chardin's works that appeared the same year. All three paintings were featured in a small exhibition held at the Los Angeles County Museum of Art in 1990 and are fully discussed in the accompanying publication. It is not necessary to repeat all the arguments of these several studies, but it is agreed that all three canvases are from Chardin's hand and were painted at about the same time, in 1733 or 1734. As mentioned, Chardin exhibited a version of *Soap Bubbles* at the Salon of 1739, but it is not known for certain which picture it was. Most likely it was another, fourth version, which was probably the painting engraved by Pierre Filloeul, whose print (fig. 13c), in reverse, was advertised in December 1739. It had become normal practice for engravings to be made of Chardin's figure paintings after their exhibition at the Salon. Filloeul's print, however, does not correspond exactly to any of the extant autograph works: it is closest to the Washington one in the vertical format, but this treatment does not show any convincing signs (let alone the definite presence) of the carved relief with putti underneath the window ledge that is quite clearly reproduced in the engraving. The leaves in the Washington picture seem to have been added by another hand at a later date. In the New York painting, however, the fronds are certainly by Chardin and are an integral part of the work, so the idea can be ruled out that it is a subsequently cut down section of the engraved picture. Similarly, technical evidence points to the fact that the Los Angeles canvas was always horizontal in format, and in any case two horizontal versions are recorded in the eighteenth century. All the evidence points to a fourth, missing, "original" painting, one vertical in format, without a decoration of leaves, but with the relief under the window ledge, that was exhibited in 1739 and then engraved by Filloeul.

The probable companion of this lost picture was *Knucklebones* (Baltimore Museum of Art), which was engraved by Filloeul in 1739 as the pendant of his *Soap Bubbles* engraving. The Baltimore *Knucklebones* seems to be unique; it is one of the very few figure paintings of the 1730s that Chardin did not repeat. Study of this work supports the argument that there is a missing *Soap Bubbles*. *Knucklebones* has quite a few pentimenti in its design. Some of these can be seen with the naked eye, others with the aid of X-radiography. Nearly all of the first versions of Chardin's figure subjects and still lifes show such changes of mind as he composed. Subsequent

FIG. 13C
Pierre Filloeul (after Jean-Siméon Chardin), *Soap Bubbles*, 1739, engraving, 9¼ x 7⅜ in. (23.5 x 18.7 cm), bequest of William P. Babcock, courtesy Museum of Fine Arts, Boston.

FIG. 13d
Jean-Siméon Chardin, *The Young Schoolmistress*, c. 1733–34, oil on canvas, 24⅜ x 28¾ in. (62.0 x 73.0 cm), National Gallery of Ireland, Dublin.

Notes

1. Denis Diderot, *Salon de 1769*, ed. Jean Seznec (*Diderot: Salons*, Oxford: Oxford University Press, 1967), 4:83.

2. Rosenberg, *Chardin, 1699–1779*, 208.

renderings, on the other hand, are almost invariably the same as the finally resolved design of the prototype. All three extant versions of *Soap Bubbles* are exactly alike in the dimensions and outlines of the main group, from the glass of soapy liquid and the bubble-blowing youth to the watching child. The fact that none of them has any pentimenti is further evidence that none is the "original" picture.

It is not possible among the three surviving versions of *Soap Bubbles* to establish a sequence for their execution. They all have the richly impastoed handling and restrained palette characteristic of Chardin in the early and mid-1730s, a date that is in accord with Mariette's anecdote.

It was not unusual in the eighteenth century for an artist to repeat a successful design if there was a market for it. It was really only in the Romantic period that a high premium was put on originality, that everything an artist produced had to be an innovation or express a new and unique feeling or idea. Chardin does seem to have repeated successful images rather often, however, but his contemporaries give clues as to why this was so. Mariette observed that invention was quite a struggle for Chardin; indeed the artist did not have the academic training as a draftsman with a large repertoire of forms at his fingertips that would have enabled him to invent much out of his own head, so he nearly always had to work from observation. Moreover, Mariette observed that Chardin's technique was quite laborious and without facility (which of course can also be one of its attractions); painting did not come easily to him. This would help explain why, when he did succeed in creating a satisfactory design, he would exploit its difficult resolution as often as he could in successive versions. Denis Diderot, the great critic and a wholehearted admirer of Chardin, put it more aphoristically: "Chardin copies himself frequently, which makes me think that his works cost him dearly."[1]

If it is possible to keep track of Chardin's paintings through his lifetime—in the Salon exhibitions, through known collections, and in the saleroom—the rapid decline of interest in his art after his death in 1779 means that the history of his works often gets lost or obscured until the revival of interest in his art during the 1840s. It is, therefore, often difficult to link up existing works such as the museum's picture or the other extant renderings of *Soap Bubbles* with earlier provenances. The dimensions of the Los Angeles painting, however, point to its tentative identification as a version that is recorded in three sales during the eighteenth century and possibly one early in the nineteenth century. Just as cautiously the theory can be advanced that its pendant in all four sales is the ruinously abraded *The Young Schoolmistress* at the National Gallery of Ireland, Dublin (fig. 13d).

Chardin's employment of pendants adds a richness of meaning to his works. When *Soap Bubbles* is joined with *Knucklebones* (and Rosenberg has suggested that the latter picture may have been painted as a pendant later in the 1730s), each supports the other's message, which is a veiled castigation of idleness (the Baltimore picture presents a girl playing knucklebones; her work apron and prominently placed scissors indicate the duties that should occupy her time).[2] *Soap Bubbles* and *The Young Schoolmistress* would be a contrasting pair of idleness and industry, of a bad and good example. In the former the younger child is led astray by the frivolous bubble-blowing of the youth, while in *The Young Schoolmistress* the infant learns to read thanks to the diligence of the older girl.

PC

Adoring Angel

ANNIBALE FONTANA
Italian (Milan), 1540?–87

1583–84
Wax with metal armature on wood base
21¾ x 6⅜ x 6⅞ in. (55.2 x 16.2 x 17.5 cm)
with base
Gift of The Ahmanson Foundation
M.80.191

PROVENANCE:
Paris, Alain Moatti (dealer).

SELECT LITERATURE:

Peter Fusco, "Two Wax Models by Annibale Fontana," *Antologia di belle arti*, n.s. nos. 21–22 (1984): 40–46.

Patrick de Winter, "Recent Accessions of Italian Renaissance Decorative Arts, Part 2," *The Bulletin of the Cleveland Museum of Art* 73, no. 4 (April 1986): 165–68, fig. 187.

Scott Schaefer, "Three Centuries of European Sculpture: Bandini to Bartholdi," *Apollo* 124, n.s. no. 297 (November 1986): 415–16, fig. 2.

When this wax *Adoring Angel* appeared on the Paris art market, it carried an attribution to Jacopo Sansovino. In 1980, however, Peter Fusco, then curator of European sculpture for the museum, with the help of Signe Jones, identified it as a *modello* by Annibale Fontana for one of the angels on the facade of Santa Maria presso San Celso in Milan (fig. 14a). He published it and the other wax angel that had been rediscovered with it (*Trumpeting Angel*, now in the Cleveland Museum of Art, inv. no. 84.38) in 1984.[1]

Fontana was the preeminent sculptor in Milan in the second half of the sixteenth century; the facade of Santa Maria presso San Celso was, Wolfgang Lotz points out categorically, the one great Italian church facade of the sixteenth century on which a full didactic program of sculpture was realized.[2]

Begun in 1493, Santa Maria was under construction for more than fifty years, with the sculptors Cristoforo Solari and Amadeo serving as advisors. Only by 1565 was the building ready for a facade; this commission was awarded to Galeazzo Alessi of Genoa. His project, dating from around 1570 and preserved in the Biblioteca Ambrosiana in Milan, provided for a rhythmic sequence of relief panels, statues in niches, and freestanding sculptures, outlined and defined by pilasters and set off by decorative carved garlands.[3] At the summit five piers were sketched in, ready to receive the sculptures that would pierce the skyline: a suite of angels flanking an *Assumption of the Virgin*. Fontana, then working in the south, and the Florentine Stoldo Lorenzi were called to Milan to provide the sculptures for the facade, but Lorenzi returned to Florence, leaving Fontana to complete the ensemble. From 1574 until 1587, the year of his death, Fontana designed eleven sculptures for the facade, and for the interior, the Altar of the Virgin of Miracles (1583–86), which comprised a marble *Assumption* and silver reliefs.

The museum's *Adoring Angel* is one of the few surviving wax models of the

FIG. 14a
Galeazzo Alessi, et al., detail of the upper part of the facade of Santa Maria presso San Celso, Milan. Photo: Alinari/Art Resource. The museum's wax is the model for the angel immediately to the left of the Virgin.

Notes

1. Fusco, 46, n. 10, cites an article by Anna Patrizia Valerio ("Annibale Fontana e il paliotto dell'altare della Vergine dei Miracoli in Santa Maria presso San Celso," *Paragone* 24, no. 279 [May 1973]: 32–53) in which she mentions three terra-cotta (or clay) models recorded in an inventory from 1685 of the Biblioteca Ambrosiana in Milan. The same inventory, however, also records "Tre modelli d'Angioli ritti su piedi, due con una mano tesa in alto, l'altro in atto di meraviglia . . . d'Annibale Fontana" (Three models of standing angels, two with an outstretched hand, the other in wonderment . . . by Annibale Fontana). Their medium is unspecified. Could it be that the two models of angels with an outstretched hand referred to in this document are for the trumpeting angels at the summit (which are not mirror images) and that the third model "in wonderment" is the Los Angeles wax? See Valerio, 44, n. 10.

2. Ludwig H. Heydenreich and Wolfgang Lotz, *Architecture in Italy 1400–1600*, trans. Mary Hottinger (Harmondsworth: Penguin Books, 1974), 294. For the history of the church see 110, 292–94.

3. Alessi's sketch is illustrated in Heydenreich and Lotz, pl. 314.

4. Valerio, 33–34.

Renaissance. Colored probably with cinnabar or burnt sienna, it is made of beeswax, a delicate medium that was thought of originally as just an auxiliary material serving in the process of creation of a finished sculpture. Much of the modello's preciousness today is owed to its ephemeral character. Other wax sketches that have been preserved, by Sansovino, Michelangelo, Cellini, and Giambologna, must have been treasured even in their time, not for their material value, but as documents of the creative genius of their authors. The museum's wax, still on its original wood base, preserves an image just as it was finished by the artist's hand.

The figural style of the *Adoring Angel*, with its athletic musculature, depends on the legacy of Michelangelo. Fontana, however, transmuted Michelangelo's influence with a new lyricism, shown in the softened draperies that sweep about the angel's body, counterbalancing the diagonals of the contrapposto. This moving composition and the expression, alive with expectation and wonder, are elements of a style that place Fontana at the dawn of the baroque. He did not live to see his *Angel* (or its pendant, a mirror image) carried out on the large scale; instead these were carved after his death by Milano Vimercati. Unfortunately the spiritual rapture embodied in the wax model did not survive translation into stone.

The campaign to finish the sculptured decoration of the facade of Santa Maria coincided almost exactly with the last years of Milan's renowned archbishop, Saint Carlo Borromeo (see cat. no. 19). As one of the great zealots of the Counter-Reformation, Borromeo revitalized the Church's sacred glory. Preaching strict doctrinal discipline, he had forbidden the representation of apocryphal subjects, but Marian imagery was too profoundly ingrained in the popular imagination to have been affected by an interdiction. To the contrary, the Assumption of the Virgin could be understood as a symbol of the Church Triumphant; Borromeo himself had approved Fontana's Altar of the Virgin of Miracles, with its own *Assumption*.[4]

MLL

Portrait of Giacomo Dolfin

TITIAN (TIZIANO VECELLIO)
Italian (Venice), c. 1489–1576

c. 1531
Oil on canvas
41⁵⁄₁₆ x 35¹³⁄₁₆ in. (104.9 x 91.0 cm)
Inscribed on letter: Al Cl[]mo Giacomo
dolfin / M[]co D[] Prvi / a Vrcinovi
[or Venezia]
Gift of The Ahmanson Foundation
M.81.24

PROVENANCE:
Venice, Giacomo Dolfin.
Venice, Danese Cattaneo, by May 1566.
Como, Antonio Canova, until 1822.
England, private collection.
London, sale, Christie's, 2 December 1977,
no. 41.
London, Thomas Agnew and Sons (dealer).

SELECT LITERATURE:
Giorgio Vasari, *Le vite* (1568), ed. Gaetano
Milanesi (*Le opere*, Florence: G. C. Sansoni,
1906), 7:456.
Charles Hope, "Titian's 'Portait of Giacomo
Dolfin,'" *Apollo* 115, n.s. no. 241 (March 1982):
158–61.

Venetian art theorist Lodovico Dolce observed in 1557 that "Titian's works had won him so great a reputation that there was not a nobleman in Venice who did not take care to possess some portrait or other invention of his making."[1] By the 1550s Titian was one of the most sought-after portraitists in Europe, a reputation that had its beginnings in 1532, when he met the Holy Roman Emperor Charles V in Bologna. Charles, probably inspired by a portrait Titian had made of Federico Gonzaga of Mantua, sat for the painter twice while in Italy and then again in Augsburg in 1548–49, where Titian created the great *Emperor Charles V Seated* (Alte Pinakothek, Munich) and *The Emperor Charles V at the Battle of Mühlberg* (Prado, Madrid). After the early 1530s Titian rarely deigned to paint any but the most distinguished sitters from the ruling houses of Italy and the rest of Catholic Europe. His *Portrait of Giacomo Dolfin*, done about 1531, just at the moment the artist was about to achieve European fame, was one of the last he made for a sitter who was not widely known. However, the economy of this image, with its intimidating characterization, established a type of official portrait in Venice, serving as a model during the rest of the sixteenth century and well into the next.

Professor Charles Hope, whose article cited above serves as the basis for this entry, convincingly identifies the sitter as Giacomo di Andrea Dolfin (c. 1469–1545), a man who held a number of legal and administrative positions in Venice and its dependent towns. Dolfin entered the Maggior Consiglio (Great Council) of Venice in 1494; between about 1513 and 1522 he was Podestà (the Venetian representative in a subject city) at Noale, San Lorenzo, and probably Lonigo. In 1526 he was a member of the Quarantia Criminale and was elected Avvocato per gli Uffici in Rialto. In 1529 he was one of the Consoli dei Mercanti. In 1531–32 Dolfin was a Provveditore at Orzinuovi, a Venetian fortress near Brescia; in 1540, a Provveditore sopra le Fabbriche in Padua. In 1544 he was recorded as a Camerlengo in Vicenza. Wearing his burgundy-colored velvet robes of office, Dolfin is presented as a typical middle-ranking officeholder of the Venetian Republic. According to Hope the letter he holds

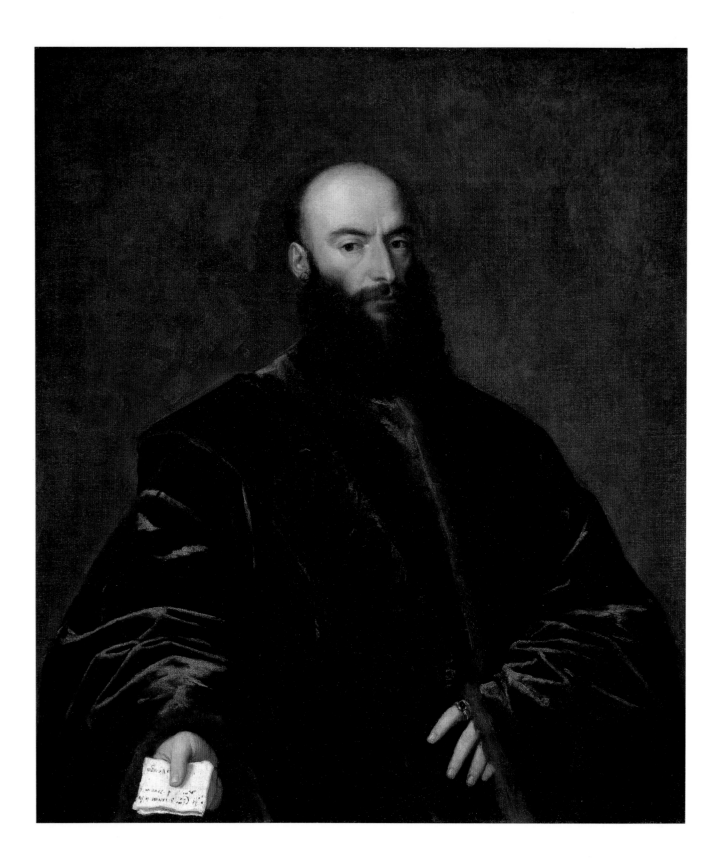

Notes

1. Lodovico Dolce, *Dialogo della pittura di M. Lodovico Dolce, intitolato l'Aretino* (1557; in *Dolce's "Aretino" and Venetian Art Theory of the Cinquecento*, by Mark W. Roskill, New York: College Art Association/New York University Press, 1968), 189.

2. William Suida, *Le Titien* (Paris: A. Weber, 1935), pl. 195.

seems to be addressed to him at Orzinuovi in the office he held in 1531–32: "Al Cl[arissi]mo S[ignor] iacomo dolfin [or dolfino] / M[agnifi]co D[omino] P[] / a Vrcinovi." A subsequent, closer reading is listed in this entry's caption. Unfortunately the letter has been somewhat abraded, which makes an exact reading difficult. Hope's letter "S" (for Signor) is probably a capital "G" (for Giacomo), and his "P" can be extended to Prvi (for Provveditore). The last word of the inscription could also read "Venezia." Thus the letter could be addressed to Dolfin in his official capacity as Provveditore in Orzinuovi, but it would be just as likely for it to be addressed to him in Venice. Both interpretations are convincing. In 1531–32 Dolfin was in his early sixties, and the style of Titian's painting is right for that date.

Titian shows his mastery at conveying a sense of the sitter's personal, social, and political power. Dolfin's image is straightforward, monumental, and dignified. He forms a powerful and bulky pyramidal shape in a pictorial space that he seems to dominate with confidence. Titian also conveys this assured air by Dolfin's stance and the firm grip he has on the letter. It is not a very intimate portrait, but Titian gives the sitter a definite if somewhat stern character befitting his public office. A certain softening of the haughty air can be detected in Dolfin's action of seeming to hand the letter to the viewer. The painting manages to be both somber and sumptuous at the same time, conveyed through the costume, which is sober in color but opulent in cut and style, and Titian's characteristically rich and painterly handling. One wonders if Dolfin realized how fortunate he was to be painted by the artist who even then was being sought by Emperor Charles V.

When Giorgio Vasari briefly visited Venice in May of 1566, he saw a handful of collections, including that of sculptor Danese Cattaneo, his Tuscan compatriot. In Cattaneo's collection Vasari saw "un ritratto di man di Tiziano, d'un gentiluomo da ca Delfini" (a portrait by the hand of Titian, of a gentleman of the Delfini family). The painting is next recorded in the nineteenth century, in the collection of another sculptor, Antonio Canova, where it is noted in an inventory taken after his death in 1822 (this was confirmed by an old label discovered on the back of the painting when it was cleaned before coming to the museum). It is tempting to speculate that its appeal to the two sculptors was its monumentality of form. A copy of the painting, now in the Norton Simon Museum, Pasadena, shows a cloth hanging behind the figure.[2] When the Los Angeles painting was sold at auction in 1977, it too had the cloth in the background (illustrated in the sale catalogue). Subsequent examination revealed it to be a later addition, so it was removed in cleaning.

PC

Lot and His Daughters

JOACHIM ANTHONISZ WTEWAEL
Dutch, 1566–1638

c. 1595
Oil on canvas
64 x 81 in. (162.6 x 205.7 cm)
Gift of The Ahmanson Foundation
M.81.53

PROVENANCE:

Possibly Antwerp, "an Italian," by 1604.

Possibly The Hague, Seger Tierens sale, 23 July 1743, no. 114.

Dorking, Surrey, Francis Howard, until 1955.

London, sale, Christie's, 25 November 1955, no. 47.

London, Arcade Gallery, 1955.

Florence, Orselli (dealer), 1963.

Rome and Los Angeles, private collection, 1963–81.

SELECT LITERATURE:

Carel van Mander, *Het Schilderboeck* (1604), trans. Constant van de Wall (*Dutch and Flemish Painters: Translation from the Schilderboeck*, New York: McFarlane, Warde, McFarlane, 1936), 412.

Anne W. Lowenthal, *Joachim Wtewael and Dutch Mannerism* (Doornspijk: Davaco Publishers, 1986), 20, 59, 91–92, no. A–13, 203.

Anne W. Lowenthal, "Lot and His Daughters as Moral Dilemma," in *The Age of Rembrandt: Studies in Seventeenth-Century Dutch Painting*, Papers in Art History from The Pennsylvania State University, no. 3 (University Park: Pennsylvania State University, 1988), 12–27, fig. 1–1.

Utrecht, like other Netherlandish cities, witnessed the emergence of a new style of painting at the end of the sixteenth century: mannerism, a movement that was to bring the Northern artistic centers up to date with their Italian rivals. Taking its cue from the high *maniera* of the post-Raphael generation in Florence and Rome, the new style matched elegant forms and elaborate compositions with erudite interpretations of subject matter. It appealed primarily to the sophisticated tastes of the court, especially that of Rudolf II in Prague, which fostered the style through Bartholomeus Spranger and his circle. In Utrecht its principal exponent was Joachim Wtewael, who spent the majority of his life there, specializing in religious and mythological scenes (he also painted genre pictures and portraits). Early in his career Wtewael spent two years each in Italy and France; in both places he absorbed the mannerist precepts that he would use throughout his career. By 1592 he had returned to Holland and been accepted by the local artists' guild. Like other Dutch artists he was also a businessman, acquiring a considerable fortune as a flax merchant and in real estate. In addition he was a member of the Utrecht town council and an active Contra-Remonstrant.

By the turn of the century Wtewael's reputation was such that Carel van Mander in his *Schilderboeck* could judge him "to be worthy of a place among the best painters of the Netherlands."[1] According to the writer, Wtewael had "good judgement and a keen knowledge, two qualities that do not often combine in an artist," and he singled out for admiration a version of *Lot and His Daughters* that he had seen in Antwerp in the collection of "an Italian": "it represents Lot and his daughters; life-size nudes appear in this picture; the rendering of the fire, the trunks of the

trees, and other details, are very interesting."[2] It is unclear whether van Mander is referring to the museum's picture or the very similar composition recently acquired by the Hermitage in Leningrad.[3]

The Los Angeles painting illustrates the well-known story from Genesis 19, which tells of Lot, who lived in Sodom. When God sent angels to destroy the sinful city, the virtuous Lot was forewarned and fled with his family before the town was inundated by fire and brimstone. Lot's wife disobeyed the angels' command not to look back and was therefore turned into a pillar of salt. Thinking their father was the last man left in the world, the two daughters believed their only hope of perpetuating their race was through him: "And the firstborn said unto the younger, Our father is old, and there is not a man in the earth to come in unto us after the manner of all the earth: Come, let us make our father drink wine, and we will lie with him, that we may preserve seed of our father." As a consequence of their incest each daughter bore a son, who in turn founded the tribes of the Ammonites and Moabites.

Wtewael depicted Lot and his daughters a number of times, not only in the Leningrad and Los Angeles pictures but also in a canvas in Berlin (Staatliche Museen), a meticulously finished painting on copper (also Hermitage), and three drawings.[4] In all these versions he interpreted the story as an erotic seduction scene. In the Los Angeles work Lot and the two women are shown before the entrance of the cave where they have taken shelter for the night. The daughters have shed their clothes and are lavishing their attentions on the obviously drunken Lot. In typical mannerist fashion the figures are elaborately intertwined, their limbs draped over each other, their bodies displayed in a variety of positions. Lot holds a wine cup over his head, Bacchus-like, as he gropes the breast of one of the women. In response she reaches over her shoulder to caress his beard. The other daughter proffers a bunch of grapes. In the right background the city of Sodom burns fiercely in the night. Unusually, Lot's wife is nowhere in sight.

The exaggeration of pose and composition employed by Wtewael is mitigated by the sharp passages of naturalistic detail. The contorted figure of Lot, for instance, with its unreconciled anatomy, is in startling contrast to the completely convincing rendering of his foot, with its throbbing veins and dirt-stained toes. Wtewael demonstrated his talents at imitating nature in the wonderfully tactile still-life elements: the cheese, butter, and bread behind the daughter at left are as visually

Notes

1. van Mander, 412.

2. Ibid., 411–12.

3. The author is grateful to Dr. Xenia S. Egorova of the Pushkin Museum for information about this painting.

4. Lowenthal, "Lot and His Daughters," 13, 19–20.

alluring as any Dutch table piece (see, for example, cat. no. 39), while the succulent basket of fruit in the foreground appears to project into the viewer's space.

In fact, as Anne Lowenthal has shown, the still-life objects surrounding the individuals have double meanings that give the painting as a whole an ambiguous message. The grapes in the basket refer to the wine with which Lot is intoxicated but are also a reference to the Eucharist; the cheese and butter at left recall a Dutch proverb, "Butter with cheese is a devilish feast," but the nearby bread might join the wine as a symbol of the sacrament of Holy Communion.

The repugnant crime committed by Lot and his daughters was the cause of much discussion among interpreters of the Bible. Most commentators excused the characters from their sin by observing that Lot was drunk and thus did not know what he was doing and that the daughters only wished to perpetuate their family and could not be accused of lusting after their father. In Wtewael's time John Calvin reasoned that, while the dilemma of Lot's daughters was understandable, their transgression could not be excused. Lowenthal argues that the various levels of meaning inherent in Wtewael's painting served as a "moral dilemma" for the viewer, requiring a choice among several interpretations.

When confronted with the picture today, the modern viewer may feel the religious content is not very high. Lot is cast as a bumpkin, his prettified daughters as harlots. The monumental female nudes are displayed to good effect, one from the front, the other from the side. Indeed, Wtewael probably intended for male viewers to envy the position of Lot, presented as he is in the arms of two naked women with plenty of food and drink alongside. The hidden meanings and double entendres perceptible to the careful viewer would have simply added to the delight of what was, in the end, a tantalizing display of the female nude. Certainly it was in keeping with the eroticized history paintings of Italian artists like Giorgio Vasari and Pellegrino Tibaldi that Wtewael would have admired in Rome. In this work, Wtewael's first large-scale figure painting, he would have consciously wished to emulate his Italian forerunners. He would have had all the more reason to do so if, as van Mander suggested, the picture was intended for an Italian patron living in Antwerp.

RR

Saint Peter Preaching in Jerusalem

CHARLES POËRSON
French, 1609–67

1642
Oil on canvas
30 x 24¼ in. (76.2 x 61.6 cm)
Gift of The Ahmanson Foundation
M.81.73

PROVENANCE:

Probably Paris, Notre-Dame de Paris, Pierre Le Bastier and François Le Quint.

Paris, Monsieur Nourri, Conseiller au Grand Conseil sale, 24 February 1785, no. 85.

London, sale, Sotheby's, 20 June 1980, no. 99.

London, Luigi Grassi (dealer).

SELECT LITERATURE:

Pierre Rosenberg, *France in the Golden Age: Seventeenth-Century French Paintings in American Collections*, exh. cat. (New York: Metropolitan Museum of Art, 1982), 301, no. 83.

Little is known of Charles Poërson's early career, but he was one of the many students of Simon Vouet (cat. no. 31) in the years around 1630. Vouet was the most important and influential painter in Paris from the time of his return from Italy in 1627 until his death in 1649. He brought back with him a knowledge of Italian painting from the Renaissance to the contemporary Italian baroque and infused this "grand manner" into French painting. Poërson was one of the first beneficiaries of this Italianate influence, which can be perceived throughout *Saint Peter Preaching in Jerusalem*.

It is not known if Poërson ever went to Italy himself. The present writer is inclined to believe that he did not, as his art ultimately lacks the *gravitas* of Roman tradition and retains the graceful charm of an artist who still had provincial attitudes. His son Charles-François certainly knew Italy: a mediocre painter but able administrator, he served as director of the French Academy in Rome and made that institution an important feature of French and even European artistic life. The senior Poërson was heavily involved in the Parisian art world, becoming an early member of the recently created (1648) Royal Academy in 1651 and being named to the office of rector in 1658.

Poërson has been rather forgotten as an artist; only in recent years have scholars been able to distinguish his works from those of Vouet (with whom he collaborated on the decoration of the Gallery of Famous Men at the Palais-Royal in Paris), Eustache Le Sueur (with whom he worked on the royal apartments in the Louvre), Laurent de La Hyre, and Philippe de Champaigne. Poërson had a productive independent career supplying church altarpieces, private devotional works, and decorations. Among his more significant productions were two works done for Notre-Dame de Paris, one in 1642 (fig. 17a), the other in 1653, and a cycle of six paintings on the *Life of Saint Louis* (now lost) for the Hôpital des Quinze-vingts.

When it appeared in the London saleroom in 1980, *Saint Peter Preaching in Jerusalem* was attributed to La Hyre, but it is without a doubt by Poërson and is related to his

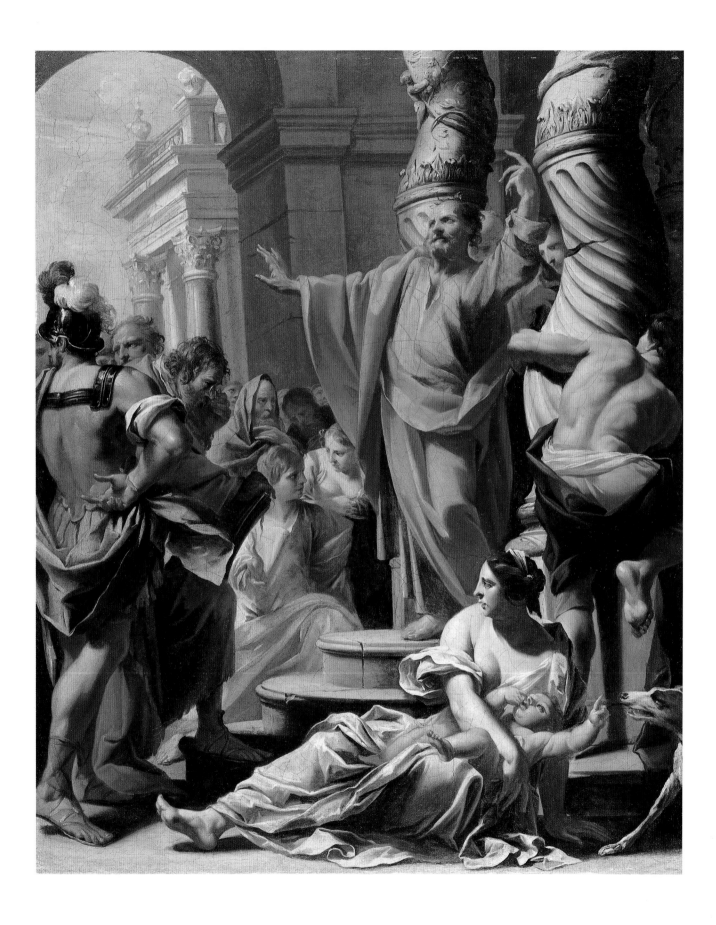

Fig. 17a
Charles Poërson, *Saint Peter Preaching in Jerusalem*, 1642, oil on canvas, 130 x 104 in. (330.2 x 264.2 cm), Notre-Dame de Paris. Photo: Arch. Phot. Paris/S.P.A.D.E.M.

large picture of the same subject at Notre-Dame, which is signed and dated 1642. The latter work is one of a series of large canvases, each about eleven feet high by eight-and-a-half feet wide, commissioned from numerous artists to decorate the columns of the nave of Notre-Dame (fig. 17b). Nearly every year from 1630 to 1708 the Paris Goldsmiths' Guild, dedicated to Saints Anne and Marcel, presented one of these large works to the church on the first of May. The painting, known as a *May*, hung for a day at the entrance to the cathedral, then for a month opposite the Chapel of the Virgin, and finally was placed on one of the pillars of the nave. Seventy-six of these were completed. They were dispersed at the time of the French Revolution, and, even though most of them have been located, Poërson's second *May* of 1653, *Saint Paul at Malta*, is still lost, although its design is known through an eighteenth-century engraving by Nicolas Tardieu.

It was considered a great honor to receive one of the *May* commissions, and despite the fact that the fee paid was notoriously low, distinguished artists were happy to undertake one. Among Poërson's more important contemporaries, *Mays* were painted by La Hyre (1635), Sébastien Bourdon (1643), Charles Le Brun (1647 and 1651), and Le Sueur (1649). Of course it was good publicity for artists, as their works were placed on permanent public display in a prestigious location, an important consideration in an age before museums.

The design of the Los Angeles picture follows fairly closely the larger one that is still in Notre-Dame, with the exception of some slight variations in the background architecture, facial expressions, and costume details. It is impossible to tell if the smaller painting is a preliminary model, followed in the work at Notre-Dame in all but minor differences, or if it is the reduced replica, which was a required part of the commission. (The replica was an obligatory gift of gratitude from the artist who won the commission to the two goldsmiths who presented the *May* each year. In 1642 they were Pierre Le Bastier and François Le Quint.) The possibility cannot be ruled out that the museum's *Saint Peter Preaching in Jerusalem* fulfilled both functions, that Poërson presented to the two goldsmiths the model he had carefully prepared for the finished design. After all, while one would expect a replica done after the main painting to be absolutely faithful to the original, it is not unusual to find minor changes between a preparatory model and final work.

The subject is derived from Acts 3, where Saint Peter addresses a crowd after he and John have healed a lame man at the Temple of Solomon in Jerusalem (the giant, twisted columns, famous in ancient times, indicate his location). With rhetorical gestures Peter attributes the miracle to his and John's faith in Jesus Christ and harangues the crowd for having condemned Christ to death in favor of the common criminal Barabbas. Some members of the gathering are skeptical; others are moved by his words. A Roman soldier is an ominous presence, a contrast with the scholarly-looking man who seems to be transcribing Peter's words. According to popular tradition he is Saint Mark, whose Gospel was inspired by Peter's preaching.

In style the painting is close to Vouet; indeed when the work was sold in 1785, it was described in the sale catalogue as "in Vouet's style." It is richly impastoed, and the overall rhythms of the design are supple and flowing. The tendency of the palette toward gray or pale lilac is Poërson's own. There is also a gracefulness about his figures, who twist, turn, sway, and gesture in a sometimes slightly affected way that is reminiscent of the more decorative traditions of the mannerist style that still lingered in France in the early decades of the 1600s. The famous and more dominant names in French seventeenth-century painting have been well studied, but the presence of Poërson's *Saint Peter Preaching in Jerusalem* in a major public art museum serves well to draw attention to the fact that many other good and quite typical painters were working in Paris in the age of Champaigne, Le Brun, and Poussin.

PC

FIG. 17b
Anonymous, *View of the Interior of Notre-Dame*, mid-seventeenth century, oil on canvas, dimensions and location unknown. The *May* of 1642 (fig. 17a) is the first painting on the right.

Dido and Aeneas

RUTILIO MANETTI
Italian (Siena), 1571–1639

c. 1630–35

Oil on canvas

57½ x 46¼ in. (146.1 x 117.5 cm)

Given anonymously in honor of
The Ahmanson Foundation

M.81.199

PROVENANCE:

Private collection.

London, Matthiesen Fine Art Limited (dealer).

SELECT LITERATURE:

Important Italian Baroque Paintings 1600–1700,
exh. cat. (London: Matthiesen Fine Art
Limited, 1981), 20–21, no. 6.

Rutilio Manetti was one of those busy and reliable provincial painters whose
manner was derived from the innovations of more important artists in major artistic
centers and who, in certain works, brought an injection of metropolitan excitement
to the art of his hometown. He fulfilled a purely local demand for altarpieces,
decorations, and history paintings in styles reflecting several of the fashions of the
day, some reminiscent of Caravaggio, others of the Gentileschi, and so on. Manetti
has benefited from the stimulating resurgence in Italy in the last twenty years of
local interest in native talent, even though he was not one of the innovators in the
history of Italian painting nor even one of those artists with a quirky and appealing
poetry who sometimes emerges despite (or, more positively and less snobbishly,
because of) a provincial heritage.[1]

If Siena, where Manetti was born in 1571 and where he spent most of his life, was
a less significant city under late Medici rule in the seventeenth century than it had
been as an independent city-state in medieval times, it still was quite an important
religious center and there was always a lively demand for a good painter or two to
serve the Church, city, and private patrons. Little is known of his early career. After
completing the altarpiece of the *Death of the Blessed Anthony Patrizi* (Sant'Agostino,
Monticiano) in 1616, a painting that betrays some knowledge of the advanced art of
Artemisia Gentileschi, who was active in Florence at that time, Manetti likely went
to Rome. There he was most susceptible to the work of such Italian followers of
Caravaggio as Orazio Gentileschi (Artemisia's father) and Bartolommeo Manfredi.
However, the sources of his style or styles (he was quite variable) are notoriously
eclectic, complex, and difficult to pinpoint. For example, sometimes his paintings
have the drama and bold contrasts of light and shade associated more with
Caravaggio's Northern followers such as Gerrit van Honthorst and Dirck van
Baburen. At other times they show an awareness of the more classical yet sensuous
art of Guido Reni. His compositions generally retain something of the crowded
quality associated with the late mannerist style, which had long been rejected by the
more advanced painters of Rome. Manetti was in any case back in Siena by 1621 and
seems to have passed the rest of his life there.

Notes

1. See *Rutilio Manetti (1571–1639)*, exh. cat. (Siena: Palazzo Pubblico, 1978).

Dido and Aeneas is a mature work, dating from the early to mid-1630s. The story comes from Virgil's *Aeneid* (4:362–92) and shows the farewell of Aeneas as he abandons the distraught and soon-to-be-suicidal Dido to continue his voyage to Latium. Two of her maids-in-waiting whisper with concern about this unwelcome departure, while an armored soldier waits impatiently for his leader. The resolve of Aeneas is clear in his firm but somewhat impersonal handshake and from the fact that he is dressed in an elaborate cuirass and plumed helmet.

The painting illustrates Manetti's eclecticism quite well. The design is based on a painting of *Dido and Aeneas* done by Reni about 1626–28, which is now known only through studio copies (Staatliche Gemäldegalerie, Kassel, and Palacio Real, Madrid). The basic composition and narrative are similar, but Manetti is more anecdotal in introducing the three subsidiary characters, making his composition more crowded. The soldier on the left, with shadows playing across his face, is quite like a character Guercino could have invented, while the two female attendants are suggestive of an artist such as Manfredi. However, the bold handling and impasto and the clear action of Aeneas and Dido recall Manetti's principal model here, Reni.

It is interesting to consider the painting in the context of the museum's other Italian baroque paintings that are discussed in this catalogue. Compare Manetti's response to Caravaggio and his followers with that of Tanzio da Varallo in his slightly earlier and earthier *Adoration of the Shepherds with Saints Francis and Carlo Borromeo* (cat. no. 19) or, in extreme contrast, with Guido Reni's polished and highly refined mythical scene of *Bacchus and Ariadne* (cat. no. 12).

PC

Adoration of the Shepherds with Saints Francis and Carlo Borromeo

TANZIO DA VARALLO (ANTONIO D'ENRICO)
Italian (Lombardy), c. 1575/80–1635

c. 1628–30
Oil on canvas
73⅛ x 59 in. (185.7 x 149.9 cm)
Gift of The Ahmanson Foundation
M.81.247

PROVENANCE:
London, art market, 1966.
Milan, Algranti (dealer), 1970.
Switzerland, private collection.
London, Matthiesen Fine Art Limited (dealer).

SELECT LITERATURE:
Important Italian Baroque Paintings 1600–1700, exh. cat. (London: Matthiesen Fine Art Limited, 1981), 60–63, no. 22.

Tanzio da Varallo's *Adoration of the Shepherds with Saints Francis and Carlo Borromeo* is one of the most vivid and intense old master paintings in the museum's collection. The energy comes from the fact that the participants loom close to the picture plane, occupy nearly all of the picture surface (little space remains at the top to give much real sense of the dark cavern of the stable at left or the landscape at right), and are all uncompromisingly observed by the artist. Each of the various physiques is strongly differentiated; each of the figures has distinctive individual characterizations. Borromeo (kneeling at left) is effectively a patent likeness of this near-contemporary saint who had died in 1585, while the four young shepherds could well have been based on the artist's studio assistants.

The strong relieflike effect of this group of people is created not only by their placement at the front of the pictorial space but also by Tanzio's employment of a sharply angled, almost raking light. This light falls from the top left, sometimes rather harshly, across the faces, heads, and hands of the individuals, framing the folds and different textures of their clothing. Colors are strong and saturated, and in combination with the lighting, they give the figures a rather odd and forced presence. For all Tanzio's attention to detail and characterization, however, the parts do not add up to a whole that makes the viewer feel present at a real event. Rather the intensity of emotion is so concentrated through the attention of the saints and shepherds that the spectator is led by the artist to feel an almost mystical sense of Christ's divinity, to experience the epiphany.

It is not a joyful adoration. The youngest shepherd, who seems to be the recipient of the Christ Child's attention and precocious benediction, is clearly moved, but is it by a premonition of the Child's fate later in life? What is the subject of the other shepherds' conversation? Saint Francis (on the right) is a discomforting and insistent presence. This is a gaunt, starved, and anguished penitent saint, not the gentle preacher to the birds and flowers. He displays his stigmatized hands, stark reminders of Christ's later Passion. On the other side Borromeo betrays the pain of a high-strung intellectual who knows all too well the suffering of the world through what

he has seen of it in the slums of Milan and experienced in the life of the mind and imagination. It is a melancholy occasion, tempered by an air of tender solicitude for the Child, displayed atop a basket in all his naked vulnerability.

Nothing is known of this painting's history before its appearance on the art market in 1966. For stylistic reasons most scholars agree that it can be dated to around 1628–30 and must have been made as an altarpiece for a church or chapel in the area of Varallo in Piedmont, where Tanzio was working at the time. He sometimes used the same compositional ideas in more than one painting. In the Museo Civico in Turin there is a much smaller canvas on a theme similar to that of the Los Angeles picture, but with only two shepherds and without Saint Francis. The arrangement of the figures is very close although necessarily simpler. The museum's work is in turn like another altarpiece, the *Virgin Adored by Saint Carlo Borromeo and Saint Francis* (Pinacoteca, Varallo), which is known from documentary evidence to have been painted by 1628 for the Oratorio di San Carlo at Sabbia. Again it is a simpler, more iconic image, with the saints on either side of the Virgin and Child in a symmetrical design reminiscent of the High Renaissance.

Antonio d'Enrico, called Tanzio da Varallo, was born in Alagna, Piedmont, between 1575 and 1580. Almost nothing is known of his early years, but in 1600 he and his brother Melchiorre, a fresco painter, were given a permit to leave their native region in order to travel wherever they needed to practice their art and to journey to Rome for the Jubilee of Pope Clement VIII. It is quite likely that Tanzio spent some time in Rome, where he may have been attracted by the earthy realism and bold use of light and shade of Caravaggio. It has also been suggested that he traveled and worked as far south as Naples, but there is no proof of this. Nor is anything else known for certain about this early phase of Tanzio's life and art until he emerges as a mature painter, documented as working on frescoes of *Christ before Pilate* in a chapel on the Sacro Monte at Varallo in 1616–17 and on a *Washing of the Hands* that was completed in another chapel in 1619. He continued to work at Varallo through the 1620s, and the Sabbia altarpiece mentioned above was installed by 1628.

The series of chapels at Varallo are an interesting phenomenon in the history of Northern Italian religious art. Founded in 1486 by the Blessed Bernardino Caimi, the original idea of the Sacro Monte was to reconstruct the Holy Places of Palestine. Inside the various chapels constructed for this purpose, the walls were decorated with frescoes and the spaces were filled with life-size sculptures usually made of terra-cotta and painted with a vivid naturalism. Glass eyes and real hair added to the uncanny sense of actuality of these tableaux. Peering into the shrines, the visitor or pilgrim felt almost present at the various scenes of Christ's Passion, acted out by the naturalistic figures before the painted backgrounds. Perhaps the greatest of these chapels was that of the *Crucifixion*, by Gaudenzio Ferrari, made between 1520 and 1530.

After a period when activity was dormant, there was a revival of interest in the concept of the Sacro Monte in the 1570s, as a particular manifestation of the Counter-Reformation in this northern corner of Italy. The region, in the foothills of the Alps on the border with Switzerland, was as much German-speaking as Italian. The Protestant Reformation became very strong here in the sixteenth century

FIG. 19a
Tanzio da Varallo, *Study of the Virgin*, red chalk heightened with white on pink prepared paper, 7¹³⁄₁₆ x 5¹⁵⁄₁₆ in. (19.8 x 15.1 cm), Los Angeles County Museum of Art, gift of The Ahmanson Foundation (M.87.109).

and won many converts. Indeed ever since the twelfth century there had been a movement of fundamentalist religious protest resistant to the dictates of the Roman Church in the Waldensian valleys near Turin. The authorities of the Catholic Church, led in Piedmont and Lombardy by Cardinal and Archbishop Carlo Borromeo of Milan, adopted various strategies to protect the status quo of the Church and to combat such heresies. One approach was to intensify the propagandistic use of religious images. Borromeo resumed the development of the Sacro Monte at Varallo (chapels continued to be added until 1765), and others were developed in the late sixteenth and early seventeenth centuries at Arona, Crea, and Varese. These special artistic features of the region, on the front line of the war against heresy and Protestantism, were vivid reminders of Christ's suffering and a testament to the powerful role of religious art.

Detail

It is not difficult to appreciate that Tanzio's rather hard, sculptural sense of form, bright color, vivid realism, and intensity of feeling owe quite a lot to this vigorous local artistic tradition, not least because he worked at Varallo after returning from his suggested travels south. The figures in his *Adoration* have the hard surface quality of painted sculpture: their space is too cramped to be quite convincing, and they are displayed against a flat background. It is almost as if Tanzio was peering into a chapel at Varallo and depicting one of the tableaux. Certainly his experience of working there affected the concept and style of this altarpiece, and its gloomy intensity can be better understood in the context of these historical and cultural circumstances.

The presence of the Milanese Borromeo in the Los Angeles altarpiece is not unusual in Lombard painting of this period, because he was such an important figure in Northern Italian religious life during the Counter-Reformation. He effectively led the movement in this region not only by encouraging the creation and dissemination of new and more emotionally persuasive religious imagery as an aid to piety but also by stimulating the construction of new churches and monasteries and by attending to the pastoral care of the poor and needy. Borromeo led an exemplary life of austerity and self-denial and placed great emphasis on acts of charity and care as an answer to the Protestant accusation that Catholics indulged in luxurious materialism. His ascetic moral and religious fervor is conveyed in Tanzio's portrait, and much of that intensity of feeling carries over into the painting as a whole.

In 1987 the museum acquired a very fine drawing by Tanzio (fig. 19a; purchased at Christie's, London, 4 January 1987, no. 57), which shows a figure of the Virgin quite similar to the one in the painting. There is another drawing of the Virgin in the Louvre, Paris, while in the Pierpont Morgan Library, New York, there is a drawing of Saint Francis that could be preparatory for both the Los Angeles painting and the Sabbia altarpiece discussed above.[1]

PC

Notes

1. For the Louvre drawing see *Acquisitions 1984–1989*, exh. cat. (Paris: Musée du Louvre, 1990), 32, no. 19; for the Pierpont Morgan Library drawing see *Tanzio da Varallo*, exh. cat. (Turin: Palazzo Madama, 1959), 50, no. 44, pl. 141.

Fragment from the Cassone Panel
"Shooting at Father's Corpse"

MARCO ZOPPO (MARCO DI RUGGERO)
Italian (Ferrara), 1432–78

c. 1462
Tempera on panel
20½ x 27½ in. (52.1 x 69.9 cm)
Gift of Howard Ahmanson, Jr.
M.81.259.1

PROVENANCE:
New York, Erich Gallery, by 1940.
New York, Duveen Brothers, by 1959.
Los Angeles, Howard Ahmanson.
Newport Beach, Mrs. Denis Sullivan.
Los Angeles, Howard Ahmanson, Jr.

SELECT LITERATURE:
Roberto Longhi, "Ampliamenti nell'officina ferrarese (1940)," and "Nuovi ampliamenti (1940–55)," in *Officina ferrarese* (Florence: Sansoni, 1968), 139–40, 184, figs. 327, 329.

Wolfgang Stechow, "'Shooting at Father's Corpse': A Note on the Hazards of Faulty Iconography," *The Art Bulletin* 37, no. 1 (March 1955): 55–56, fig. 1.

Eberhard Ruhmer, *Marco Zoppo* (Vicenza: Neri Pozza, 1966), 63, no. 32.

Lilian Armstrong, *The Paintings and Drawings of Marco Zoppo* (New York: Garland Publishing, 1976), 348–49, no. 4, 451, 479, fig. 10.

Marco di Ruggero, known as Marco Zoppo, was born in Cento (near Bologna) in 1432. He is documented in Padua between 1453 and 1455, during which time he was adopted as a son by noted Paduan painter Francesco Squarcione. The young Andrea Mantegna was also adopted by Squarcione but departed after a violent quarrel in 1448. Zoppo broke his adoption agreement in 1455 and fled to Venice. Vasari relates that Mantegna and Zoppo were friends; in any case Mantegna, by far the stronger artistic personality, probably had some influence on Zoppo. Both artists, however, were profoundly influenced by Donatello, who worked in Padua from 1443 to 1453. From these various sources Zoppo developed a hard-looking and linear style, typical of his time and place, which was probably softened by his experience of the art of the Bellini family in Venice. He is recorded in Bologna during 1461 and 1462 but by the end of that decade was back in Venice, where he died in 1478.

Zoppo's surviving oeuvre is relatively small, principally comprising three altarpieces, of which the *Madonna and Child with Saints* (San Clemente del Collegio di Spagna, Bologna) is still complete, while the two others, for Santa Giusta, Venice, and San Giovanni Battista, Pesaro, were dismembered and are dispersed. In addition there survive a handful of small private devotional works and manuscript illuminations and drawings, including an important group of twenty-six sheets at the British Museum in London.

The Los Angeles work is the left half of a long panel that was cut at an unknown date before 1940, probably long ago. The right half is in a private collection in Florence (fig. 20a). Only when the two parts are put together does the narrative scene with which they are decorated become clear, making their separation especially regrettable. Roberto Longhi was the first to recognize that the two panels

FIG. 20a
Marco Zoppo, *Fragment from the Cassone Panel
"Shooting at Father's Corpse,"* c. 1462, tempera
on panel, 21¼ x 26½ in. (54.0 x 67.3 cm),
private collection, Florence.

belonged together as one, in an article originally published in 1940. The size and
proportion of the whole panel indicates that it almost certainly formed the side
decoration of a cassone, a long linen or clothes chest that was a traditional marriage
gift from parents to children in Renaissance Italy. Here the meaning of the narrative
extols filial piety, an appropriate subject for a cassone.

In the museum's segment a group of standing men, somewhat eclectically and
even exotically dressed, are gathered around a more ornately dressed, kinglike
seated man who holds a scepter in one hand and seems to point in judgment with
the other. To the right, younger men wearing hose and padded costumes look at the
youth with his back turned, who seems to be the general focus of attention. A bow

and arrow are discarded at his feet, and he seems to be engaged in a dialogue with the king/judge. In the Florence segment two more young men are vigorously shooting arrows at the corpse of an old man, who is tied to a column at the extreme right. The scene takes place in an Italian Renaissance courtyard or piazza; in the background a group of spectators watches the event.

The subject is a rare one in Renaissance art and was correctly identified by Wolfgang Stechow as representing Shooting at Father's Corpse. Longhi and some other scholars had wrongly identified it as the Martyrdom of Saint Christopher. Stechow shows that the subject originated in the Babylonian Talmud and by the thirteenth century had migrated and been assimilated into a Christian context, where it became a judgment of King Solomon. The story is that in a dispute over inheritance several sons (in this case, three) are ordered by the judge/King Solomon to shoot arrows at their father's corpse. While the illegitimate or purely venal sons (depending on the version of the story) proceed to desecrate the dead body, the true son, out of respect and filial piety, refuses to do so and is awarded the inheritance. This is the moment depicted by Zoppo.

The style suggests a relatively early date in Zoppo's career, probably in the early 1460s. The wiry outlines of the figures and the beautifully observed and drawn nude form of the deceased father show Zoppo's absorption of Squarcione's and Mantegna's art, while the clear, boxlike space plotted by the squared pavement shows that he understood the new pictorial ideas that had been developed in Florence in the early decades of the century. Some of his personages are quite reminiscent of Domenico Veneziano or even Piero della Francesca, so solidly and carefully are they positioned in space.

Professor Lilian Armstrong, in an unpublished article on the Los Angeles panel, has compared the type of the figures, especially the exotically dressed man at the extreme left and the virtuous son at the extreme right, with drawings by Zoppo at the British Museum (figs. 20b and 20c). Whether or not the artist actually referred to these drawings for his painting, if they were made a little later, or if the characters in the panel and drawings were adapted from a common model is not known. Whatever the case, it is an unusual and even moving experience to be able to come so close to Zoppo's working methods, for it is rare that paintings and drawings dating from the middle decades of the fifteenth century (in themselves so rare) can be so nearly related.

Armstrong has also drawn attention to the fact that Zoppo was working on six cassone panels for the Gonzaga family in Mantua in 1462–63, a commission documented in the only surviving letter from the artist. Unfortunately there is no conclusive evidence to link the Los Angeles and Florence works with this fascinating commission, but perhaps a document will be found one day that firmly connects artist, patron, subject, and panels.

PC

Landscape at Vaucresson

ÉDOUARD VUILLARD
French, 1868–1940

c. 1907
Oil on canvas
13 x 18⅛ in. (33.0 x 46.0 cm)
Signed at lower right: E. Vuillard
Gift of Howard Ahmanson, Jr.
M.81.259.2

PROVENANCE:
England, Dean of York.
Paris, Galerie Charpentier, 1950.
London, Arthur Tooth.
Los Angeles, Howard Ahmanson.
Newport Beach, Mrs. Denis Sullivan.
Los Angeles, Howard Ahmanson, Jr.

SELECT LITERATURE:
Autour de 1900, exh. cat. (Paris: Galerie Charpentier, 1950), no. 188.

When this small painting was exhibited in 1950, it was called *Landscape at Vaucresson* and dated 1907. There is little reason to doubt the title or date, but it is not easy to identify precisely the view painted by Vuillard. The town of Vaucresson, a suburb outside Paris in the rolling hills near Versailles, was a popular escape from the city and a favored locale for Vuillard during World War I. The artist and his mother usually stayed with their intimate friends, Jos and Lucy Hessel, who lived in a number of villas at Vaucresson during these years. The gabled house nestled at the edge of the woods in the upper right of the painting may be one of them. Vuillard himself rented a villa in the town during the 1920s and 1930s, but relatively few landscapes of this small scale are known from this later period.

In 1900, one year after the disbandment of the Nabis, the avant-garde group of artists of which Vuillard was a founding member, he traveled to Switzerland, where he stayed for two years, spending time with Félix Vallotton and Odilon Redon, also charter members of the group. The occasion was something of a Nabis reunion, for they were later joined by other members, including Pierre Bonnard and K.-X. Roussel.[1] It was at Romanel, near Lausanne, that Vuillard painted a number of small landscapes, quickly and freshly realized, of the surrounding countryside and lake. These pictures, remarkable for their concentration and focus, are careful compositional studies that explore the relationship of color and line without neglecting the traditional landscape concerns of depth and atmosphere.

Upon his return to France, Vuillard continued, though infrequently, this kind of fresh landscape study. The intimate scale of *Landscape at Vaucresson* belies the complexity and sophistication with which he rendered this aspect of the French countryside outside Paris. The view is taken from a high vantage point, from a hill whose crest curves across the foreground, its sun-drenched slopes studded with rocks and bushes. From there the ground drops away from the viewer, descends to the valley floor, and then rolls up to form a gentle hill in the distance. The far side of the hill is lined by a copse of thick woods, its foliage masking several houses whose

Notes

1. Belinda Thomson, *Vuillard* (New York: Abbeville, 1988), 61, 64.

red-tiled roofs peek through in several places. The area in front of the trees is not wild countryside, but the cultivated land of the farmhouse or villa at the upper right. There are neatly divided gardens, which are patterned around a group of outbuildings and divided by a rutted path at center; a reservoir, whose pale blue surface reflects the sky; and a row of low-lying greenhouses at the right edge, evidence of the productivity of the locale.

Vuillard's sophisticated evocation of space and form is so understated that the perspective is at first difficult to read. The artist created a delicate, harmonious composition that is knitted together by the umber ground that breathes through the surface of the picture. His technique was anything but fastidious: the brushstrokes are juxtaposed haphazardly regardless of the sense of space they ostensibly define. This comes through most clearly in the trees; their contour is carved out by the pale blue dashes of the sky, which at certain points overlap the trees. The result is a collapsing of the distance between near and far and an enhancing of the sense of the painting as a pattern of color tones of equal intensity, delicately balanced.

Even at this small scale Vuillard's predilection for pattern and decoration asserts itself. Like the large decorative wall panels that had been the governing aesthetic of the Nabis—"There are no such things as pictures, there is only decoration," Dutch Nabis painter Jan Verkade had avowed in the early 1890s—*Landscape at Vaucresson* abandons conventional perspective devices, compositional focus, and clarity of subject, concerns that Vuillard had reviled when he was a student at the École des Beaux-Arts in the 1880s. He explored instead the weave of patterns suggested by the cultivated gardens and fields and the synchrony of umbers, olive greens, and terra-cotta reds that emerge throughout the composition. The resulting image has none of the impersonal traces of a formula or painterly exercise but instead strikes a sensitive balance between the aesthetic demands of the task at hand and the loving attention and delicate evocation of a familiar place, often visited and well loved.

RR

View of Vétheuil

CLAUDE MONET
French, 1840–1926

1880
Oil on canvas
31⅞ x 25⅝ in. (81.0 x 65.1 cm)
Stamped at lower right: Claude Monet
Gift of Howard Ahmanson, Jr.
M.81.259.3

PROVENANCE:

Giverny, Michel Monet.
Paris, Dr. Jean Stehelin, by 1947.
London, Wildenstein & Co. (dealer).
Los Angeles, Howard Ahmanson.
Newport Beach, Mrs. Denis Sullivan.
Los Angeles, Howard Ahmanson, Jr.

SELECT LITERATURE:

Daniel Wildenstein, *Claude Monet: Biographie et catalogue raisonné* (Lausanne: La Bibliothèque des Arts, 1974), 1:372, no. 603.

Late in the summer of 1878 Claude Monet, his wife, Camille, and their two sons, Jean and Michel, moved to the village of Vétheuil on the banks of the Seine, between Mantes and Vernon to the northwest of Paris, "a ravishing place" as Monet called it in a letter of September 1 to his friend, the collector Eugène Murer. Situated conveniently near Paris, the village was nestled between hills on a sweeping curve of the river and was edged with small wooded islands. Much more rural in aspect than the increasingly suburban village of Argenteuil whence the Monets had moved, Vétheuil, with its hills, meadows, woods, and river islands, offered much pictorial variety to Monet. Driven in part by financial necessity, the Monets shared a house with their friends Ernest and Alice Hoschédé and the Hoschédés' six children. The three years at Vétheuil were productive ones; Monet began by selling views of the village and the Seine to such supportive friends as painter Gustave Caillebotte, critic Théodore Duret, and doctor Georges de Bellio.

These few years following the artistic, if not financial, success of Monet's seminal Argenteuil period were a time of crisis for the painter. In addition to his financial difficulties Monet distanced himself from the other impressionist painters; it was only out of financial necessity and a certain sense of obligation that he agreed to contribute to their fourth group exhibition in April of 1879. In 1880 he finally broke with the other impressionists and succeeded in exhibiting at the Salon rather than with his old colleagues at their fifth group show. In these years Monet relied less and less on the income earned from works sold cheaply to a few understanding supporters but allowed dealer Paul Durand-Ruel to manage his affairs. There was a domestic crisis too. Ever since the move to Vétheuil, Monet had been confiding in letters to Dr. de Bellio his concern for the health of Camille, which had been poor since the birth of Michel in March of 1878. Her untimely death in September of 1879 was a great blow. That autumn Monet did not paint much outdoors but concentrated on still lifes of flowers, fruits, and dead game.

The winter of 1879–80 was one of the hardest ever known in the Paris region, so cold that the Seine froze over completely. The breakup of the ice in January and the resulting floes on the river inspired a remarkable series of paintings by Monet. Their bleak beauty has sometimes been associated with his state of mind during this period of mourning for Camille. Nothing the artist said or wrote confirms this, however. If there is any truth to the story, then perhaps the following spring, when the museum's painting was probably executed, the artist was coming out of his misery and enjoying a sense of emotional warmth and the promise of renewal. Alice Hoschédé, who was eventually to become Monet's second wife, was already occupying a more significant place in his life.

View of Vétheuil is a panoramic landscape, where the artist looks down from a nearby hillside to the village by the river and then across to the far hills. There is a rich variety of brushwork, which conveys a sense of the sun dancing across the landscape, while flecks of warm color suggest the first flowers of spring. This painting remained in Monet's possession until his death and passed with his estate to Michel Monet. Before the son placed it on the market, it was given the stamped studio signature at lower right. The work is a typical example of Monet's art at this transitional phase of his career, between his pioneering years at Argenteuil and the more settled artistic and personal life he was soon to enjoy at Giverny from the early 1880s onward.

PC

A Norman Milkmaid at Gréville

JEAN-FRANÇOIS MILLET
French, 1814–75

1871
Oil on cardboard
31½ x 21⅞ in. (80.0 x 55.6 cm)
Gift of Howard Ahmanson, Jr.
M.81.259.4

PROVENANCE:

Paris, Paul Durand-Ruel (dealer), 1871.

Paris, Laurent Richard Collection, by 1878.

New York, Mr. J. M. Rhodes, 1902.

New York, Paul Durand-Ruel (dealer), 1902.

New York, Charles M. Schwab, 1902.

New York, sale, Tobias, Fischer and Co., 24 April 1940, no. 49 (bought in?).

Westport, Connecticut, Edward H. Schwab, 1940.

New York, Kleinberger Galleries, 1941.

Boston, Vose Gallery, 1942.

Boston, Robert C. Vose, Jr., 1942.

New York and London, John Nicholson (dealer), 1943.

London, Arthur Tooth Gallery, 1957.

Los Angeles, Howard Ahmanson.

Newport Beach, Mrs. Denis Sullivan.

Los Angeles, Howard Ahmanson, Jr.

SELECT LITERATURE:

Étienne Moreau-Nélaton, *Millet raconté par lui-même* (Paris: Henri Laurens, 1921), 3:71, 126, 129, fig. 269.

Robert L. Herbert, "'La laitière normande à Gréville' de J.-F. Millet," *La revue du Louvre* 30, no. 1 (1980): 14–20, fig. 13.

In the summer of 1870 Jean-François Millet decided to take his family and flee the troubled atmosphere of the Paris region during the upheavals of the Franco-Prussian War. He returned to his birthplace, the hamlet of Gruchy at the village of Gréville in Normandy. Millet had been living in Paris and at the village of Barbizon in the Forest of Fontainebleau more or less continuously since the late 1830s. He had been back to Gréville only occasionally during those years, in 1844, 1845, and in 1853, when his mother died. The longer visit of 1870–71 was a moving one for the artist. It brought back many memories, as he saw again the simple and rugged places of his childhood, the green fields and hills, stone walls and ancient cottages, geese and sheep, and peasant population of this remote corner of France overlooking the Atlantic.

A Norman Milkmaid at Gréville was inspired by this return to the scenes of Millet's childhood. It shows a solidly built peasant girl wearing homespun clothes and wooden shoes carrying on her back a *canne* (urn) full of milk; the vessel is sealed with bunches of leaves. This type of urn was typical of the region; Millet had proudly inherited a couple from his mother. The weight of the milk container can be sensed through the tension of the cord that is wrapped around the girl's forearm and passes over her capped head to the handle of the jug. She has carefully balanced

her body, with her left hand on her hip to take the weight. The milkmaid is coming down a path that winds across a gently sloping hillside. She is partially silhouetted against a sunset sky, but there is enough ambient light to make out the features of her face and costume and to allow the artist to model her form fully in the round. She is monumental in appearance, not only because she is posed against the sky, but also because the viewer is placed quite low in relation to her advancing figure. By conceiving the milkmaid in this simplified, monumental, and dominating way, Millet idealized and gave grandeur to someone whose life on the land must really have been one of hard toil. The burden of her daily round is clear, but at the same time it is presented with integrity, dignity, and even nobility.

Millet treated the theme of the milkmaid several times throughout his career; Robert Herbert has discussed the different versions fully in the article cited above. He reproduces a lost drawing of the early 1840s, which was Millet's first attempt at the subject early in his career, when he was interested in rococo art. It shows a rather blowsy female, a descendant of the flirtatious types depicted by Boucher and Fragonard in the eighteenth century. Around 1848, however, a year of revolution and social upheaval in France, Millet began to treat rural and peasant themes in a more realistic way. Works such as his famous *Winnower* (National Gallery, London), shown at the Paris Salon of 1848, mingle his sympathy for country folk, a certain anger at their lives of relentless toil, and an admiration for their stoicism, dignity, and moral rectitude. There is no doubt where his sympathies lay, so moving are his images of rural labor.

After 1849 Millet spent most of his time at the village of Barbizon, away from the venalities of Paris and closer to nature and the humble shepherds and woodcutters of Fontainebleau. He was one of a group of artists, known as the Barbizon School, who turned their backs on official academic art, the quarrels of Classicists and Romantics, and petty bourgeois genre scenes. Painters such as Millet and his friends Narcisse Virgile Diaz, Charles-Emile Jacque, and Théodore Rousseau wanted to bring some of the authenticity of nature into their works. Although their art was challenging and radical in 1848–49 and took quite a few years to find acceptance in official artistic circles in France, it soon found a sympathetic audience among thinking people who came to admire these images of rural life at a time when industrialization and urban expansion were beginning to change traditional values and ways of living.

A Norman Milkmaid at Gréville probably came to the United States in the last decades of the nineteenth century, although there is no documentary evidence to support this. The Frenchman Paul Durand-Ruel, who acted as agent for the painting in 1871 and 1902, had been a well-known dealer in Paris since the 1860s and in New York since 1888. It was Easterners, above all Bostonians, who were Millet's principal supporters during his lifetime, and his reputation was certainly well established in America by the early 1870s, owing in large part to the help of Durand-Ruel.

In 1848 or 1849 Millet made a series of drawings of milkmaids, leading to a small oil painting that is now in the Princeton University Art Gallery. Although small in scale, it is in his new, more realistic manner. The design anticipates the Los Angeles picture, except that the earlier worker is turned the other way and holds the supporting thong in her hand rather than wrapping it around her forearm. Millet

returned to the theme again between 1851 and 1853, notably in an oil that shows the milkmaid returning by moonlight (University of Birmingham, Barber Institute of Art). In another painting done in the early 1860s (Palazzo Communale, Milan), Millet shows the girl for the first time carrying the traditional Norman canne, identifiable because of its side handle; this milkmaid walks home in the cool and misty light of early morning. In 1874, the year before his death, Millet painted his last *Milkmaid* (Louvre, Paris); it is an unfinished picture, in his somber late manner, where the worker has an almost tragic air of grandeur. She is shown in a rather sketchy form against a strong sunset sky. It is a haunting image, perhaps rendered the more moving because it is known to be one of Millet's last works.

PC

Saint Michael Casting Satan into Hell

CIRCLE OF DOMENICO ANTONIO VACCARO

Italian (Naples), 1680–1750

c. 1705–25
Polychrome wood with glass
52½ x 27¼ x 24¾ in.
(133.4 x 69.2 x 62.9 cm)
Gift of The Ahmanson Foundation
M.82.7

PROVENANCE:

Spain, probably gift of the Viceroy of Naples to his daughter in the Convent of the Religiosas Agustinas in Salamanca.

Spain, Convent of the Religiosas Agustinas until 1938.

Spain, private collection.

Lugano, Silvano Lodi, and Rome, Enzo Costantini (dealers).

SELECT LITERATURE:

Antonio García Boiza, *La iglesia y convento de MM. Agustinas de Salamanca*, Filosofía y Letras, vol. 1, no. 1 (Salamanca: University of Salamanca, 1945), 31 (also illustrated).

Alvar González-Palacios, "Un capolavoro della plastica napoletana barocca," *Antologia di belle arti*, n.s. nos. 21–22 (1984): 118.

Alvar González-Palacios et al., *Civiltà del seicento a Napoli*, exh. cat. (Naples: Electa, 1984), 226, 318–19 (as Francesco Picano).

Alvar González-Palacios, *Il tempio del gusto: Le arti decorative in Italia fra classicismi e barocco* (Milan: Longanesi & Co., 1984), 1:206, fig. 473, 268 (as Francesco Picano).

Ursula Schlegel, *Die italienischen Bildwerke des 17. und 18. Jahrhunderts, Erwerbungen von 1978 bis 1988* (Berlin: Mann, 1988), 64 (as Francesco Picano).

This multicolored, gilded wood sculpture, ornamented with bits of inset glass, is composed of forty pieces; the flames and rocks of the base are only roughly joined. It comes from the Convent of the Religiosas Agustinas in Salamanca, whose collections were dispersed during the Spanish Civil War. This convent was founded by the Count of Monterrey, Viceroy of Naples, who was said to have made a gift of the *Saint Michael* when his daughter became a member of the religious community.[1] The sculpture represents the climax of the "war in heaven" recounted in Revelation 12:7–9, in which the Archangel Michael defeats the legions of rebel angels led by Satan and casts them out of heaven.

This cosmic battle has long exercised a particular fascination for the visual arts, inspiring some of the great masterpieces of European painting and sculpture. Two of the most significant examples are Raphael's painting commissioned for François I (1518, Louvre, Paris) and the over-life-size bronze by Hans Reichle (1603–6, Augsburg Arsenal). During the Counter-Reformation, Saint Michael's victory was represented with increasing frequency, as it symbolized the triumph of the Catholic Church over heresy. It could be understood further as a universal allegory of virtue overcoming evil, with the archangel's celestial beauty overwhelming the monstrosity of Satan, who was represented from Raphael's time onward less as a dragon, as he is referred to in Revelation, than as a demon with human features.

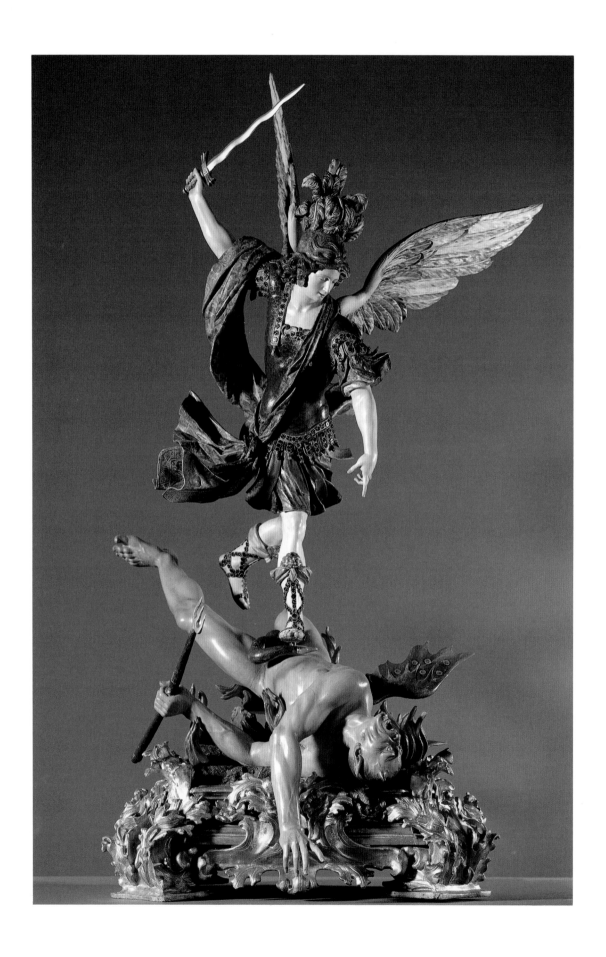

FIG. 24a
Gian Domenico Vinaccia, *Saint Michael with the Dragon*, 1691, silver, dimensions unavailable, Treasury of San Gennaro, Naples. Photo: Alinari/Art Resource.

FIG. 24b
Attributed to Lorenzo Vaccaro, *Saint Michael Defeating Satan*, 1685–1700, silver, silver-gilt, and wood, h: 26 in. (66.0 cm) with base, Staatliche Museen, Berlin (inv. no. 21–78).

It was surely one, if not two, paintings by the Neapolitan artist Luca Giordano together with the altarpiece by Guido Reni in Santa Maria della Concezione in Rome (before 1636) that set a formal prototype for representations of the metaphysical adversaries in southern Italy, where the subject was treated over and over again in the seventeenth and eighteenth centuries. Giordano's two pictures are preserved today in Berlin (probably 1684, Staatliche Museen) and Vienna (late 1650s, Kunsthistorisches Museum); the Vienna painting portrays a Saint Michael that may easily have been a direct inspiration for the saint in the Los Angeles sculpture.[2]

Saint Michael was declared one of the patron saints of Naples in 1691. In that year the Congregazione dei Settantatrè Sacerdoti of the parish of San Gennaro commissioned a silver statue of Saint Michael overcoming the dragon for the Treasury of San Gennaro (fig. 24a). Although there is still some question about its authorship, it is usually given to Lorenzo Vaccaro (1655–1706).[3] On the basis of this attribution a related series of slightly smaller silver statuettes of Saint Michael overcoming Satan (Staatliche Museen, Berlin, fig. 24b; Germanisches National-museum, Nuremberg; art market, Munich; and Museo Municipal, Salamanca) has also been attributed to Lorenzo or his son Domenico Antonio Vaccaro.[4] Of these it is the example in Salamanca that relates most directly to yet another, grander version in silver in the Rothschild Collection (Paris), which is in turn virtually identical, but for its material, to the Los Angeles *Saint Michael*.

Alvar González-Palacios has written that the Los Angeles sculpture is a copy of the Rothschild silver and is that which is mentioned in a document of 1705. This document records a commission to the otherwise little-known Neapolitan sculptor Francesco Picano to make a polychrome wood "Saint Michael and the Dragon" after a model by Lorenzo Vaccaro.[5] Consequently the Rothschild group would be considered the original by Lorenzo Vaccaro. However, this document refers precisely to a Saint Michael overcoming a dragon, not Satan. Notwithstanding this, Ursula Schlegel has supported the attributions proposed by González-Palacios.[6]

Notes

1. González-Palacios (*Il tempio del gusto*, 1:268), citing García Boiza, states that it was a gift of the nephew of the viceroy, while in an undated letter to Peter Fusco, Manuel González-López writes that the nuns who sold the sculpture in 1938 told the new owner that a viceroy gave it to the convent when his daughter joined their community.

2. Erich Schleier, "Der Heilige Michael: ein unbekanntes Hauptwerk Luca Giordanos," *Pantheon* 29, no. 6 (November/December 1971): 510–18.

3. Elio and Corrado Catello, *La cappella del tesoro di San Gennaro* (Naples: Banco di Napoli, 1977), 84, 146, n. 92. Gian Domenico Vinaccia, one of Lorenzo Vaccaro's main competitors, carried out the commission. The authors emphasize that this occurred at a time when Vinaccia was in open discord with Vaccaro, and that Vinaccia always used his own models. González-Palacios, followed by Schlegel, attributes the model for the San Gennaro sculpture to Lorenzo Vaccaro, although González-Palacios believes the original design to be by Luca Giordano (see note 7).

4. Ferdinando Bologna, "A Silver Sculpture Ascribed to Domenico Antonio Vaccaro," *The Burlington Magazine* 121, no. 913 (April 1979): 220–25. Bologna attributes the Berlin statuette to Domenico Antonio Vaccaro; the Munich and Nuremberg examples to his studio. See González-Palacios, "Domenico Antonio Vaccaro's St Michael?" *The Burlington Magazine* 121, no. 917 (August 1979): 516, fig. 64, 518, for the Salamanca sculpture and a rejection of Bologna's attributions. Schlegel, 64, attributes the Berlin statuette to Lorenzo Vaccaro.

5. González-Palacios, *Il tempio del gusto*, 1:268. The San Gennaro sculpture represents Saint Michael and the Dragon.

6. Schlegel, 64.

7. González-Palacios, "Un capolavoro della plastica napoletana barocca," 122; *Il tempio del gusto*, 1:266–67. In the latter González-Palacios suggests attributing the original design to Luca Giordano, the model to Lorenzo Vaccaro, and the execution of the finished sculpture to Vinaccia.

8. Franco Mancini, *Il Presepe napoletano: nella collezione Eugenio Catello*, Forma e Colore, no. 47 (Florence: Sadea, 1961), 1.

9. Schlegel, 62.

10. Mancini, 2.

The San Gennaro *Saint Michael with the Dragon* is of capital importance for the attribution of the Rothschild and Los Angeles sculptures.[7] The elongated torso, idealized features, morphology of the wings, and pose (in particular the position of the left arm, its downward gesture rationalized but obscured by the Archangel's shield, absent from the Rothschild and Los Angeles figures) demonstrate that it must be directly related to these two sculptures. However, their more open compositions and delicate proportions would suggest a date somewhat later than 1691. The style of the Los Angeles *Saint Michael* points directly to the exquisite delicacy so characteristic of the Neapolitan rococo of the succeeding century.

Furthermore, the museum's *Saint Michael* is related to another type of sculpture whose full flowering occurred in Naples in the eighteenth century, the crèche figure. These doll-like figures are made up of components of polychromed carved wood or terra-cotta, which were assembled and articulated with hinges, then padded and dressed in fanciful fabrics and trimming. Grouped together, they made fabulous tableaux vivants, usually representing the Nativity.[8] In her analysis of the Berlin *Saint Michael*, Schlegel discusses how the silver statuettes can be understood in terms of the production of Neapolitan crèche figures: the silver sculptures too are assembled from numerous components (some of which are cast from the same mold) with varying degrees of finish and sometimes gilded or combined with a different material (bronze, for example) for coloristic effects. Thus, Schlegel writes, the statuettes resemble the crèche figures not only in technique but also in principle.[9] It is worth noting in this context that crèche figures were also commissioned by the aristocracy and from major artists, among them Giuseppe Picano and Lorenzo Vaccaro.[10] Having originated as popular art, they became court art as well. This correspondence between the crèche figures and the silver statuettes should be contemplated with special regard to the Los Angeles *Saint Michael* because it too is made of many components and because it may be a replica in polychrome wood of a silver group, the Rothschild *Saint Michael Overcoming Satan*.

Indeed the splendor of a Saint Michael in silver would in any circumstances but those found in Naples around 1700 make it unlikely that it would have a wood twin of equal beauty. Naples, however, had a long tradition of polychrome wood sculpture, and this tradition survived, intact but brilliantly transformed at a level of sophistication rivaling that of the arts in more noble materials. Rarely has this achievement been shown to greater advantage than in the museum's *Saint Michael*, where a composition of twirling pinwheels, lightly stabilized, has been colored as in a kaleidoscope and touched with jewels of glass.

MLL

The Death of Lucretia

LUDOVICO MAZZANTI
Italian (Rome), 1686–1775

c. 1735–37
Oil on canvas
71 x 56 in. (180.3 x 142.2 cm)
Gift of The Ahmanson Foundation
M.82.75

PROVENANCE:

Probably Naples, Prince of Aragon.
New York, Walter P. Chrysler Collection.
New York, private collection.
New York, Rejaee Collection.
New York, Christophe Janet (dealer).

SELECT LITERATURE:

Paola Santucci, *Ludovico Mazzanti (1686–1775)* (L'Aquila: Japadre Editore, 1980), 119, no. 60, 169–70.

Very little is known about Mazzanti's life and career, but he was evidently a very successful and esteemed artist, having been granted the papal title of *cavaliere*, awarded to only the most outstanding artists, as well as the title of *conte*, possibly by the Grand Duke of Tuscany. In 1744 he was elected a member of the exclusive Academy of Saint Luke. Born in Rome, Mazzanti was apprenticed at a very young age to the great decorative painter Giovanni Battista Gaulli. Gaulli's style combined the precocious baroque elements of Correggio, the sixteenth-century Emilian painter, with the refined classicism of Carlo Maratta, Gaulli's contemporary, influences that are felt in the early works of Mazzanti, such as his *Assumption of the Virgin*, painted for the ceiling of Sant'Ignazio in Rome. Mazzanti worked primarily in Rome and Viterbo but made two extensive trips to Naples, from 1726 to 1731 and from 1733 to 1737, where he worked with Francesco Solimena.

The Death of Lucretia was unknown in the scholarly literature before its appearance on the art market and acquisition by the museum. Mazzanti's notebook of 1770, preserved in the archive in Orvieto, lists a "Suicide of Lucretia" in the collection of the Prince of Aragon, along with several other works by the artist, including a "Sacrifice of Hercules," which may have been a pendant to the Lucretia. The notebook mentions a second painting of Lucretia, "painted in Naples," belonging to the Sciviman family in Venice. It seems entirely likely that these two pictures refer to the Los Angeles work and another of Lucretia, now in the Crocker Art Museum in Sacramento (fig. 25a).[1]

The two versions are very similar in composition and details, although the Los Angeles painting is considerably larger and the head of Lucretia is more sharply turned to the left in it than in the painting in Sacramento. The latter also includes a statue of a draped figure in a niche in the left background. The exact relationship between the two variants is uncertain, and it is not clear which one Mazzanti painted first. The Los Angeles painting is more finished in execution, its composition better resolved, suggesting that it came after the Crocker version. The Sacramento picture seems too large to be considered a *modello*, however.

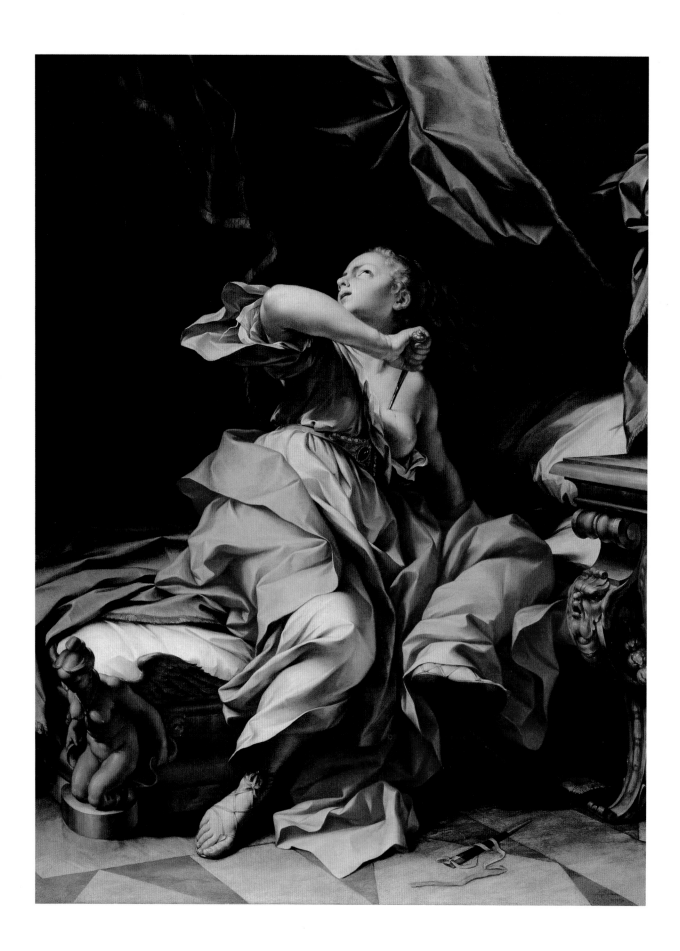

FIG. 25a
Ludovico Mazzanti, *The Death of Lucretia*,
c. 1735, oil on canvas, 39⅛ x 29¼ in.
(99.4 x 74.3 cm), copyright 1872, Crocker
Collection, Crocker Art Museum, Sacramento,
California (CAM 1872.349).

Notes

1. Santucci, 169–70; Roger D. Clisby, *Crocker
Art Museum Handbook of Paintings* (Sacramento:
Crocker Art Museum, 1979), 43–44, 119,
no. 42.

2. Santucci, 113, fig. 50.

If the Prince of Aragon commissioned the painting now in Los Angeles, it was most likely during the artist's second sojourn in Naples. The crisp, fluttering draperies, upraised elbow of Lucretia, and difficult perspective of her head closely relate to figures in the *Expulsion of Heliodorus*, which Mazzanti painted in the Neapolitan Church of the Girolomini in 1736, when he was under the influence of Solimena. Moreover the painting compares very closely in the disposition of the figure and the nature of the setting and its furnishings to Mazzanti's *Joseph and Potiphar's Wife* (private collection, Rome), which Santucci dates to the years 1738–40.[2]

Lucretia was the wife of Tarquinius Collatinus, one of the commanders of the tyrannical King Tarquinius Superbus, who ruled Rome. Collatinus boasted of his wife's virtuousness and faithfulness, in contrast with the foolishness and unchasteness of the wives of his kinsmen. Smitten by Lucretia's great beauty and industry, Sextus Tarquinius, the king's son, stole into her bedchamber and raped her at knife-point. The next morning Lucretia summoned her father and husband and, after demanding that they avenge her honor, stabbed herself to death. Outraged, Collatinus and his comrades were inspired to drive out the evil king, laying the foundations for the Roman republic.

Mazzanti depicts Lucretia's death on an epic scale suitable to the story. Her monumental figure, posed in dramatic contrapposto, dominates the composition. The heroine twists in agony, turning her head to the heavens as she plunges the dagger into her breast. The viewer's sense of her agitation is increased by the electric folds of the draperies, which crackle about her form as if driven by a swirling wind. Yet in Mazzanti's rendition of the story almost all of Lucretia's moral righteousness and heroic self-sacrifice is hidden beneath a veneer of sexual allure. The artist eroticizes the story by painting an attractive Lucretia, en déshabillé, in a provocative and inviting setting. The bed on which she was assaulted is covered with billowing robes and plump pillows; the furniture boasts a sculpted harpy and a leering satyr head. Rather than emphasizing the social and political ramifications of Lucretia's action, the painting concentrates on the seductive charms of the woman's great beauty. Lucretia is cloistered alone in her bedroom, where her suicide is enacted in a personal rather than public context.

Mazzanti's painting, like most depictions of the story in Renaissance and baroque art, treats the fate of Lucretia more for decorative than didactic purposes. The closest prototype for this full-length Lucretia is Guido Reni's large *Death of Lucretia* in the Neues Palais in Potsdam. In the eighteenth century educated patrons like the Prince of Aragon and his intimates would have been familiar with Lucretia's tragic story but also drawn to such a painting for its dynamic composition, the intrinsic beauty of its painted surface, and its appeal to certain tastes in eroticism.

At the same time, however, Mazzanti reveals a certain sympathy for the heroine. For all the lurid references to the rape, Lucretia is shown as assertive and bold as she prepares to die for her principles. In the sensitive depiction of her face Mazzanti has, perhaps more than most artists, attempted to evoke her conflicting feelings as she turns to the gods for strength.

RR

Study of an Oriental Head for "The Marriage at Cana"

GAETANO GANDOLFI
Italian (Bologna), 1734–1802

c. 1766–75
Oil on canvas
19 x 13¹⁵⁄₁₆ in. (48.3 x 35.4 cm)
Gift of The Ahmanson Foundation
M.82.199

PROVENANCE:
Italy, private collection.
London, Matthiesen Fine Art Limited (dealer).

SELECT LITERATURE:
Unpublished.

Gaetano Gandolfi was the most talented member of a family of artists that dominated Bolognese painting in the second half of the eighteenth century. Early in his life he studied with his elder brother, Ubaldo; he later was a pupil of the sculptor-anatomist Ercole Lelli at the Accademia Clementina in Bologna. In 1760, under the auspices of an important early patron, Bolognese merchant Antonio Buratti, Gaetano and Ubaldo traveled to Venice for a further year of study. In Venice, Gaetano was deeply impressed by the art of Sebastiano Ricci and Giovanni Battista Tiepolo, painters whose fluent brushwork and effortless technique had a dramatic impact on his art.

Upon his return to Bologna, Gaetano soon established himself as the city's leading painter and began what would be a long and productive career. He produced altarpieces and frescoes for the Church and the Bolognese aristocracy but was best appreciated for his drawings and oil sketches; he also executed a small number of etchings.

The unpublished *Study of an Oriental Head* shows Gandolfi at his most accomplished, as a painter of loose and spontaneous oil sketches. The painting was produced in conjunction with one of the artist's major commissions, the monumental *Marriage at Cana*, which was painted for the refectory of the convent of San Salvatore in Bologna and is now in the Pinacoteca Nazionale, Bologna (fig. 26a). This painting, dated 1775 and measuring about twenty-two feet across, occupied the artist for some ten years. The Los Angeles oil sketch (along with three preparatory drawings and a *modello*, the latter which is now in the Walters Art Gallery, Baltimore) is one of several studies made for the larger work.[1]

One of the artist's most ambitious productions, the painting for San Salvatore contains more than forty figures situated in an elaborate architectural setting. The focus of the composition is the resplendent figure of Christ, whose gesture to the stewards across the table changes the water in their amphorae into wine. To guide him in his elaborate design, Gandolfi turned to the Venetian paintings he had studied earlier, basing this composition on Veronese's famous *Feast in the House of Levi* in the Accademia in Venice. Gandolfi drew inspiration as well from such contempo-

Notes

1. Federico Zeri, *Italian Paintings in the Walters Art Gallery* (Baltimore: Walters Art Gallery, 1976), 2:552–53, no. 442, pl. 289.

raries as Ricci and the French expatriate Pierre Subleyras. Around the table where Christ performs his miracle, Gandolfi posed his figures in a great variety of positions, creating something of a summa of academic pose, gesture, and anatomical fore-shortening, demonstrating the proficiency with which he understood the principles of history painting. For all its ambition, however, *The Marriage at Cana* leaves the viewer somewhat cold, so high-blown is its drama and spectacular its effects.

More sympathetic are the individual reactions that Gandolfi painted on the faces of the witnesses to Christ's miracle. The artist must have explored these expressions in drawn and painted studies, but only the museum's example has surfaced. It depicts the head of the turbaned Oriental who stands at the far left of the composition, looking quizzically at Christ as he performs the transubstantiation. These types of exotic characters were invariably included in such scenes for local color; Gandolfi's observer is very similar to the one that appears in Subleyras's *Banquet in the House of Simon the Pharisee*, painted in 1737 for the monastery at Asti and now in the Louvre in Paris. Concentrating on the single head allowed Gandolfi to free himself from the fussiness and preciosity that characterizes the final painting. With his brush loaded with paint, he carved out the form of the head from the dark background, a few long brushstrokes created the folds of the turban, and the flowing beard was made palpable by leaving a rich impasto. The composition is held together by the craggy hand, half in shadow, which juts in from the lower right.

The oil sketch may have been a preliminary study through which Gandolfi investigated the particular reaction of this old man, whose sense of doubt may be lessening under the bright light of Christ's halo. It may well be, however, that this "study" was created after the large picture was finished. As a composition it works extremely well in its own right, and as a genre type it follows a tradition of paintings of wizened old men produced by artists from Rembrandt to Ricci. The aged Oriental is certainly one of the most successful figures in *The Marriage at Cana*, and Gandolfi might have wished to exploit the energies and ideas that he expended on the commission by reusing its best parts. As an individual painting the *Study of an Oriental Head* would have found a sympathetic audience in those amateurs who appreciated a good, fired-off sketch that showed the painter at his most creative and spontaneous.

RR

Fig. 26a
Gaetano Gandolfi, *The Marriage at Cana*, 1775,
oil on canvas, 208¹¹/₁₆ x 267⁵/₁₆ in. (530.0 x
679.0 cm), Pinacoteca Nazionale, Bologna.

Piazza San Marco Looking South and West

CANALETTO (GIOVANNI ANTONIO CANAL)
Italian (Venice), 1697–1768

1763

Oil on canvas

22¼ x 40½ in. (56.5 x 102.9 cm)

Signed on back: Io Antonio Canal, detto il Canaletto, fecit. 1763.

Gift of The Ahmanson Foundation

M.83.39

PROVENANCE:

England, the Honorable Mrs. John Ashley, by 1906.

London, Duveen Brothers (dealer).

New York, William P. Clyde sale, American Art Association, 25 March 1931, no. 148.

Bound Brook, New Jersey, Dr. Benjamin Borow.

New York, sale, Sotheby's, 27 March 1963, no. 83 (withdrawn).

London, sale, Sotheby's, 30 June 1971, no. 98.

London, Herner and Wengraf (dealer).

Milan, Nehmad.

Possibly Zurich, Dino Fabri.

London, sale, Sotheby's, 1 November 1978, no. 50 (bought in).

London, Harari & Johns Ltd. (dealer).

SELECT LITERATURE:

W. G. Constable, *Canaletto*, 2d ed., rev. by J. G. Links (Oxford: Oxford University Press, 1976), 2:210–11, no. 54*.

J. G. Links, *Canaletto* (Ithaca: Cornell University Press, 1982), 206–7, pl. 198, 209, 211.

André Corboz, *Canaletto: Una Venezia immaginaria* (Milan: Alfieri Electa, 1985), 2:740, no. P451.

Katharine Baetjer and J. G. Links, *Canaletto*, exh. cat. (New York: Metropolitan Museum of Art, 1989), 14, 53, 62, 274–75, no. 84.

This view is taken from the Campo San Basso, at the side of the Church of San Marco, the arches of which appear at the extreme left in the painting. In this extraordinary panorama of the Piazza San Marco, Canaletto has sewn together several viewpoints, leaving the observer with a virtually encyclopedic rendering of Venice's most famous square. Through the arch of San Marco is a view across the Piazzetta to the column of Saint Theodore and the lagoon beyond; from there the eye sweeps across the twin facades of the Library and the Procuratie Vecchie, one in brilliant sunlight, the other in shadow, at the apex of which stands the Campanile of San Marco. At the far end of the Piazza is the facade of San Geminiano, followed by the Procuratie Nuove, its dramatic length broken by the shadow of the Campanile. The composition culminates with the Torre dell'Orologio, sparkling in sunlight in the right foreground. Throughout the Piazza, Canaletto has painted the strollers, tourists, merchants, and children who always populate his pictures and who serve to draw the eye in and around the scene.

One of Canaletto's last paintings, *Piazza San Marco Looking South and West*, with its all-encompassing composition and fulsome detail, was the culmination of the artist's forty-five-year career as the most brilliant and admired Venetian *veduta* (view) painter. The natural beauty of the Venetian topography had always been an inspiration to artists, and the cityscape frequently appeared as backdrops in the pictures of earlier artists such as Gentile Bellini, Vittore Carpaccio, and Jacopo

FIG. 27a
Canaletto, *Mestre*, c. 1742, etching, 17 ¾ x
22¼ in. (45.1 x 56.5 cm), Los Angeles County
Museum of Art, gift of The Ahmanson
Foundation (M.85.118).

Tintoretto. In the late seventeenth century there arose a tradition of view painting
that took as its primary subject matter the depiction of Venice and Venetian life.
The first successful practitioners of this new category of painting were Gaspar van
Wittel and Luca Carlevaris. In the eighteenth century Canaletto developed and
perfected view painting, eventually becoming famous throughout Europe.

The artist was born in Venice in 1697; at an early age he was apprenticed to his
father, a theater set designer. Canaletto made a trip to Rome in 1719 but was back
in Venice the next year, where he was listed as a painter. From very early on in his
career he was patronized by foreign art collectors and visitors to Venice; he was
especially popular in the 1720s and 1730s with British collectors who visited the city
as part of their grand tour. Canaletto's paintings served as beautiful and valuable
souvenirs of their trip. These tourists were encouraged in their purchases by
expatriate businessmen and art collectors Owen McSwiney and Joseph Smith. Such
transactions hastened Canaletto's growing reputation abroad; by the mid-1740s,
however, English demand for his pictures had diminished and the artist felt it
necessary to diversify his repertoire by painting capriccios, whimsical pictures that
combined fanciful elements with topographical sites. During this period Canaletto
also produced a large number of etchings, which reached a wide audience. His
view of Mestre (fig. 27a) demonstrates his fine skills as a draftsman, and its wide-
open vista shares the perspectival complexity of his paintings.

In 1746 Canaletto traveled to London, where his career was given a boost by such
illustrious patrons as the Duke of Richmond and Sir Hugh Smithson (later Duke of
Northumberland); for them and others Canaletto painted views of the city as well
as of their country seats. Canaletto stayed in England for ten years, producing both
veduta paintings and capriccios, and was a profound influence on a generation of
British view painters like Samuel Scott and William James.

Canaletto returned to his native city in 1756 and was eventually elected to the
Venetian Academy in September of 1763, after having been passed over the previous
January. The same year he painted *Piazza San Marco Looking South and West*, inscribing
the back, "Io Antonio Canal, detto il Canaletto, fecit. 1763." (I Antonio Canal, called
Canaletto, made this. 1763.). This unusually formal inscription suggested to J. G.
Links that the artist had intended to present the painting to the Academy as his
reception piece. No doubt the academicians deemed a view painting unacceptable,
for Canaletto evidently withdrew the painting, instead presenting, two years later,
the more fanciful *Capriccio: A Colonnade Opening on to the Courtyard of a Palace*, which
still hangs in the Gallerie dell'Accademia in Venice.[1]

Academic prejudice may indeed have played a role in Canaletto's decision to
withdraw the *Piazza San Marco*. As a "mere" recording of nature, an ostensibly
objective veduta painting, in contrast with a morally elevating picture in the
historical genre, would have been viewed with skepticism by members of the
Academy. A capriccio, however, was closer to the academic ideal of painting
as a liberal art, since it relied on the artist's powers of invention and creative
manipulation of motifs.

The irony is that Canaletto's view paintings are rarely, if ever, objective
representations; he invariably rearranged actuality for aesthetic purposes. As André
Corboz has demonstrated in his monumental study of Canaletto's oeuvre, the

Notes

1. Links, 193, pl. 188, 209, 211.

2. Ibid., 103–6, fig. 93.

3. Ibid., 17–19, fig. 11.

4. Constable, 2:208–10, nos. 53–54.

painter continually took liberties with the topography of the city in order to better compose his pictures or to include a larger number of Venice's popular sights. His capriccios of Venice, in which he whimsically repositioned such landmarks as the flagpoles or the horses of San Marco, are only the most obvious examples of what was always, in the end, an imaginative and provocative reimaging of the city.

In *Piazza San Marco* Canaletto did not rearrange the scene as much as he simply included more than the human eye could possibly see from the northeast corner of the square. The painter conflated two of his most popular views, the Piazza looking west and the Piazzetta looking south, into one grand picture. In the process he amplified the Piazza so that it became a vast plain, stretching sublimely to the horizon, dotted with innumerable passersby. The spectator is thus presented with several viewpoints and multiple points of interest, and the effect of looking at (and around) the picture is akin to the experience of the tourist in the square itself, whose eye continually moves in response to the multitude of sights and sounds. As if to remind the onlooker of the capricious nature of the picture, Canaletto painted weeds and moss growing from the arches of San Marco.

The extent to which Canaletto employed the aid of mechanical devices and optical instruments to create these spectacular views has caused undue debate. In the Museo Correr in Venice there is a small camera obscura upon which is written Canaletto's name, and several eighteenth-century sources mention him as having used this primitive instrument as a guide to framing his views.[2] Logic demands that Canaletto's interest in perspective and optical phenomena would have led him to experiment with such a device; the panoramic view of the *Piazza San Marco* is akin to that seen through a wide-angle or fish-eye lens. Nevertheless by this time in his life Canaletto was wholly adept at perspective, a science he had long ago mastered in his father's theater design studio. As Links has shown, the perspectival dynamism of Canaletto's paintings, which often have vanishing points "offstage" to the right or left, is a design tactic preferred for theater sets, such as those of Giuseppe Galli Bibiena, a member of a family of innovative stage designers.[3]

Canaletto would have had no trouble working out the complex spatial relationships of the buildings in this picture. *Piazza San Marco* is in fact one of three paintings by the artist that captures a sweeping, wide-angle view of the square (the others are in the Cleveland Museum of Art and the Wadsworth Atheneum, Hartford).[4] The complex angles and difficult foreshortenings that are among the most appealing attributes of these paintings had been resolved by the artist in a series of drawings (there is a large group at Windsor Castle) that were then incorporated into his designs for the paintings.

Yet despite all the tricks of perspective and whimsical rearrangements, *Piazza San Marco* is characterized most by its vivid portrayal of the locale, the convincing evocation of the mood and atmosphere of the town square seen late in the day. It was this attentiveness to the details of architecture, the nuances of light and shadow, and the life of the city that most inspired the kudos of Canaletto's contemporaries. The artist's unparalleled capturing of the effects of sunlight, whether reflecting off the ripples in a canal or, as here, bathing a white facade with its warmth, was what distinguished his hand from those of his rivals and imitators.

RR

Portrait of Cardinal Roberto Ubaldino

GUIDO RENI
Italian (Bologna), 1575–1642

c. 1625

Oil on canvas

77½ x 58¾ in. (196.9 x 149.2 cm)

Inscribed on letter in sitter's hand: All Illmo et Rs mo Sg / Cardinalle Vbaldino; on letter on table: All Illmo Ro / Sig. Card Vbaldi

Gift of The Ahmanson Foundation

M.83.109

PROVENANCE:

Bologna, Roberto Ubaldino, then by descent to his family in Rome or Florence.

England, Dr. Somerville, 1821.

England, George James Welbore, Baron Dover.

England, Georgiana Howard, Lady Dover.

England, Henry, Third Viscount Clifden.

England, Henry George, Fourth Viscount Clifden.

London, sale, Christie's, 6 May 1893, no. 29 (bought in).

London, sale, Robinson and Fisher, 25 May 1895, no. 731.

London, Sabin (dealer), 1895.

Newport, Rhode Island, Robert Goelet sale, 5–6 December 1947 (withdrawn).

Newport, Rhode Island, Salve Regina College, until 1982.

New York, sale, Sotheby's, 21 January 1982, no. 87.

Rome, Bracaglie (dealer).

London, P. & D. Colnaghi & Co. Ltd. (dealer).

SELECT LITERATURE:

D. Stephen Pepper, *Guido Reni: A Complete Catalogue of His Works with an Introductory Text* (New York: New York University Press, 1984), 251, no. 101, pl. 126.

The Age of Correggio and the Carracci: Emilian Painting of the Sixteenth and Seventeenth Centuries, exh. cat. (Washington, D.C.: National Gallery of Art, 1986), 511–12, no. 181.

Guido Reni 1575–1642, exh. cat. (Los Angeles: Los Angeles County Museum of Art, 1988), 244–46, no. 37.

Guido Reni, in theory at least, preferred not to paint portraits. Invited to France to capture the likeness of Louis XIII for a significant financial consideration, "he replied that he was not a painter of portraits."[1] Malvasia's story of Reni's refusal is probably also to be read as an Italian gesture against France and French aspirations to cultural dominance as well as an indication of Reni's standing, important enough to refuse one of the most powerful rulers in Europe. Although the biographer does go on to list thirteen portraits Reni did paint, of family members, fellow artists, writers, members of the nobility, and important prelates, he does not mention the *Portrait of Cardinal Roberto Ubaldino*, one of Reni's greatest. Probably Malvasia just did not know it.

A painter such as Reni, a leading master in the Bolognese-Roman tradition of classical idealism, would have seen himself as an artist elevated above the mere depiction of natural appearances. However, when he painted Cardinal Ubaldino, he nevertheless produced one of the finest and most vivid formal portraits of his century. Ubaldino is seated in a red velvet armchair, which he has just moved away from his writing table. On the desk is an inkwell bearing his coat-of-arms and

cardinal's insignia. He is turning his attention from his correspondence—one letter is on the table and another in his hand is addressed to him—to look steadily out of the picture's space. His presence is very directly conveyed, and his features, isolated against the dark purplish red of the curtain, are rendered with sensitivity. Ubaldino looks stern in his official role, but both the play of light that so delicately models

Detail

his face and the sympathetic expression in his eyes give him a real human presence, even if it is all a little cool and calculated. While Reni proves his astonishing ability as a naturalistic observer, not only in the face but also in the virtuoso treatment of the surfaces of velvet, silk, and lace, he reveals the power of his conceptual, idealizing side as an artist.

This grand picture is in the tradition of papal and royal portraits established in the sixteenth century by Raphael and Titian, the two artists Reni admired most. The high, straight-backed chair, oversize table, grand swag of gilt-bordered drapery, and arcade with a glimpse of parkland beyond are all designed to convey a sense of the importance of this somewhat intimidating sitter, who is working in his study in some grand palace. The light red, watered silk of the cassock and mozzetta, with their shimmering highlights, is a brilliant foil for the *punta in aria* lace, creamy white paint flicked on with an amazing dexterity of the wrist. As well as Raphael and Titian, van Dyck seems to have been an inspiration or even a challenge to Reni. It is difficult to imagine that Reni was not aware of van Dyck's great *Portrait of Cardinal Bentivoglio* (Pitti Palace, Florence), completed only in 1623. Ubaldino's pale, plump, fleshy, and beautifully manicured hands are almost a tribute to the Flemish master.

Rather little is known about Ubaldino. He was grand-nephew of Pope Leo XI Medici and cardinal legate in Bologna from 1623 to 1627. He probably commissioned the portrait on the occasion of the Jubilee year of 1625. At that time Reni was well established as the leading painter in his native Bologna. Shortly thereafter a copy was commissioned and executed in Reni's studio, in order to be sent back to Florence, the sitter's native city. The copy, with a full inscription identifying the artist and the sitter, was seen and admired in Florence by art historian Filippo Baldinucci in about 1690. Until the remarkable rediscovery of the present painting in 1982, the copy, endorsed by Baldinucci, was assumed to be the original. The duplicate, recorded in England since 1865, was in the home of Benjamin Guiness at Mignano, Italy, by 1940 but unfortunately was destroyed during the bombardment of Monte Cassino in 1943. Most of the recent literature on the museum's painting discusses its recent rediscovery and its relation to the copy, all of which is succinctly summed up in Stephen Pepper's 1984 catalogue raisonné.

PC

Notes

1. Carlo Cesare Malvasia, *The Life of Guido Reni* (1678), trans. Catherine and Robert Enggass, (University Park: Pennsylvania State University Press, 1980), 113.

The Mystic Marriage of Saint Catherine

BARTOLOMÉ ESTEBAN MURILLO

Spanish, 1617–82

1680–82

Oil on canvas

28 x 20½ in. (71.1 x 52.1 cm)

Gift of The Ahmanson Foundation

M.83.168

PROVENANCE:

Possibly Puerto de Santa Maria, Spain, Marqués de la Cañada.

Cádiz, Sebastian Martinez, by 1794.

Cádiz, Manuel de Leyra.

London, Captain Davis, by 1819.

The Netherlands, Otto Bernel.

The Netherlands, W. Hekking.

San Francisco, Irving M. Scott Collection.

New York, sale, American Art Galleries, 6 February 1906, no. 31 (bought in).

San Francisco, Irving M. Scott Collection, then by family descent.

New York, sale, Sotheby's, 20 January 1983, no. 86.

New York, P. & D. Colnaghi & Co. Ltd. (dealer).

SELECT LITERATURE:

Jonathan Brown, *Murillo and His Drawings*, exh. cat. (Princeton: Princeton University Art Museum, 1976), 34–35, fig. 10, 184, 190, no. 33.

Diego Angulo Íñiguez, *Murillo* (Madrid: Espasa-Calpe, S. A., 1981), 2:243, no. 291a, 3: pl. 427.

Murillo was born in Seville, where he trained with Juan del Castillo, a relative of his mother. An early biographer, Antonio Palomino, says the artist traveled to Madrid early in his career, where he met Velazquez, but there is no proof of this; Murillo apparently spent his entire career in Seville, where he cofounded the local art academy and operated a flourishing workshop.

Seville in the seventeenth century was a city in decline. Natural and economic disasters had tarnished its once impeccable reputation as a cultural and economic center. Murillo's remarkable paintings of beggar children, such as the *Street Urchin* (1645–50, Louvre, Paris), are an indication of the poverty prevalent in the city. Many of his religious works, for example *Saint Thomas of Villanueva Giving Alms to the Poor* of around 1668 (Museo de Bellas Artes, Seville), celebrate the role the Church played in aiding the poor and destitute. In Seville the Church was the center of social and cultural life; consequently the great majority of Murillo's pictures are religious in content. One of his favorite subjects was the Immaculate Conception, which he painted some twenty-two times. He also painted genre scenes and was one of the century's most brilliant portraitists. In the 1660s he completed his greatest works, the two large cycles for the Capuchin monastery and the Hospital de la Caridad in Seville.[1]

Murillo's last project was the retable for the Capuchin Church of Saint Catherine in Cádiz (fig. 29a). The commission was recorded in the artist's will, drawn up on

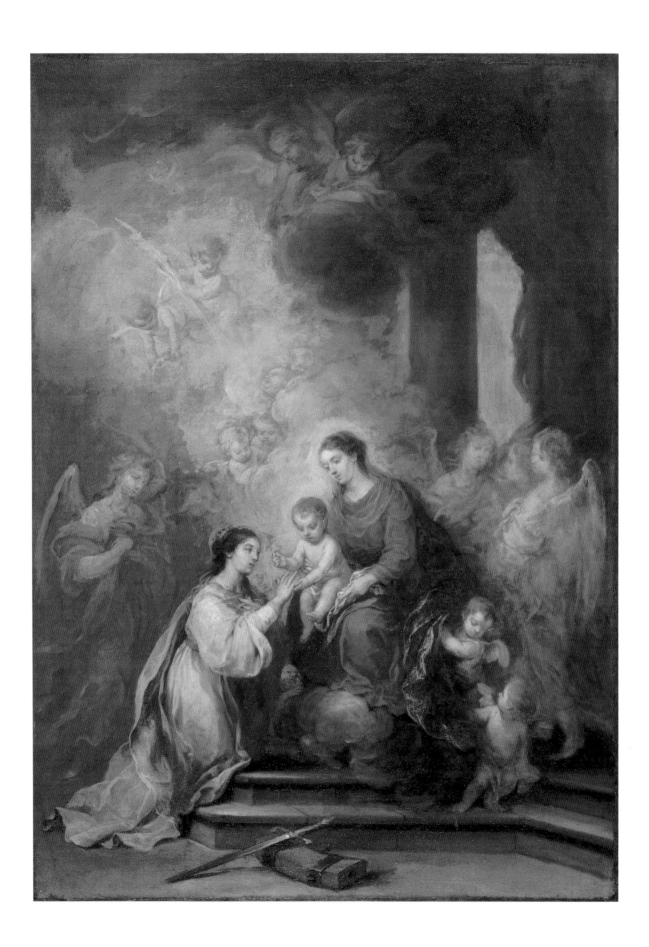

April 3, 1682, wherein he states that he is "painting a large canvas for the convent of the Capuchins in Cádiz and four other smaller canvases, for which I will be paid nine hundred pesos."[2] The museum's oil sketch is the *modello* for the large canvas mentioned by the painter, which took as its subject the Mystic Marriage of Saint Catherine. The altarpiece eventually contained six paintings in total: the Saint Catherine in the central panel, a lunette depicting God the Father, and four flanking pictures of Saint Michael, the Guardian Angel, Saint Joseph, and Saint Francis. Recently the ensemble was dismantled and the canvases placed in the Museo de Bellas Artes in Cádiz.

In fact Murillo painted only part of the retable. The project was interrupted by

FIG. 29a
Bartolomé Esteban Murillo and Francisco Meneses Osorio, *Saint Catherine Altarpiece*, Capuchin Church of Saint Catherine, Cádiz, c. 1682, oil on canvas, central painting (*The Mystic Marriage of Saint Catherine*): 178 x 131½ in. (452.1 x 334.0 cm). Photo: Ampliaciones y Reproducciones Mas.

Notes

1. Antonio Domínguez Ortiz, "Murillo's Seville," in *Bartolomé Esteban Murillo 1617–1682*, exh. cat. (Madrid: Museo del Prado, 1982), 29–39.

2. Angulo Íñiguez, 2:94.

3. Ibid., 1:87–97, 2:93–97.

his death in 1682, and Murillo's assistant, Francisco Meneses Osorio, is assumed to have completed the project (the painting of Saint Francis is signed by him). According to most scholars Murillo began the central panel of the *Saint Catherine*, sketching in the general outlines of the forms, but Meneses finished the work upon his master's death.[3] In painting the main picture, Meneses would have referred to the modello, which is entirely by Murillo. Murillo explored the subject in several drawings, one of which is in a private collection in England; it shows in essence the final composition. The artist then painted the oil sketch, which was probably presented to Father Francisco de Valverde, the Provincial of the Cádiz Capuchins and the man who had commissioned the altarpiece. Only after his approval could work begin.

In composition the finished altarpiece differs little from the modello. The most notable change is in the position of the arm of the angel at the far left, which hangs at the side in the final painting but is held to the breast in the sketch. Meneses added several angels to the upper area of the altarpiece as well. In style and technique, however, the two works are worlds apart. The oil sketch is painted in light, delicate passages of paint that flow freely throughout the composition, dissolving around some forms while highlighting others. Murillo concentrated on the mystical exchange of the principal figures in the foreground, leaving the attendant angels and the cascade of putti to merge into the atmosphere. The painter's bravura brushwork is everywhere apparent, noticeably in the fall of draperies, as in Saint Catherine's cascading cope. In contrast, Meneses's handling is taut, his forms ruled by contour and clearly defined; this clarity was necessary for the large altarpiece to read well from the congregation below.

The Golden Legend of Jacobus de Voragine tells the story of Saint Catherine of Alexandria, who was martyred by the fourth-century emperor Maxentius for her attempts to convert his subjects. A fourteenth-century legend described how Catherine, while praying before an image of the Madonna and Child, envisioned that Christ turned to her, placing a ring on her finger as a sign of her spiritual betrothal to God. This episode subsequently became a popular subject in painting. Murillo depicts the vision as if it were occurring in a cathedral: at the steps before the high altar the Virgin and Child, attended by angels and cherubs, float on a cloud upon which they have descended from heaven; the little Christ Child holds the ring, which he is about to place on the finger of Catherine, who kneels on the steps. The viewer is clearly meant to recognize the visual parallel of this scene to the ritual of the priest administering Communion. In the foreground Murillo painted the symbols of Catherine's martyrdom: the spiked wheel that a thunderbolt from heaven destroyed while she was tied to it and the sword with which she was beheaded.

RR

Death of a Gladiator

JEAN-SIMON BERTHÉLEMY
French, 1743–1811

1773
Oil on canvas
40¼ x 53½ in. (102.2 x 135.9 cm)
Signed at upper left: Berthelemy / 1773
Gift of The Ahmanson Foundation
M.83.169

PROVENANCE:
Possibly Paris, Berthélemy sale, 8 April 1811, under no. 15.
Private collection.
New York, Walter P. Chrysler, Jr., Collection.
New York, Christophe Janet (dealer).

SELECT LITERATURE:
Marc Sandoz, *Jean-Simon Berthélemy 1743–1811* (Paris: Éditart-Quatre Chemins, 1979), 41, 71, 83, no. 27, 86, no. 33 [?], 89, no. 37.
Nathalie Volle, *Jean-Simon Berthélemy (1743–1811): Peintre d'histoire* (Paris: Arthena, 1979), 31–32, 78, nos. 34–35, 81, no. 43.

Along with Jacques-Louis David, Jean-Simon Berthélemy was one of the great French neoclassical painters working in Paris in the last decades of the eighteenth century. He was born in Laon but at an early age moved to the capital, where he entered the studio of Noël Hallé. Under Hallé's sponsorship Berthélemy became a student at the Royal Academy and won the coveted Prix de Rome in 1767. This allowed him to finish his artistic training at the French Academy in Rome, where he studied from 1770 to 1774.

Upon his return to Paris, Berthélemy was accepted as a member of the Academy in 1781 (the same year as David) with his *Apollo and Sarpedon* (Musée Saint-Didier, Langres). Throughout his career he exhibited regularly at the official Salons and received numerous royal and imperial commissions. His most famous painting is the large *Manlius Torquatus Condemning His Son to Death* (Musée des Beaux-Arts, Tours), which was exhibited at the Salon of 1785 alongside David's *Oath of the Horatii*.

Death of a Gladiator, signed and dated 1773, is the only extant painting that was executed by Berthélemy during his sojourn in Rome. He arrived there in October of 1770 and took up lodgings in the French Academy, which was located in the Palazzo Mancini. The cultural milieu of the city during this period was ideal for an artist like Berthélemy, whose impending career as a history painter was predicated on a thorough knowledge of old master painting and ancient art.

Like all young artists at the Academy, Berthélemy was expected to perform certain tasks in fulfillment of his education. These included executing copies of the great masterpieces of Renaissance and baroque art as well as making drawings after the antique. In addition, in order to master the depiction of human anatomy, students were required to paint studies after the nude model. *Death of a Gladiator* is an example of the latter. Called *académies*, these works were intended as fully realized pictures in their own right, which would indicate the progress the artist was making. Such works would be sent back to Paris each year to be evaluated by the director of the Academy.[1]

Notes

1. Philip Conisbee, *Painting in Eighteenth-Century France* (Ithaca: Cornell University Press, 1981), 18–20.

2. Anatole de Montaiglon and Jules Guiffrey, *Correspondance des directeurs de l'Académie de France à Rome* (Paris: Libraire de la Société de l'Histoire de l'Art Français, 1902), 12:397–98, no. 6361.

3. Montaiglon and Guiffrey (1904), 13:31, no. 6536.

4. Sandoz, 89.

Berthélemy's mastery of anatomy and his ease with the difficulties of foreshortening are clearly apparent in *Death of a Gladiator*. The picture is confidently painted, and the artist has called attention to his fluent brushwork and vibrant coloristic effects. The handling of the lighting, which bathes the model in a rich chiaroscuro, is equally proficient, and such details as the subtle passages of red that reflect off the drapery onto the flesh of the figure signal the hand of an accomplished painter. To enliven the subject, Berthélemy added an antique setting and accessories, giving the figure a context. The gladiator, leaning against a shield, is posed before the base of a column; a sword has dropped from his hand. The transformation from a picture like this to a full-scale history painting would not be difficult to imagine.

Charles-Joseph Natoire, the director of the French Academy in Rome, in a letter of September 9, 1772, to the Marquis de Marigny, the *surintendant des bâtiments* in Paris, expressed satisfaction with the progress Berthélemy was making, concluding that "he is well on the way to distinguishing himself in his art."[2] When *Death of a Gladiator* was shipped back to Paris in September of 1774, Natoire wrote enthusiastically to the Abbé Terray, Marigny's successor, "I have the honor of sending you three large painted académies, two by Berthélemy and one by Suvée, which appear to me to have much merit."[3]

Indeed what would have impressed Berthélemy's superiors more than the painter's obvious mastery of technique and anatomy would have been his convincing evocation of the attitude of the dying warrior, the pathos of the heroically exhausted body as it releases a final breath. What Natoire and Terray were looking for in a work like *Death of a Gladiator* were the signs that the artist had mastered the painting of the "passions," the difficult task of displaying through pose, gesture, and facial expression the figure's state of mind. Only then could the painter be expected to carry out the full-scale narrative canvases he was being trained to do.

Berthélemy was evidently pleased with *Death of a Gladiator*, for he chose to include it in the group of pictures he exhibited at the Salon of 1777 soon after his *agrément* (probationary acceptance) into the Academy. Judging from comments in the press, *Death of a Gladiator* was a critical success, the writers admiring just those qualities that the Academy was trying to instill in its students. The *Année littéraire* appreciated the painting's "good sense of design," commenting that the artist had clearly studied nature "which he renders with a happy facility." The *Journal de Paris* thought *Death of a Gladiator* did Berthélemy honor and "should convince him that nature is the mother of the arts."[4]

RR

Virginia da Vezzo, the Artist's Wife, as the Magdalen

SIMON VOUET
French, 1590–1649

c. 1627
Oil on canvas
40 x 31 in. (101.6 x 78.7 cm)
Gift of The Ahmanson Foundation
M.83.201

PROVENANCE:

England, Alderman T. Holroyd, by about 1860.

England, a religious institution.

Lancashire, local auction.

London, Trafalgar Galleries (dealer).

SELECT LITERATURE:

Arnauld Brejon de Lavergnée, "Four New Paintings by Simon Vouet," *The Burlington Magazine* 124, no. 956 (November 1982): 685–89, fig. 34.

Marilena Mosco, ed., *La Maddalena tra sacro e profano* (Florence: La Casa Usher, 1986), 231, fig. 1.

Simon Vouet was one of the most influential French painters of his time. His career can be divided into two major periods, the first spent in Italy, the second in France. After training with his father, minor painter Laurent Vouet, the twenty-three-year-old Simon traveled to Italy in 1612. He soon settled in Rome, the artistic capital of Catholic Europe and the hub of a large international community of artists.

In Rome painters such as Annibale Carracci and Caravaggio had laid the foundations of seventeenth-century Italian painting, and artists of Vouet's generation were exploring and developing the implications of these innovative achievements. Vouet studied both the monumental grandeur of Carracci's classical forms and the earthy realism and dramatic light and shade of Caravaggio. In 1617 King Louis XIII of France began to support the young painter in Rome with a royal pension. Soon Vouet won important commissions to execute works for Roman churches and private patrons, and his reputation grew to rival those of native Italian painters. In 1624 he was honored by Roman artists, who elected him principal of the Academy of Saint Luke.

Having spent some fourteen years in Rome studying and then working independently, Vouet was recalled to Paris in 1627 by Louis XIII, who conferred on the artist the official title of *premier peintre du roi*. The French ruler wanted the now-famous painter back in Paris to devote his talents to the royal service and to add to the artistic prestige of his native land. Vouet's arrival in Paris transformed the artistic life of the city from that of a relatively provincial backwater to one that was soon to rival Rome as a glittering center of creativity and innovation, a model for the rest of Europe. He was to be one of the influential founding members of the Royal Academy in 1648.

While it has been argued that *Virginia da Vezzo, the Artist's Wife, as the Magdalen* was executed shortly after Vouet's return to France, scholars now generally agree that the style of the painting, with its saturated colors, strong, rich brushwork, and forms boldly modeled by light and shadow, points to an execution date at the end of

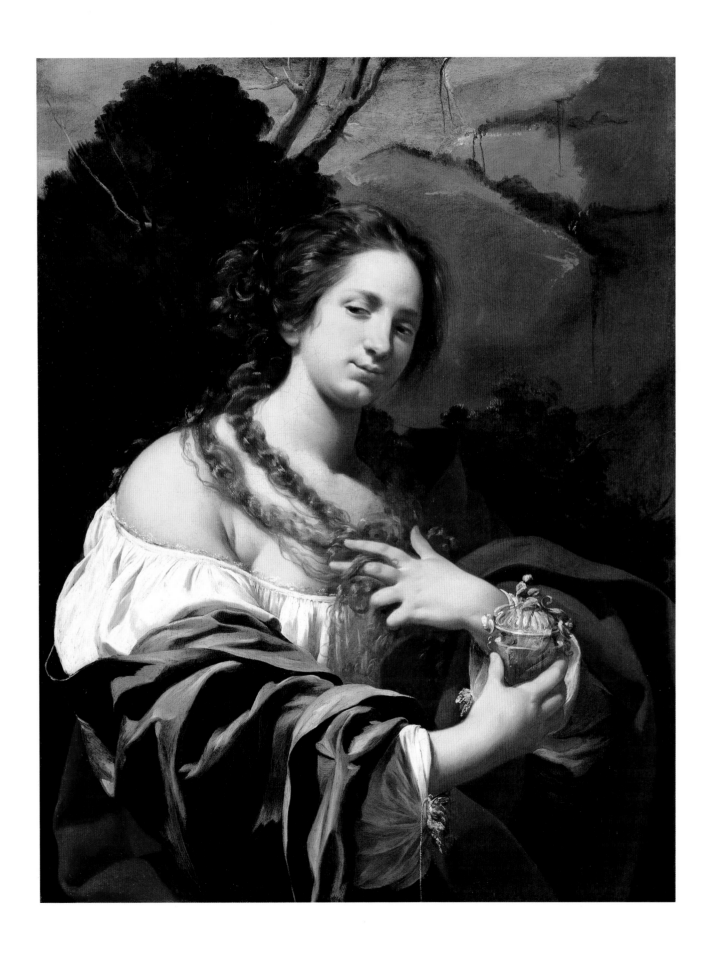

Vouet's Roman sojourn, most likely in 1626 or 1627. By this time Vouet had been exposed to the work of a variety of contemporary Italian painters, such as Bolognese master Guido Reni and the "Neapolitan Guido Reni," Massimo Stanzione. The painting's warm and lyrical atmosphere is created by the golden light and creamy impasto that Vouet may have learned from his fellow artists.

Drawing on these various sources in Italian early baroque painting, Vouet, by the end of his Roman period, had developed a sumptuous, personal poetry. The masterpiece of this style is his *Time Vanquished by Hope, Love, and Beauty* (1627, Prado, Madrid), whose stylistic features correspond closely to the Los Angeles picture. Indeed for the figure of Venus in the Prado's picture Vouet used the same model as for the *Magdalen*, his wife, Virginia da Vezzo, whose features can be recognized from a portrait engraved by Claude Mellan in 1626. Vouet had married this celebrated beauty, who was also a painter, the same year. Some of the warmth and earthiness of the *Magdalen* comes from the fact that Vouet cast his recent wife in this role, which gives the work a playful eroticism. Her attitude, the manner in which she twirls her long hair in her fingers, and the way she looks out knowingly at the spectator provide quite a contrast with Georges de La Tour's meditative and repentant *Magdalen with the Smoking Flame* (cat. no. 10).

In Christian iconography the Magdalen's long hair and jar of ointment refer to the Gospels (for example, see Luke 7:36–50), where it is recorded that during a supper at the house of Simon the Pharisee, Mary washed Christ's feet with tears, dried them with her hair, and anointed them with ointment in an act of repentance (see also cat. no. 49). This religious message is undercut by the sensuality of Vouet's image. The ambivalence is well expressed in the way the Magdalen plays with her hair: is she teasing with it in a suggestive way or do her fingers indicate that she is going to cut it off in penance?

The Los Angeles work was probably made for the enjoyment of a private collector, who very likely knew the artist and his wife. However, there is no firm evidence that the painting, as has been suggested by some scholars, is the *Magdalen* that once belonged to the celebrated Roman patron Cassiano dal Pozzo, who was a friend of Vouet and his spouse.

PC

Saint Thomas

PIERRE LE GROS II
French (active Rome), 1666–1719

1703–5

Terra-cotta

27⅜ x 18½ x 10¾ in. (69.5 x 47.0 x 27.3 cm)

Purchased with funds provided by William Randolph Hearst, The Ahmanson Foundation, Chandis Securities Company, B. Gerald Cantor, Camilla Chandler Frost, Anna Bing Arnold, an anonymous donor, Duveen Brothers, Inc., Mr. and Mrs. William Preston Harrison, Mr. and Mrs. Pierre Sicard, Colonel and Mrs. George J. Dennis, and Julia Off

84.1

PROVENANCE:
London, Cyril Humphris (dealer).

SELECT LITERATURE:
Scott Schaefer, "Three Centuries of European Sculpture: Bandini to Bartholdi," *Apollo* 124, n.s. no. 297 (November 1986): 415–16, fig. 3.

This terra-cotta is a *modello* for the gigantic (over fifteen feet high) marble *Saint Thomas* (1705–11, fig. 32a), one of a series of twelve sculptures of apostles commissioned to fill the tabernacles built in the mid-seventeenth century down the nave of San Giovanni in Laterano in Rome. The Lateran, one of Rome's oldest, largest, and most venerated churches, is the cathedral of the pope in his capacity as bishop of Rome.

By the seventeenth century the Constantinian basilica of the Lateran had decayed into a seriously dilapidated state. In 1646, with the Jubilee year of 1650 approaching, Pope Innocent X ordered Francesco Borromini to renovate the church. This great architect of the Italian baroque devised a scheme in which alternating pairs of the numerous small piers of the early church were encased in what became enormous tabernacles in a massively articulated arcade leading down the nave (fig. 32b).[1] In this way much of the fabric of the early church was disguised but not destroyed. The tabernacles were designed in white and multicolored marble, their pediments bulging out from the plane of the arcade, with multiple sculptural effects to be achieved through variegated architectural profiles, decorative relief carving, and monumental statues for the niches. Borromini's personal interest in the play of light in architecture found a sublime opportunity here, as his commission was intended for a Jubilee under Rome's winter sun. The sculptures in the niches would be illuminated by shafts of raking light.[2]

The statues of the apostles were not, however, carried out until a half-century after the Jubilee. In 1699 Cardinal Benedetto Pamphili was named archpriest of the Lateran; the following year his friend Clement XI was elected pope. The cardinal, a connoisseur of the arts, supported by the pope, set about seeing the work in the Lateran to completion. The expensive, colossal sculptures, each to be carved from

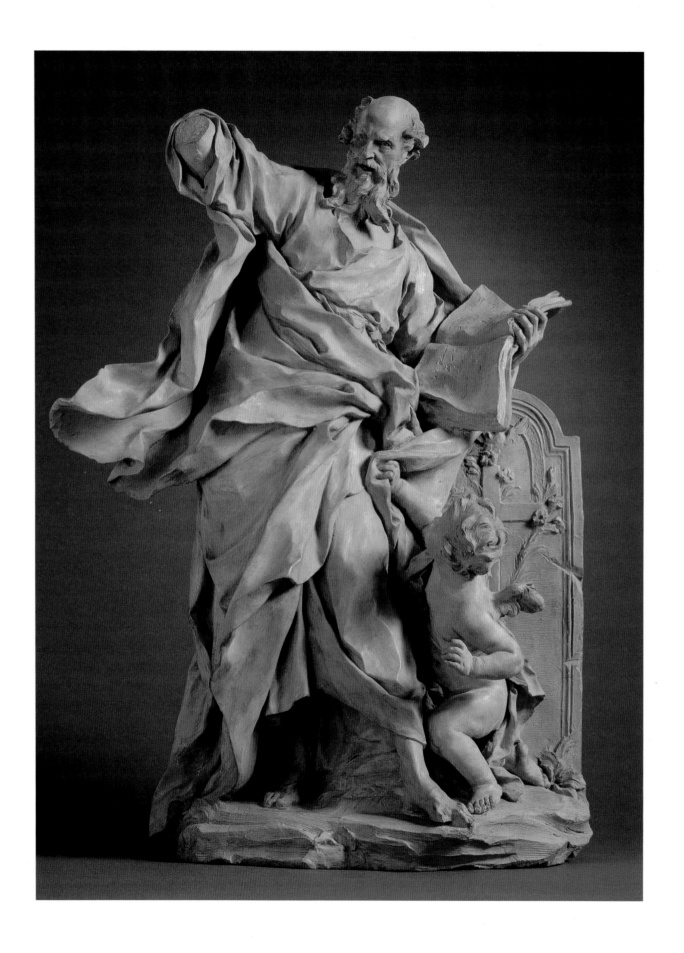

FIG. 32a
Pierre Le Gros II, *Saint Thomas*, 1705–11, marble, h: approx. 180 in. (457.2 cm), San Giovanni in Laterano, Rome. Photo: Alinari/ Art Resource.

FIG. 32b
Martino del Don, *Interior of San Giovanni in Laterano, Rome*, watercolor and gouache over pencil, 13⁷⁄₁₆ x 19⁵⁄₁₆ in. (34.1 x 49.0 cm), Cleveland Museum of Art, gift of the Reverend and Mrs. Danila Pascu (CMA 81.228). The marble *Saint Thomas* (fig. 32a) is in the second niche on the right.

Notes

1. Rudolf Wittkower, *Art and Architecture in Italy 1600–1750*, 3d ed. (Harmondsworth: Penguin Books, 1973), 140, 290.

2. Marcello Fagiolo and Maria Luisa Madonna, *L'Arte degli anni santi: Roma 1300–1875*, exh. cat. (Rome: Palazzo Venezia, 1984): 37–39, figs. 1(w), 1(x).

3. For information on Le Gros and the marble *Saint Thomas* see: Pierre d'Espezel, "Notes historiques sur l'oeuvre et la vie de Pierre II Le Gros," *Gazette des Beaux-Arts*, 6th period 12 (July–December 1934): 154; Frederick den Broeder, "The Lateran Apostles: The Major Sculpture Commission in Eighteenth-Century Rome," *Apollo* 85, n.s. no. 63 (May 1967): 360–65, fig. 4; Robert Enggass, *Early Eighteenth-Century Sculpture in Rome* (University Park: Pennsylvania State University Press, 1976), 1:124–31, 142–43, 2: figs. 135–38; and François Souchal, *French Sculptors of the Seventeenth and Eighteenth Centuries* (Oxford: Cassirer, 1981), 2: 273–74, 288–89, no. 24.

a single block of marble, were subsidized by an international subscription. The king of Portugal, Pedro II, paid for the statue of Saint Thomas, the apostle who is said to have brought Christianity to Portuguese India. The commission was awarded to Pierre Le Gros II, a French artist who found himself, even as a student at the French Academy in Rome, celebrated as one of the greatest sculptors in the Eternal City.[3]

Le Gros, the son of a sculptor, was also trained in design by his uncle, the engraver Jean Lepautre. In 1690 the *surintendant des bâtiments du roi*, the Marquis de Louvois, sent Le Gros to study at the French Academy in Rome. Supported by a royal stipend, the artist was to have worked exclusively for the Crown, but instead he surreptitiously competed for, and won, the commission for a multifigured group in marble, *Religion Casting Down Heresy*, for the chapel of Saint Ignatius Loyola in the Jesuits' church of the Gesù. This sculpture, in its asymmetry, turbulence, and broken silhouettes, differed considerably from the grand, unified character of the baroque of the preceding century. Le Gros went on to win the competition for the central figure of this chapel, the huge silver statue of Saint Ignatius (destroyed in 1798). His other great commissions, the altar of Saint Luigi Gonzaga in Sant'Ignazio and the *Saint Filippo Neri* in San Girolamo della Carità, share a theatrical animation and capriciousness that herald the fantasy of the rococo.

The terra-cotta *Saint Thomas* is understandably more animated than the monumental marble that was realized from it. Le Gros's predilection for complex groupings is manifested in the little angel crouching beside the apostle in the terra-cotta (omitted from the marble). The slab with the cross, a symbol of the divine palace built by Saint Thomas that was revealed to King Gundaphous of India in a dream, is treated much more decoratively in the terra-cotta. And the book, symbol of the apostolic message, has been replaced in the marble by the architect's rule, thereby reducing the breadth of the silhouette and weakening the dramatic diagonal of the saint's gesture. In the terra-cotta the figure of Saint Thomas twists more dynamically, the facial expression is more intense, and the rendering of creases and folds is accomplished with a driving force that makes the whole composition seem to unfurl like a magnificent banner in the wind.

MLL

Noah's Sacrifice after the Deluge

GIOVANNI BENEDETTO CASTIGLIONE

Italian (Genoa), 1609–63/65

1650–55
Oil on canvas
55¼ x 76¼ in. (140.3 x 193.7 cm)
Gift of The Ahmanson Foundation
M.84.18

PROVENANCE:

Probably Mantua, Carlo II Gonzaga, then by descent.

Althorp, Northampton, the Honorable John Spencer, by 1742, then by descent to the Earl Spencer, until 1984.

New York, Wildenstein & Co. (dealer).

SELECT LITERATURE:

Ann Percy, *Giovanni Benedetto Castiglione: Master Draughtsman of the Italian Baroque*, exh. cat. (Philadelphia: Philadelphia Museum of Art, 1971), 57, n. 124.

Il Genio di G. B. Castiglione: Il Grechetto, exh. cat. (Genoa: Sagep Editrice, 1990), 64, 147.

The Old Testament stories of Abraham, Jacob, and Noah were among Castiglione's favorite subjects, for they permitted him to exploit his skill at painting large caravans of people and animals laden down with supplies as they travel the landscape. *Noah's Sacrifice after the Deluge* is one of the most complex and elaborate compositions of this sort. It takes as its ostensible theme an episode rare in art, when Noah gives thanks to God for safe passage during the flood (Genesis 8:20–21). As is usual with these pictures, however, the actual event is relegated to the distant background. Instead interest is focused on the flawlessly painted mélange of animals, pots and pans, traveling cases, and clothing, the cargo just unloaded from the ark, whose prow rests on the rocky bluff at the upper right.[1] Castiglione often repeated the same animals and groupings of objects in several paintings on a similar subject: many of those that appear in this picture are also included in *The Animals Leaving the Ark* (c. 1635, Galleria di Palazzo Bianco, Genoa) and *The Sacrifice of Noah* (c. 1650–55, Musée des Beaux-Arts, Nantes), the latter being closest in composition to the Los Angeles version.[2]

Castiglione was one of the brightest talents to emerge in seventeenth-century Genoa, which laid claim to a flourishing native artistic tradition. During his lifetime Genoa was still a vital international port that, with its unique location at the crossroads of Europe, had intimate economic and artistic ties with Spain and the North. The great trading families that ruled the city turned to Flemish painters as the chief means of expressing their ideological pretensions in art; Rubens and, in particular, van Dyck, with whom Castiglione studied in the 1620s, painted these wealthy patrons in a number of grandiose portraits. But there was an equal fascination among Genoese connoisseurs with the low-life painting of the *bamboccianti*, those Flemish and North Italian artists who specialized in the depiction of peasant life, rustic kitchens, still lifes, and animals. Castiglione would have been particularly responsive to these latter influences, especially the work of Sinibaldo Scorza, with whom he may have studied. The biblical/pastoral subjects of the Bassano family in sixteenth-century Venice had a profound effect on his style as well.

By 1632 Castiglione was in Rome, intent on completing his artistic education. There he was in contact with the circle of Cassiano dal Pozzo, the antiquarian and patron of Poussin, although stylistically Castiglione seems to have been most taken with Pietro Testa, another favored artist of dal Pozzo. Under the influence of these painters Castiglione turned to the creation of pastorals, idealized landscapes inspired by the Roman *campagna*, with its antique associations. He visited Naples in 1635 but by the end of the decade had returned to his native city, painting a number of pictures for Genoese churches and palaces during the 1640s.

After a second stay in Rome from 1647 to 1651 Castiglione worked for the court at Mantua and, except for trips to Venice, Parma, and Genoa, apparently stayed there for the remainder of his life. It was presumably in Mantua that he painted *Noah's Sacrifice after the Deluge*. On the basis of style a number of works with such subjects can be dated to the 1650s, including the Nantes picture. Indeed an inventory of the ducal collections taken around 1700 lists "Un quadro lungo 3 brac. sul camino col sacrifizio di Noè, fatto da Giovanni Benedetto Castiglioni" (A picture 3 braccie [approximately 75 inches] long over the fireplace with the sacrifice of Noah, made by Giovanni Benedetto Castiglione).[3] These dimensions match the Los Angeles painting better than any of the other extant versions of the subject.

Noah's Sacrifice after the Deluge admirably demonstrates the eclecticism Castiglione had perfected by this stage in his career, combining the subject matter of the bamboccianti and the Bassani with the grandiose pictorial strategies of the Flemish baroque. The aggregation of beasts, paired "two and two," masks an elaborate and refined handling of space and organization of form. The focus is the looming hulk of the cow at center, its head languorously lifted to meet the eye of the viewer, the strong diagonal traced by its back providing a stabilizing force within the disarray of the foreground elements. This surge is held in check by the framing trees at left and the man at right, whose head turns attention back into the center of the image.

Detail

Notes

1. Pentimenti indicate that Castiglione originally positioned the ark in the middle ground below the rocky bluff.

2. *Il Genio di G. B. Castiglione*, 63–64, no. 4.

3. Carlo d'Arco, *Delle arti e degli artefici di Mantova* (Mantua: n.p., 1857), 2:189.

Within this framework the viewer can easily become absorbed in the plethora of natural and man-made objects displayed in the foreground. Castiglione carefully placed these objects close to the picture plane, inviting viewers to appreciate the differences in form, color, and texture. Shown are the supplies that sustained Noah's family during the months in the ark: water jugs, flasks of wine, blankets, lanterns, baskets of food, and chests of clothes. The creatures Noah saved ("Every beast, every creeping thing, and every fowl, and whatsoever creepeth upon the earth, after their kinds, went forth out of the ark") are juxtaposed to celebrate God's infinite creativity. One senses in the picturesque disorder, which assumes the orchestrated casualness of a still life by Frans Snyders, Castiglione's desire to impress the viewer with his sheer command in the painting of such variety. The animals themselves are aware of their status as objects of display; the Jacob ram, cow, donkey, rabbits, and kittens all return the viewer's gaze.

Despite the obvious visual delight of *Noah's Sacrifice*, the picture never degenerates into a meaningless feat of painterly dexterity and never loses its biblical context. Castiglione has gone to some trouble to set the scene and evoke the moment. It is clear the flood waters have just receded. Seashells litter the left foreground; the pale corpses of drowned sinners are scattered across the grassy knoll at right. The sky is still strewn with clouds, as if the rains had just ceased, but the bright light that illuminates the entire landscape signals the dawn of a new era. This cycle of destruction and rebirth is symbolized in the pair of trees at left, one dead, its trunk split, the other growing up out of the composition in full foliage.

In the distance Noah and his family are kneeling before the altar, preparing the sacrificial lambs for the pyre. God appears in the smoky trail above, his hand raised in blessing as he promises never again to curse the ground for man's sake. Instead man would now have dominion over all living things on earth. Indeed the sheer abundance of animals and the wealth of material goods that are displayed to such good effect assume the essence of God's new covenant with Noah: "Be fruitful, and multiply, and replenish the earth." Soon the rainbow would appear in the moisture-laden sky, symbolic of the new age, and Noah and his family would begin the regeneration of the human race.

RR

Saint Veronica with the Veil

MATTIA PRETI (IL CAVALIERE CALABRESE)
Italian (Naples), 1613–99

c. 1655–60
Oil on canvas
39½ x 29½ in. (100.3 x 74.9 cm)
Gift of The Ahmanson Foundation
M.84.20

PROVENANCE:
Rome, Cardinal Carlo Barberini, by 1692–1704.
Private collection.
New York, French & Company (dealer).

SELECT LITERATURE:
Marilyn Aronberg Lavin, *Seventeenth-Century Barberini Documents and Inventories of Art* (New York: New York University Press, 1975), 432, no. 117.

Painting in Naples 1606–1705: Caravaggio to Giordano, supp. to the exh. cat., by Sheldon Grossman (Washington, D.C.: National Gallery of Art, 1983), [5–6].

Preti was born in Calabria, a province of the kingdom of Naples, hence his nickname. His early training is unknown, but apparently by 1630 he was already an established painter. That year he set up a studio in Rome with his older brother, Gregorio. In Rome, Preti studied the art of Guercino and Caravaggio, which was to have a decisive impact on the development of his style. He traveled widely, to Florence, Bologna, and Venice, but remained based in Rome; there he painted a fresco cycle of the life of Saint Andrew (Sant'Andrea della Valle) in 1650–51. In 1653 he was elected to the Academy of Saint Luke.

The next two years were spent in Modena, after which Preti went to Naples, where he remained until 1661. In the seventeenth century Naples was a dominion of the Spanish Hapsburgs and a major center for the Counter-Reformatory Church. It hosted a vital community of artists as well, united in their admiration of Caravaggio, who had worked in the city in 1606–7. These local artists, organized into the *Corporazione dei pittori napoletani*, were often hostile to outside painters, and Preti was no exception; his work in Naples was incessantly attacked, especially by Luca Giordano, who criticized the darkness of Preti's paintings and what he saw as the vulgarity of the figures.[1] In the year Preti arrived, however, Naples was in the throes of a devastating plague that claimed the lives of more than half the population, including some of the most talented local painters. Preti soon found himself the leading artist in town and over the course of four years received numerous private and public commissions. His masterwork of this period is the fresco cycle painted in the nave of San Pietro a Maiella, the *Life of San Pietro Celestino and Santa Caterina di Alessandria* (1657–59).

Preti's moving *Saint Veronica with the Veil* was probably painted during this Neapolitan sojourn. It conforms to the manner he adopted in response to painters like Jusepe de Ribera and Giovanni Battista Caracciolo, who had based their art on Caravaggio's incisive realism and dramatic treatment of light and shade. Like Preti's full-length *Saint Sebastian* (Museo di Capodimonte, Naples), painted in 1657 for

Notes

1. George Hersey, "Mattia Preti, 1613–1699," in *A Taste for Angels: Neapolitan Painting in North America 1650–1750*, exh. cat. (New Haven: Yale University Art Gallery, 1987), 87–90.

2. Lavin, 432, no. 117.

the church of San Sebastiano, *Saint Veronica* presents its subject before a dark background, theatrically spotlit from above. The effect gives the saint a formidable plasticity as she seemingly emerges from the canvas to present the sudarium to the viewer. Veronica gazes heavenward, tears rolling softly down her cheeks, as she acknowledges the divine source that illuminates her.

Preti's style was eclectic, influenced by a variety of painters he had studied on his trips in Italy. The strong modeling of the saint's face recalls the Bolognese classicism of Domenichino (cat. no. 47), while the fluently painted drapery harks back to the Venetian tradition. The theatrical effects of light and shadow accentuate the miraculous genesis of the Holy Face, but the simple composition, softened by beautiful passages of paint and convincing, naturalistic details, is more suited to the painting's intimate size and theme.

Veronica was one of the holy women who accompanied Christ to Calvary. She wiped his brow with her veil, which miraculously became imprinted with his image. According to one legend Veronica took her veil to Rome, where it cured the Emperor Tiberius of an illness. Consequently the saint's cult was very strong in Rome; her veil and subsequent representations of it were worshiped for their healing powers. The veil had special meaning for artists as well since it was considered to represent the true image of Christ's likeness; in fact the saint's name derives from the Latin phrase *vera icon*.

Although images of Saint Veronica were relatively scarce in the seventeenth century (Zurbarán painted several pictures of the veil alone), Preti followed the accepted manner of depicting Christ's face in reddish brown tones, like a Byzantine icon. Jesus stares out at the viewer from the folds of the cloth, the crown of thorns visible around his brow. The small scale of the picture and, for Preti, its unusually subdued and meditative qualities indicate that the painting was intended for private devotion.

Although undoubtedly painted in Naples, *Saint Veronica* was most likely intended for a Roman patron. The painting is first mentioned in an inventory of the Palazzo Barberini in Rome that was drawn up at the end of the seventeenth century at the behest of Cardinal Carlo Barberini: "Una S.ta Veronica con Volto S.to in mano con velo bianco in Testa di Tela di p.mi: 4: Cornice dorata del Cav.le Calabrese" (A Saint Veronica with the Holy Face in her hand and a white veil on her head, on canvas, 4 palmi [approximately 35 inches], in a gilt frame by the Cavalier Calabrese).[2] A poorly conserved copy of the Los Angeles painting exists in the Palais Fesch in Ajaccio, Corsica.

Around 1660 Preti returned to Rome; the following year he settled in Malta. There he spent the last forty years of his life, producing a great number of pictures for local patrons as well as for export to Italy.

RR

Jupiter and Danaë

HENDRICK GOLTZIUS
Dutch, 1558–1617

1603

Oil on canvas

68¼ x 78¾ in. (173.4 x 200.0 cm)

Signed at lower left, along lid of chest: HGoltzius. ANNO.1603.

Gift of The Ahmanson Foundation

M.84.191

PROVENANCE:

Leiden, Bartholomeus Ferreris, by 1604.

Possibly Leiden, Hendrick Ferreris, after 1622.

Amsterdam, Jeronimus Tonneman, until 1750, then by descent to his mother, Maria van Breusegom, 1750–52.

Amsterdam, Tonneman sale, 21 October 1754, no. 6.

Amsterdam, Gerret Braamcamp, 1754–71.

Amsterdam, Braamcamp sale, 4 June 1766, no. 1 (bought in).

Amsterdam, Braamcamp sale, 31 July 1771, no. 66.

Amsterdam, Jan Lucas van der Dussen sale, 31 October 1774, no. 4.

Amsterdam, Cornelis Ploos van Amstel.

Silesia, Sagan Castle, Peter von Courland, by 1778, then by descent to his daughter, Dorothea Princess Biron of Courland, in 1845.

Paris, Duc de Talleyrand-Valençay-Sagan sale, Georges Petit, 2 December 1899, no. 31.

Paris, Vicomte Chabert de Vatolla, by 1912.

England, private collection.

Zurich, art market, by 1914.

Stockholm, Fritzes (dealer).

Stockholm, Claes Adolf Tamm, 1918–33.

Stockholm, sale, Svensk-Franska Konstgalleriet, 4–5 October 1933, no. 37.

Stockholm, Dr. Runnquist, 1933–35.

Stockholm, sale, Bukowski's, 11–12 April 1935, no. 80.

Stockholm, Nordgren (dealer).

New York, Suzanne's Studio Inc., by 1974.

Los Angeles, Eugene Allen, 1974–84.

San Francisco, sale, Butterfield and Butterfield, 8 November 1984, no. 2072.

SELECT LITERATURE:

Carel van Mander, *Het Schilderboeck* (1604), trans. Constant van de Wall (*Dutch and Flemish Painters: Translation from the Schilderboeck*, New York: McFarlane, Warde, McFarlane, 1936), 370, 498, no. 32.

Otto Hirschmann, *Hendrick Goltzius als maler 1600–1617* (The Hague: Martinus Nijhoff, 1916), 42–46, 73–74, no. 5, fig. 7.

Erwin Panofsky, "Der gefesselte Eros (Zur Genealogie von Rembrandts Danae)," *Oud-Holland* 50, nos. 1–6 (1933): 210–11, fig. 22.

Lawrence W. Nichols, "Onsterfelijkheid in smetteloos naakt," *Openbaar Kunstbezit* 29, no. 5 (October 1985): 158, 160–61, fig. 15 (in reverse).

Ben Broos, *Great Dutch Paintings from America*, exh. cat. (The Hague: Mauritshuis, 1990), 238–44, no. 22.

Hendrick Goltzius achieved international fame at the end of the sixteenth century as Europe's premier engraver and draftsman. Around 1600 he turned to oil painting and was subsequently quite influential to the development of history painting in the Netherlands.

Born in Mühlbracht on the German border, Goltzius was trained as a glass painter in his father's studio and later studied engraving with Dutch humanist and statesman Dirck Volkertsz Coornhert. In 1577 he followed Coornhert to Haarlem, where he set up his own print shop five years later. Soon thereafter Goltzius met the painters Carel van Mander and Cornelis van Haarlem, who introduced him to the paintings of another Fleming, Bartholomeus Spranger. Goltzius engraved many of

Spranger's compositions, which were a distillation of the Roman mannerist style Spranger had formed in Italy and perfected at the courts of Vienna and Prague.[1]

In the early 1580s van Mander, with Goltzius and van Haarlem, established the Haarlem Academy, an association of artists drawn to mannerism and eager to initiate a Northern school of painting to rival the Italian model. Van Mander's treatises laid the foundations for the Academy, propagating the preeminence of history painting based on the art of Spranger and the Italian mannerists.[2] His *Schilderboeck*, published in 1604, combined theoretical writings with biographies of artists and also included an interpretation of Ovid's *Metamorphoses*, which van Mander advised artists to use for subject matter. The Haarlem style was disseminated through Goltzius's prints, which circulated throughout Europe.

Goltzius made a fruitful trip to Italy in the early 1590s, where he visited all of the major art centers, especially Rome and Venice. Shortly after his return to Haarlem he took up painting, probably at the suggestion of van Mander. The latter reports that Goltzius's first commission was a small painting on copper depicting the Crucifixion, "a good study, well conceived, definite, and beautifully painted."[3] This picture has been lost; in fact less than fifty paintings by Goltzius are known. All of these are history paintings, divided between biblical scenes, mythological subjects, and allegories.[4] *Jupiter and Danaë* is one of his most important surviving works and among his largest. Soon after it was painted, it was described by van Mander in his *Schilderboeck*:

> In 1603, Goltzius painted, on a large canvas, a nude and recumbent figure of Danaë, life-size. She is sleeping, and her pose is beautiful. The carnation is painted marvellously, as is the modelling. The work reflects his great study of outline and anatomical construction of the body. There is in this picture, a shrewd old woman with a glowing face, and a figure of Mercury. I cannot describe the lovely little angels that are flying with gifts. The picture is beautifully composed and could not be improved in any way. This painting is at Leyden with Sr Bartholomeus Ferreris, a collector; it can be seen in his art-room.[5]

Danaë was the daughter of Acrisius, the king of Argos. Upon learning from the Delphic oracle that he would be killed by his daughter's son, the king banished Danaë to a tower to hide her from suitors. Smitten by Danaë's great beauty, Jupiter visited her in the form of a shower of gold, entering her chamber through the cracks in the ceiling; from their union was conceived the hero Perseus. Perseus, after many adventures (see cat. no. 36), eventually killed his grandfather by accident, thus fulfilling the prophecy.

The episode is mentioned only briefly by Ovid (*Metamorphoses* 4:611), but Goltzius followed tradition by depicting Danaë in an opulent bedchamber attended by her maid as Jupiter rains down accompanied by his eagle. The drops of gold turn to coins as they descend, clattering to the floor or being caught in the maid's cup. Two putti at the right pull back the canopy, revealing the sleeping Danaë, while at the left a pair of *amorini* fly in with gifts. In the center Mercury signals Jupiter with his caduceus.

The subject of Danaë was a popular one among Dutch artists in the seventeenth century. Joachim Wtewael painted a meticulously finished version on copper (Louvre, Paris), and there are other depictions by Spranger, Cornelis Ketel, and

Abraham Bloemaert. Bloemaert's design, engraved by Goltzius's son-in-law, Jacob Matham, in 1610 (fig. 35a), is iconographically very similar to Goltzius's painting. Matham also treated the subject in a drawing (private collection, London), which combines elements of Goltzius's painting with his own engraving after Bloemaert.

Van Mander explained the meaning of the myth in his *Wtlegginghe op den Metamorphosis* (Interpretation of the *Metamorphoses*), which was published with the *Schilderboeck*: "Undoubtedly Jupiter seduced and cheated his girlfriend and her nurse with lavish gifts of gold. We may well say that gold, loved and desired everywhere, conquers everything . . . climbs the highest walls . . . smashes the strongest ties . . . stains the purest hearts . . . destroys chastity, virtue, fidelity, honor, and good laws and everything else that man ought to value higher than his own life."[6]

This is an unusual reading of the myth, breaking sharply with the standard interpretation of Ovid, which was codified in the fourteenth century in the *Ovid moralisée*. This annotated version drew parallels between the ancient fables and the stories of the Bible. Thus Danaë, hidden from suitors in a tower like Saint Barbara, is celebrated for her chastity, and her miraculous impregnation is likened to that of the Virgin Mary.[7] For van Mander the humanist, however, the *Metamorphoses* served better to reveal truths concerning human nature and social customs. He saw in the story of Jupiter and Danaë a warning against human greed and the corrupting power of money, especially in matters of love. By transforming himself into a shower of gold, Jupiter gained illicit entrance into Danaë's affections.

Goltzius was well aware of van Mander's interpretation of the Ovidian myths. It was at the latter's suggestion that he designed in 1589 a series of fifty-two prints based on the *Metamorphoses*. The story of Danaë was not included in the series, but in the Los Angeles painting Goltzius plays van Mander's cynical appraisal of the story off against the more virtuous Christian interpretation. Here Danaë is young and virginal, oblivious to her imminent fate. The crystal cup at her side is a symbol of her purity. She presents an easy target for the wily Jupiter, whose lusty designs on her are manifest in the riot of accoutrements and ancillary figures that fill the room. The gifts surrounding Danaë are indeed lavish, and there is no doubt that her pure heart will be stained and her chastity and virtue destroyed. The unusual appearance of Mercury, god of commerce, underscores the idea of mercenary love. It is further emphasized by the crone, who acts the role of the procuress, holding the cup of money as she gently awakens her charge. These elements reappear, as Lawrence Nichols has pointed out, in Goltzius's *The Artist's Emblem*, which he repeated in several drawings. The one illustrated here (fig. 35b) features an overflowing pot of gold coins in which is thrust a caduceus surmounted by a seraphim. At the top of the print Goltzius inscribed his personal motto, *Eer Boven Golt* (Honor above Gold). Gold has clearly won out over honor in the painting, however, and everywhere are signs of immoderation and rapacious behavior: in the tiny Bacchus that tops the golden Pronk cup at the lower right, the overflowing, ornate chest, and the swelling money bags flown in by the amorini. Goltzius's Danaë, demure or not, conforms more to the recumbent Venus type than to other artists' depictions of her.

Goltzius clearly remembered Titian's celebrated pictures of the goddess of love, such as *Venus and Cupid with a Lute Player* (Metropolitan Museum of Art, New York, fig. 35c). This seems the better comparison than Titian's own versions of Danaë,

FIG. 35b
Hendrick Goltzius, *The Artist's Emblem*, 1609, pen and brown ink, 6 x 3½ in. (15.2 x 8.9 cm), copyright 1871, Crocker Collection, Crocker Art Museum, Sacramento, California (CAM 1871.143).

FIG. 35c
Titian, *Venus and Cupid with a Lute Player*, c. 1565–70, oil on canvas, 65 x 82⁷⁄₁₆ in. (165.0 x 209.4 cm), Metropolitan Museum of Art, New York (36.29).

which Goltzius surely knew as well. Titian's Venus, like Goltzius's Danaë, is laid on a bed billowing with cushions; both women are tilted forward as if presented for the spectator's delight.

Van Mander remarked on the deep impact Venetian art had on Goltzius, particularly "the fine modelling and chiaroscuro by Titian, in the beautiful textures and silks in works by Veronese and those by other Venetian masters."[8] Danaë's elegantly proportioned figure, painted in glowing colors and warm shadows that melt around her form, is far removed from the marmoreal contortionists depicted in most contemporary history paintings in Holland, like the ones in Wtewael's *Lot and His Daughters* (cat. no. 16). Van Mander appreciated these features of the painting, pointing to Goltzius's obvious mastery of drawing and anatomy and praising especially the composition of the picture. In the *Schilderboeck* van Mander recommended studying from nature and carefully planning compositions. He apparently welcomed Goltzius's turn away from the mannerist excesses of Spranger and van Haarlem, embracing instead the appealing mix of classicism and naturalism characteristic of the Venetian Renaissance. In this respect the figure of Danaë heralds a new direction in painting in the Netherlands, one that would find its culmination in Rembrandt's extraordinarily personal representation of the subject in 1636 (Hermitage, Leningrad).

As noted, van Mander relates that the first owner of *Jupiter and Danaë* was Bartholomeus Ferreris, an important collector and friend of van Mander, who dedicated the section on Italian artists in the *Schilderboeck* to him. Whether Ferreris commissioned the work from Goltzius or purchased it later is unknown, but he was no doubt drawn to the Titianesque qualities of the picture, with its warm, rich colors and glowing nude. In the eighteenth century the painting belonged to Jeronimus Tonneman of Amsterdam; it later was in private collections in France and England before being sold in Sweden. The painting, surely Goltzius's masterpiece, was last seen publicly in Stockholm in 1935 before its rediscovery in 1984 in a Los Angeles warehouse.

RR

Detail

Notes

1. Pieter van Thiel, "Late Dutch Mannerism," in *Gods, Saints and Heroes: Dutch Painting in the Age of Rembrandt*, exh. cat. (Washington, D.C.: National Gallery of Art, 1980), 77.

2. Nichols, 157.

3. van Mander, 368–69.

4. Nichols, 157.

5. van Mander, 370.

6. *Gods, Saints and Heroes*, 92.

7. Panofsky, 203–7.

8. van Mander, 368.

Andromeda Chained to the Rock **Sir Anthony van Dyck**
Flemish, 1599–1641

1637–38
Oil on canvas
84¼ x 52 in. (215.3 x 132.1 cm)
Gift of The Ahmanson Foundation
M.85.80

PROVENANCE:

Possibly London, collection of the artist.

Possibly England, Earl of Pembroke.

England, Dunmore Park, Earl of Dunmore,
by 1834.

London, T. Humphrey Ward.

Paris, Charles Sedelmeyer (dealer), 1900.

Paris, Eugene Fischoff, 1901.

New York, Clement A. Griscom sale, American
Art Galleries, 26–27 February 1914, no. 28.

New York, Vanderlip Collection.

New York, sale, Christie's, 12 January 1978,
no. 56 (withdrawn).

Connecticut, Dudley Schoales, until 1984.

New York, Christophe Janet (dealer).

SELECT LITERATURE:

Gustav Friedrich Waagen, *Galleries and Cabinets
of Art in Great Britain* (London: John Murray,
1857), 457.

Lionel Cust, *Anthony van Dyck: An Historical
Study of His Life and Works* (London: George
Bell and Sons, 1900), 221, no. 91.

Ovid, in his *Metamorphoses* (4:665–739), tells the story of Andromeda, the
daughter of King Cepheus and Queen Cassiopeia of Ethiopia. The mother's claims
to beauty so angered the Nereids that Neptune sent a sea monster to ravage the
kingdom. To free the country from this scourge, Cepheus was forced to sacrifice
Andromeda. Van Dyck depicted the moment the terrified Andromeda, chained to
a rock near the monster's lair, is rescued from her fate by Perseus, who flies above
on his winged horse, Pegasus. The sea monster can be seen thrashing about in the
waves below. The subject was a popular one among artists of the sixteenth and
seventeenth centuries, offering the challenge of portraying the female nude in
distress. Both Rubens and Rembrandt painted the story of Perseus and Andromeda,
but this is the only known example by van Dyck, who rarely painted mythological
pictures.

Anthony van Dyck was born in Antwerp in 1599 and as early as 1618 was
accepted into the Guild of Saint Luke; the same year he is recorded as an assistant
in the studio of Rubens. After traveling to England with his mentor in 1620, van
Dyck set off for Italy in 1621, spending the next seven years there. In Italy he worked
in Genoa, Rome, and Venice, where he was profoundly affected by the art of Titian.
Like Rubens, van Dyck became one of the most successful and distinguished
painters of the seventeenth century. He traveled widely and enjoyed the patronage
of the major courts of Europe, painting religious pictures as well as portraits.
On the basis of his international reputation van Dyck was called to England by
King Charles I in 1632, remaining there, except for brief trips to Europe, until his

death in 1641. Van Dyck's effect on the development of art in England cannot be overestimated, and the influence of his style, particularly with regard to portraiture, resonated well into the nineteenth century. Soon after his arrival at the court of Charles, van Dyck was appointed "principalle Paynter in ordinary to their Majesties," and in 1633 he was knighted. He enjoyed exclusive rights in painting the monarch and the royal family, and his output in England is distinguished especially by his dynamic equestrian portraits of Charles as well as portraits of the aristocracy. In mid-seventeenth-century England there was little demand for the large-scale historical painting that flourished on the Continent, and van Dyck painted only a handful of subject pictures during his years in London. Prior to the reappearance of *Andromeda Chained to the Rock*, only one mythological painting from the artist's period in England was known. This was the *Cupid and Psyche* (Royal Collection, London, fig. 36a), a picture commissioned by Charles in the late 1630s for the King's Gallery at Whitehall.[1]

FIG. 36b
Titian, *Perseus and Andromeda*, 1554–56, oil on canvas, 72 x 78⁵/₁₆ in. (182.9 x 198.9 cm), Wallace Collection, London.

Notes

1. Christopher Brown, *Van Dyck* (Ithaca: Cornell University Press, 1983), 186–88, fig. 187.

2. The author is grateful to Dr. Brown for sending a draft of an article he is preparing on the painting.

Stylistically *Andromeda* compares well with *Cupid and Psyche*, and there can be little doubt that it was painted at the same time, around 1637–38. In each the somber earth tones of the landscape elements provide a muted background for the softly modeled forms of the figures. In both paintings van Dyck accented the composition with passages of brilliantly painted drapery; the highly saturated metallic blue of the cloth around Andromeda appears to be the same studio prop used for the drapery of the sleeping Psyche. In the London picture, however, the figures are smaller and more integrated with the landscape setting than in the Los Angeles painting, where the statuesque female form dominates the composition. Here van Dyck turned for inspiration to Titian's *Perseus and Andromeda* of 1554–56 (fig. 36b), now in the Wallace Collection, London, but which at the time was owned by van Dyck himself, one of nineteen pictures ascribed to the Venetian painter that he possessed. The soft, painterly traces of the brush and the warm, tactile evocation of flesh are direct responses to the sensuous passages of paint in the Titian, but whereas Titian's painting gives equal emphasis to both Perseus and Andromeda, van Dyck concentrated on the form of the woman, extracting in effect Titian's nude and adapting her pose to fit the extreme verticality of the picture. In the Titian the threat to the heroine is immediate and real, and the intervention of Perseus comes in the nick of time; van Dyck, however, banished Perseus to the distant sky, and the miniature sea monster presents little danger to the heroine. As Christopher Brown indicates, van Dyck showed minimal interest in the narrative moment, and consequently the pose of Andromeda is unclear, her head turned away from the action.[2]

This fascination with the nude figure at the expense of a persuasive iconographic structure results from the fact that the features of Andromeda represent Margaret Lemon, van Dyck's mistress in London until 1639, when he married Mary Ruthven, one of the queen's ladies-in-waiting. Several depictions of Margaret by van Dyck, including a portrait painting in the Royal Collection, compare closely with the woman posed as Andromeda. Given the personal relationship between the artist and model, it is extremely likely that the painting was a private work done for himself or his mistress.

Van Dyck used the mythical story as a pretext to paint a portrait of his lover on a grand scale usually reserved for his images of English court society (but in this instance the sitter wears no clothes). The effect is on a par with Rubens's celebrated painting of Hélène Fourment in a fur wrap, known as *Het Pelsken* (Kunsthistorisches Museum, Vienna). Van Dyck's picture, like Rubens's painting, is best understood when the personal feelings behind it are known.

RR

Hagar and the Angel

PIETER LASTMAN
Dutch, 1583–1633

1614

Oil on panel

20 x 26⅞ in. (50.8 x 68.3 cm)

Signed at lower left, on rock: PL / 1614

Purchased with funds provided by The Ahmanson Foundation, Mr. and Mrs. Stewart Resnick, Anna Bing Arnold, Dr. Armand Hammer, and Edward Carter in honor of Kenneth Donahue

M.85.117

PROVENANCE:

Paris, private collection.

Paris, Didier-Aaron.

New York, Frederick Mont (dealer), until 1976.

Los Angeles, Mr. and Mrs. Bernard Solomon (on loan to the museum until 1985).

New York, sale, Sotheby's, 6 June 1985, no. 76.

SELECT LITERATURE:

Unpublished.

Pieter Lastman was the leading artist in Amsterdam in the generation before Rembrandt. Primarily a painter of biblical scenes, he was the dominant influence on a group of artists, sometimes referred to as the "Pre-Rembrandtists," who were instrumental in breaking with the sophisticated and exaggerated forms of the Northern mannerists (exemplified by Joachim Wtewael, cat. no. 16). Such artists as Jan Pynas and Claes Cornelisz Moeyaert instead forged a style based on naturalistic detail and narrative clarity, inspired by the art of Caravaggio and the German expatriate Adam Elsheimer, whose works several of them had seen in Italy.[1]

Lastman himself was in Italy in 1603–4, where he most likely visited Venice and Rome. By 1607 he was back in Amsterdam, apparently staying there the rest of his life. His large and active studio trained a number of artists, including Jan Lievens and Rembrandt, who spent six months with Lastman in 1622–23. Lastman painted few works on commission, preferring to work for the burgeoning Dutch art market. When he died in 1633, he was lauded as being among Holland's greatest artists.

Hagar and the Angel, signed and dated 1614, is an excellent example of the type of small, carefully composed, and brilliantly polished religious picture through which Lastman gained his reputation. Its clear dramatic structure and appealing naturalism recall the new Italian style of Caravaggio, while its small format and meticulous finish are indebted to the intimate cabinet paintings of Elsheimer.

Genesis 21:9–21 tells of Abraham's banishment of his slave Hagar and their illegitimate son, Ishmael, to the wilds of Beersheba. The mother and child soon ran out of water, and Hagar, not wanting to watch her son die, laid him under a bush. An angel then appeared to her and asked: "What aileth thee, Hagar? Fear not; for God hath heard the voice of the lad where he is." Explaining that God intended for Ishmael to found a great nation, the angel then revealed a source of water from which Hagar and Ishmael could drink.

FIG. 37a
Pieter Lastman, *Hagar and the Angel*, 1600, pen, dark brown ink, and blue, purplish brown, and gray wash heightened with white, 9⁹⁄₁₆ x 15¹¹⁄₁₆ in. (24.3 x 39.8 cm), Yale University Art Gallery, New Haven (1961.64.6).

Notes

1. Astrid Tümpel, et al., *The Pre-Rembrandtists*, exh. cat. (Sacramento: Crocker Art Gallery, 1974), 15–43.

Lastman concentrated on the essential elements of the story and organized the composition to maximize the inherent drama of the last-minute salvation. The exchange between Hagar and the angel is the central focus, and the dialogue between them is revealed within a dynamic of pose, gesture, and glance. Hagar is depicted leaning back from the picture plane, sprawled against a rock in a position that echoes the fitfully sleeping Ishmael. The angel of mercy counterbalances Hagar's pose; he surges toward the viewer, the arresting foreshortening of his body directly counterposing the tired resignation of Hagar's apathetic form. His energetic gestures—one muscular arm reaching out to indicate the dying Ishmael, the other cocked and aimed at the heavens—visualize the saving grace of God and make Hagar's heavy arms and splayed, inarticulate fingers all the more leaden and useless.

The clear narrative structure of *Hagar and the Angel*, coupled with convincing figures in a naturalistic setting, show Lastman as a master of history painting, while the work demonstrates his skills as a painter of landscape and still life as well. Of particular beauty is the fecund vine growing rapaciously behind Hagar. Its juicy fruit, glistening with dew, provides the only relief from the arid wasteland the characters inhabit. It is possible that Lastman intended this visually appealing detail as a symbol of the well that would soon be revealed by God.

Hagar and the Angel is a recent addition to Lastman's oeuvre, having been in a private collection in Los Angeles before it was acquired by the museum in 1985. Its early history is unknown, but in style and composition the painting is closely related to several of Lastman's small biblical pictures, such as the *Expulsion of Hagar* from 1612 (Kunsthalle, Hamburg) or the larger *Tobias Catching the Fish* from 1613 (Gemeentelijk Museum, Leeuwarden). The latter is particularly similar in the gestural interchange of the principal characters and the use of a vista on the left to open up the scene.

These characteristics appeared in nascent form in a drawing by Lastman from 1600 that also illustrates the story of Hagar and the Angel (Yale University Art Gallery, New Haven, fig. 37a). In this earlier rendition Lastman rather awkwardly used the mannerist device of placing the figures completely to one side and leaving the other side open to a distant landscape. There is little of the urgency that characterizes the Los Angeles painting, and Lastman neglected to include the dying Ishmael. By the time he painted the museum's panel, Lastman had completely rejected the mannerist conventions that characterize the Yale drawing. He was now responding to the new naturalistic painting he had seen in Italy. The innovations he mastered and introduced to Dutch painters in Holland would see their greatest expression in the art of Rembrandt.

RR

Madonna and Child

JACOPO BELLINI
Italian (Venice), c. 1400–1470/71

c. 1465
Oil on panel
27⁷⁄₁₆ x 18½ in. (69.7 x 47.0 cm)
Inscribed in rondels: M.P θ.V; on halo:
*AVE*MARIA*GRATIA*PLENA*DOMINUS*TE[CUM]
Gift of The Ahmanson Foundation
M.85.223

PROVENANCE:

France, private collection.
Monaco, sale, Sotheby's, 25 June 1984,
no. 3332.
New York, Piero Corsini (dealer).

SELECT LITERATURE:

Keith Christiansen, "Venetian Painting of the
Early Quattrocento," *Apollo* 125, n.s. no. 301
(March 1987): 171, pl. 5, 174, 176–77.

Colin Eisler, *The Genius of Jacopo Bellini: The
Complete Paintings and Drawings* (New York:
Abrams, 1989), 46, 56, fig. 41, 298, 514.

Jacopo Bellini was the patriarch of the most important artistic dynasty in Renaissance Venice. His sons Giovanni and Gentile became the leading Venetian painters of the late fifteenth century. Little is known about Jacopo's early life; he was evidently born in Venice about 1400 and is first recorded as a painter in 1424. According to Vasari, Bellini was a student of Gentile da Fabriano, the premier exponent of the courtly International Gothic style. It is likely that during the early 1420s Bellini was in Florence as an apprentice in Gentile's studio, although he may have known him as early as 1408–14, when the latter was in Venice.

Following his apprenticeship with Gentile, Bellini worked for the Este court in Ferrara; it was there in 1441 that he bested Pisanello in a competition to make a portrait of Lionello d'Este. The court in Mantua attracted some of the most celebrated figures in Italy, and it is likely that Bellini met there the great humanist and theorist Leon Battista Alberti. (Bellini's *Annunciation*, painted in 1444 for the church of San Alessandro in Brescia, shows an understanding of Albertian principles of one-point perspective.) By 1452 Bellini was back in Venice; for the remainder of his career he worked on numerous public and private commissions in the Veneto. Many of his paintings are lost, but his artistic personality is known through two extraordinary drawing albums (Louvre, Paris, and British Museum, London). These huge collections of sketches, which may have also served as model books for paintings, demonstrate his absorption of Renaissance innovations in the study of science, nature, and the antique.

This beautiful and well-preserved *Madonna and Child* is a recent addition to Bellini's oeuvre. It captures to a remarkable degree the artist's proclivity for blending archaic and naturalistic forms in his small, private devotional pictures. Bellini presents the Madonna in half-length against a black background, cradling in her arms the small Christ Child, who snuggles closer, tugging on his mother's mantle. Yet, Bellini cannot break completely free from the Gothic devotion to pattern and ornamentation he learned during his apprenticeship with Gentile: the

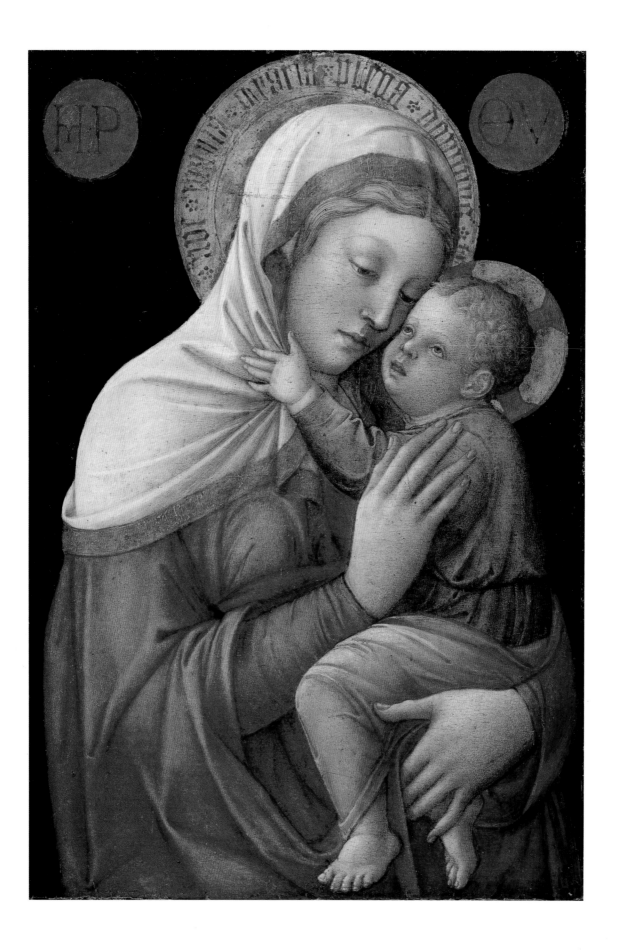

dark background emphasizes the contours of the figures, while the repeated folds of the draperies take on a decorative interest of their own. The artist intensified the surface adornment by painting utterly flat, gold halos on the Madonna and Child and rondels in the upper corners. The rondels are inscribed with Greek initials, "M.P" and "θ.V," meaning "Mother of God." The Virgin's halo bears, in Latin, the angel Gabriel's salutation to Mary during the Annunciation (Luke 1:28): "Hail Mary, full of grace, the Lord is with thee."

This Byzantine decorative quality is softened in the work by the surprisingly volumetric forms of the figures. Bellini's usual practice in such pictures was to place the Virgin frontally, eyeing the viewer, with the Child standing before her on a parapet (an example is the *Madonna and Child* in the Galleria dell'Accademia, Lovere) or held stiffly in her arms (such as the *Madonna and Child* in the Uffizi Gallery, Florence).[1] The result was invariably a static composition that denied the solidity of masses in favor of the contours of forms. In this painting, however, the Virgin has been turned three-quarters to the right, away from the viewer, to the embrace of her son. Her right shoulder projects strongly, as does Jesus's left knee, and the complex overlapping of arms, legs, and hands creates a subtle but nonetheless palpable plasticity that is unique in Bellini's *Madonna* panels. The resulting naturalism lends the picture an intimacy and sweetness that is stronger and more appealing than in other renditions of the theme.

The sculptural quality that is the distinguishing feature of the work is a good example of the interchange of ideas between sculptors and painters in the quattrocento. In the fifteenth century the influence most often flowed from the sculptor's chisel to the painter's brush; the naturalism and solidity of forms found in Masaccio's paintings, for example, owe their innovations to the works of Donatello, the greatest Italian sculptor of the century.[2] In Venice, where the archaic Byzantine tradition had a stronger hold on artists, such influence was less pronounced. A rare exception is a famous drawing by Bellini, datable to the 1450s, in the Louvre album (R.F. 1536, Index 74); inscribed "Mater Omnium" by the artist, it depicts a standing Madonna, flanked by two musical angels, holding the Christ Child.[3] The drawing was clearly inspired by full-length public sculptures of the Madonna and Child readily known to Bellini, such as the one in the Mascoli Chapel in San Marco, Venice, which dates from around 1430.

Bellini's *Madonna and Child* is his only known painting based on an identifiable sculptural prototype. Its composition was drawn directly from a relief by Donatello, known through several copies, such as the one illustrated here (fig. 38a). (A partially autograph version, datable to around 1425, was recently identified in the Armenian S.S.R. Art Gallery, Yerevan; its composition is closer still to the Bellini.[4]) Bellini turned to the Donatello relief for the salient features of his painting, such as the placement of the hands and the tender embrace of the mother and child. It is in the volumetric falls of drapery, however, which circumscribe the anatomical forms beneath, that the museum's painting assumes the dynamic palpability of its sculptural model.

The uniqueness of the painting compared with Bellini's other treatments of the theme has led to some debate over the picture's date. Colin Eisler suggests it was painted in the early 1450s, on the basis of the painting's relationship to the Mater

FIG. 38a
Style of Donatello, *Virgin and Child*, c. 1425,
polychrome stucco relief, 31 x 25⅛ in.
(78.7 x 63.8 cm), by courtesy of the Board of
Trustees of the Victoria and Albert Museum,
London.

Notes

1. Eisler, 53, fig. 38, 57, fig. 43.

2. Paul Joannides, "Masaccio, Masolino and
'Minor' Sculpture," *Paragone* 38, no. 451
(September 1987): 3–24, especially 4–5, 20,
n. 10, plates 2–3.

3. Eisler, 264, pl. 138, 503.

4. Charles Avery, "Donatello's Madonnas
Reconsidered," *Apollo* 124, n.s. no. 295
(September 1986): 176, fig. 2.

Omnium drawing. Keith Christiansen, however, argues that the painting's incisive
naturalism and convincingly solid forms point to a date well past Bellini's static,
frontal depictions of the theme, which are usually thought to have been produced in
the 1440s and 1450s; he suggests instead 1460–65. Indeed the Los Angeles *Madonna
and Child* seemingly heralds a new period of Venetian art, one governed by warm
colors and sensual passages of paint. The innovative implications of the picture
would be advanced further by the paintings of Bellini's sons Gentile and Giovanni
and son-in-law, Andrea Mantegna.

The Los Angeles *Madonna and Child* departs from Bellini's other versions of the
subject iconographically as well as stylistically. Christiansen points out that the
Greek inscriptions on the rondels owe their appearance to the influence of
Byzantine icons; moreover the tender relationship between the mother and child is
related to the Byzantine *Glykophilousa*, or affectionate Madonna and Child type. Such
a direct recollection is a testament to the enduring fascination Venetian artists had
for Eastern Orthodox formulas. Yet it is as much an outgrowth of the Donatello
reliefs. Here, as in those prototypes, the intimate, even melancholy, communion
between the Madonna and Christ predicts their final embrace at the foot of the
cross. Mary knew her child's fate was predestined, but in this panel, intended for
private devotion, her metaphysical knowledge cannot contain her human emotion.
Ultimately it is this subtle psychological drama that places the *Madonna and Child*
wholly within the Renaissance tradition.

RR

*Still Life with Oysters
and Grapes*

JAN DAVIDSZ DE HEEM
Dutch, 1606–84

1653
Oil on panel
14¼ x 20⅞ in. (36.2 x 53.0 cm)
Signed at upper left: J. de Heem f. Ao 1653
Gift of The Ahmanson Foundation
M.86.95

PROVENANCE:
Cologne, Baron Albert Oppenheim, 1875–1914.
Berlin, Oppenheim sale, Lepke, 27 October 1914, no. 17.
Germany, Gerard Oliven, 1927/28–c. 1938.
England, Gerard Oliven, c. 1938–45.
United States, Gerard Oliven, 1945–85.
New York, sale, Christie's, 5 June 1985, no. 156.
Zurich, David Koetser (dealer).

SELECT LITERATURE:
Unpublished.

In seventeenth-century Holland still life was one of the most popular categories of painting. Various artists specialized in its different forms: vases of flowers, *vanitas*, breakfast settings, trompe l'oeil, and *pronkstilleven* (ostentatious still life). For the sheer variety and ambition of his oeuvre de Heem is considered the greatest still-life painter of the period. He was born in the Dutch city of Utrecht but early in his career worked in Leiden, where his paintings were influenced by the still lifes of Balthasar van der Ast. By 1636 he had established a studio in Antwerp, the leading artistic center of Flanders; the same year he was accepted into that city's Guild of Saint Luke. Shortly thereafter he must have met David Teniers the Younger, collaborating on that painter's *An Artist in His Studio* (cat. no. 2). De Heem is known to have returned to his native city several times; between 1669 and 1672 he is listed as a member of the Utrecht guild. Around 1672 he moved again to Antwerp, where he lived out the rest of his life. His paintings had a profound impact on subsequent still-life painters such as Pieter de Ring, Nicolaes van Gelder, and especially Abraham van Beyeren (cat. no. 40).

The fact that de Heem divided his career between Utrecht and Antwerp was significant for the development of still-life painting in northern Europe, for in many ways his art unites the two traditions that had arisen in the Netherlands. Early in his career de Heem emulated the restrained, predominantly monochromatic style of such Dutch compatriots as Pieter Claesz and Willem Heda. Paintings like *Pronk Still Life with a Nautilus Cup*, signed and dated 1632 (University of Birmingham, Barber Institute of Arts), are characterized by simple and carefully balanced compositions and were painted in warm tones, occasionally accented by the pale yellow of a peeled lemon or the glint of a silver plate.

By the 1640s, however, de Heem's still lifes had become more sumptuous, both in technique and subject. In these pictures he introduced bright passages of color and imported luxury items such as lobsters and rare shells. Correspondingly his

technique became more self-conscious, with lavishly orchestrated compositions and more obvious displays of his painterly virtuosity. De Heem reached a pinnacle in this later style with the *Pronk Still Life with Shells* of 1642, a huge and complex picture that includes not only lobsters, rare shells, and fruit but also musical instruments, a vase of flowers, ornate silver, columns, fluttering drapes, and a landscape view in the distance.[1] This change in his approach can be traced to the artist's move to Antwerp and the high baroque manner he would have observed there in the sumptuous and broadly painted still lifes of such artists as Frans Snyders.

Still Life with Oysters and Grapes, which is in an extraordinarily good state of preservation, was painted during de Heem's first Antwerp period and is a fascinating synthesis of his early Dutch and subsequent Flemish painting styles. Its deceptively simple composition, with the props arranged on a rough-hewn table placed before a cracked and pitted wall, recalls the still lifes of Claesz, who had earlier brought his sober and restrained style to a supreme degree of perfection in such works as *Still Life with Herring, Wine, and Bread* (fig. 39a). As Claesz did in his picture, de Heem used a simple diagonal (rising in this case from lower left to center right) to organize the seeming disarray of his composition. Within this austere arrangement, however, he painted a great variety of objects, and the density of the composition and the sensuousness of the handling of paint are of a piece with his large-scale banquet table pictures.

A large number of elements, from luminous grapes, succulent oysters, and a fresh hazelnut to a pewter saltcellar, crystal wine glass, and coarse cloth, are placed at eye level close to the picture plane, inviting the viewer to marvel at de Heem's mastery in the depiction of contrasting textures and reflected light. The drops of water that roll off the oyster shells and the ants scurrying over the grapes are common trompe l'oeil devices. De Heem made the illusion complete by painting the corner of the background wall out of focus, thereby creating a startling leap in space from the crystalline clarity of the grape leaves in the foreground. This technique suggests that the artist employed an instrument such as a camera obscura.

The convincing realism and technical bravura of *Still Life with Oysters and Grapes* would certainly have been enough to appeal to the tastes of a cultivated seventeenth-century art lover. Dutch and Flemish still lifes, however, originally were understood to contain moralizing or cautionary messages as well. The paintings held hidden meanings beneath the superficial beauty of the objects depicted.[2] De Heem's painting warns of the impermanence of natural beauty and the vanity of pursuing earthly pleasures; the fruit, after all, will decay (one leaf is beginning to turn), the ants will eat the grapes, and the oysters will spoil. The transient nature of life is symbolized by the caterpillars, which will metamorphose into butterflies like the one at left. Not all the objects in the work caution against worldly indulgence, however; some testify to the enduring role of the Reformed Church in combating hedonism and materialism. This accounts for the inclusion of the prominent wine glass and bread in the center of the picture, reminding the viewer of God's saving grace through the Eucharist.

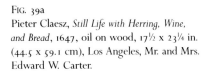

FIG. 39a
Pieter Claesz, *Still Life with Herring, Wine, and Bread*, 1647, oil on wood, 17½ x 23¼ in. (44.5 x 59.1 cm), Los Angeles, Mr. and Mrs. Edward W. Carter.

Notes

1. Formerly Bergsten Collection, Stockholm; see Sam Segal, *A Prosperous Past: The Sumptuous Still Life in the Netherlands 1600–1700*, exh. cat. (The Hague: SDU Publishers, 1988), 146, fig. 8.3.

2. Ingvar Bergström, *Dutch Still-Life Painting in the Seventeenth Century*, trans. Christina Hedström and Gerald Taylor (New York: Thomas Yoseloff Inc., 1956), 154–59.

3. Segal, 147–48.

With its cautionary messages regarding the transience of life and salvation through Christ, *Still Life with Oysters and Grapes* continues the vanitas tradition of painters like Claesz. If the moralizing references occasionally seemed too oblique, de Heem sometimes drove the point home by adding allegorical inscriptions that spelled out the underlying meaning of his paintings. One picture carried the dictum, "No matter how you squirm or squeak, oh Man, this is your Fate: Whether rich or poor, learned or dumb, what lives, must die." The meaning of a work like *Still Life with Oysters and Grapes*, which does not bear any such inscription, may not have been so severe. In its careful balance of restraint in composition and beauty in technique, it is better served by another of de Heem's mottoes: "Not how much but how noble."[3]

RR

Banquet Still Life

ABRAHAM VAN BEYEREN
Dutch, 1620/21–90

1667
Oil on canvas
55½ x 48 in. (141.0 x 121.9 cm)
Signed at center: .ABf. / 1667.
Gift of The Ahmanson Foundation
M.86.96

PROVENANCE:

Rome, Pietro Camuccini, until 1833.

Rome, Giovanni Battista Camuccini,
until 1856.

Alnwick Castle, Algernon Percy, Fourth Duke
of Northumberland, by 1865, then by descent.

London, Thomas Agnew and Sons (dealer),
1978.

New York, Hermann Schickman (dealer).

SELECT LITERATURE:

Sam Segal, *A Prosperous Past: The Sumptuous Still
Life in the Netherlands 1600–1700*, exh. cat. (The
Hague: SDU Publishers, 1988), 175–77, 247,
no. 52.

In contrast with the relative sobriety of de Heem's *Still Life with Oysters and Grapes* (cat. no. 39), Abraham van Beyeren's *Banquet Still Life* creates an overwhelming impression of abundance. A profusion of luxury goods has been brought together in a complex orchestration of form, space, and light. The composition centers on a sparkling parcel-gilt standing cup with a dolphin stem, around which is placed a variety of rare objects, both natural and man-made: a silver or pewter bowl with oysters and a lemon on top of a hinged wooden storage box, a silver-gilt tazza with a cut melon and peach, a Dutch or Venetian covered goblet, a dish embossed with flowers filled with grapes and peaches atop a wicker basket, and a late Ming bowl with pomegranate slices. In the immediate foreground, hanging over the marble slab as if about to tumble out of the painting, van Beyeren placed a silver salver upon which stand two wine-filled *roemers*, a peach, and an agate-handled knife; immediately to the left is an open pocket watch, a bright red lobster, and a peeled lemon, whose rind dangles dramatically against the dark background.

Van Beyeren, the son of a glass painter, was born in The Hague, where he spent most of his career. Although he was a prolific and popular artist, he apparently suffered from financial difficulties; in 1657 he moved to Delft, perhaps to avoid his creditors. He returned to his native city in 1663 but left again in 1669 for Amsterdam. The remainder of his life was spent traveling to different cities in the Netherlands.

In the second half of the seventeenth century van Beyeren was the foremost practitioner of the *pronkstilleven*. Frequently large in scale, these paintings usually depict lavish table settings of precious objects and rare foods, often presented in sumptuous surroundings. *Banquet Still Life*, signed and dated 1667, is one of his most ambitious paintings. It incorporates many of the same objects and spatial and lighting effects of the large *Still Life* of 1666 in the M. H. de Young Museum in San Francisco (fig. 40a). Van Beyeren undoubtedly owned many of the rarities shown and used them frequently as studio props.

FIG. 40a
Abraham van Beyeren, *Still Life*, 1666, oil on canvas, 55 x 46 in. (139.7 x 116.8 cm), the Fine Arts Museums of San Francisco, gift of the de Young Museum Society (51.23.2).

In the mid-seventeenth century the Dutch Republic was one of the wealthiest and most powerful countries in the world. Its standard of living was the highest in Europe, and domestic goods, in particular foodstuffs, were abundant. The ruling class was for the most part drawn from the urban bourgeoisie, and it was through the ownership of rare and fine consumer products that they asserted their status. A painting such as *Banquet Still Life* was a celebration of the owner's wealth and the culture's vitality. The diversity of the exotic objects gathered here is in one sense testimony to the success of the Dutch economy, whose strength was drawn primarily from overseas trade. Yet in keeping with the puritanical nature of seventeenth-century Dutch society, the pronk still life had to be more than an index of prosperity. Proud of his worldly success, the Dutchman nonetheless would have been wary of falling prey to material temptations and necessarily would have had ambivalent feelings about such lavish displays of wealth. In de Heem's *Still Life with Oysters and Grapes* the moral underpinnings of the picture are clear, and the dichotomy between the pleasurable world of the senses and the virtuous life in Christ is delicately balanced. In certain details *Banquet Still Life* continues this tradition; despite the alluring beauty of the painting the viewer is gently warned against succumbing to its enticements. For example, the mouse that sits on the silver plate in the foreground is a popular symbol of decay; the timepiece near the lobster is a reminder of the transient nature of wealth and power and an emblem of temperance. The implication is that the objects depicted here are impermanent and will, like other worldly things, tarnish and spoil.

In the face of the beauty and artistry of *Banquet Still Life*, however, the moral message is in no way paramount. The sumptuousness of the pronk still life also resided in the style of the painting, and van Beyeren's was distinguished as the most lavish of all. In *Banquet Still Life* the rich and bold application of paint, dazzling effects of color, and dramatic orchestration of lighting are as much the signs of its ostentatiousness as the rarefied objects depicted. Van Beyeren's technique draws attention to the picture's surface, where his artistry becomes the true subject. As a unique, handmade work of art, the painting itself becomes a pronk object. It celebrates van Beyeren's genius and testifies to the enduring power of art. The dictum *ars longa, vita brevis* (art is long, life is short), popular in seventeenth-century artistic discourse, is no better exemplified than in the flamboyant self-assertion of this painting: the fruit, lobster, and even the silver have long disappeared, as indeed have the original owner and his wealth, but van Beyeren's painting continues to delight and impress.

RR

Forest Clearing with Cattle

PHILIPS KONINCK
Dutch, 1619–88
and
ADRIAEN VAN DE VELDE
Dutch, 1636–72

c. 1665–70
Oil on canvas
34¼ x 40½ in. (87.0 x 102.9 cm)
Signed at lower left: P. Koninck
Gift of The Ahmanson Foundation
M.86.97

PROVENANCE:
Letitia Bonaparte.
Alton Towers, England, The Right Honorable Bertram Arthur, Earl of Shrewsbury.
London, sale, Christie's, 7 July 1857, no. 140.
London, Anthony (dealer).
Lockinge House, Berkshire, S. Jones Loyd, later Lord Overstone, 1867.
Lockinge House, Lady Wantage, by 1883.
Lockinge House, A. Thomas Loyd.
Zurich, Bruno Meissner (dealer).

SELECT LITERATURE:
Horst Gerson, *Philips Koninck* (Berlin: Mann, 1936), 37–38, 106, no. 30, pl. 13.
Wolfgang Stechow, *Dutch Landscape Painting of the Seventeenth Century*, 2d ed. (New York: Phaidon Press, 1968), 80.
Werner Sumowski, *Gemälde der Rembrandt-Schüler* (Landau: Edition PVA, 1983), 3:1549, no. 1068, 1618.

One of the great landscape painters of the seventeenth century, Philips Koninck is best known for his panoramic views of the Dutch countryside, which were his specialty. During his lifetime he was also esteemed for his genre scenes, portraits, and history paintings, an aspect of his oeuvre now little known. The son of an Amsterdam goldsmith, Koninck trained with Jacob, his older brother, in Rotterdam. He spent the rest of his career in Amsterdam, where he may have studied with Rembrandt in 1641.

Koninck's early landscape style was influenced by those of Hercules Seghers and Rembrandt, but by the mid-1650s he had developed his own distinctive type of landscape, which he would repeat and vary throughout his career. These are long, open views across the flat Dutch countryside, seen from a high vantage point. Often large in scale, such paintings as the *Panorama with Cottages Lining a Road* of 1655 (Rijksmuseum, Amsterdam) and the grandiose *Panoramic Landscape* of 1665 (J. Paul Getty Museum, Malibu, fig. 41a) were divided by Koninck into compositions of land and sky, exploring the evocative power of space, light, shadow, and cloud patterns.

Forest Clearing with Cattle, which dates from about 1665–70, departs radically from the motif the artist had favored throughout his career as a landscapist. While the viewpoint of the picture is still slightly raised, here Koninck depicts an intimate corner of nature rather than a sweeping panorama. A small clearing in a thinly wooded parkland is the focus of the work; little attention is paid to the cloud-filled sky, which usually dominates Koninck's pictures. In the foreground is a shallow pond, to which several cattle have strayed from their herd to drink. They are silently

watched by a herdsman, who stands at ease next to his dog. Some sheep wind their way along the rutted path, coaxed by a shepherd who walks beside a peasant woman holding a basket on her head. At the foot of a gnarled oak at left a woman and child rest at the side of the road; in the background a horse-drawn carriage slips behind a tree trunk.

The building whose rooftop rises above the copse of trees at the right of the composition has not yet been identified, although it appears to represent an actual structure. Indeed the scene depicted in the painting has the appearance of a known locale, perhaps a parkland at the edge of a town or the grounds of a country estate visited by Koninck. The incisive naturalism with which he rendered the forest glade, with its lush foliage just beginning to turn color and warm light that filters through the branches, only strengthens this possibility. If this is the case, however, the painting would be an anomaly in Koninck's oeuvre, in which the landscapes are usually imaginary.

The delicacy with which Koninck balanced the compositional elements in *Forest Clearing* and the even light that pervades the whole lends the setting an air of repose, a sylvan elegance that is uncharacteristic of his generally moody and dramatic panoramic views. Koninck painted several other pastoral views such as this, all of which date from the 1660s and 1670s, a period when the artist was apparently drawn to the landscapes of Paulus Potter and Adriaen van de Velde. Potter's *Departure for the Hunt* of 1652 (Staatliche Museen, Berlin) was clearly a model for the Los Angeles painting, with its widely spaced trees lit from behind and depictions of animals and travelers.

It is not certain what motivated Koninck to paint these intimate, down-to-earth landscapes late in his career. It is possible that he was encouraged by van de Velde, who in fact painted the animals and figures in this one. In mood and composition it is clearly dependent on the forest paintings of the younger artist, such as his *Forest Glade* of 1658 (Städelsches Kunstinstitut, Frankfurt). Perhaps uncomfortable with the task of painting prominent figures and animals, which usually appear much smaller in his panoramic scenes, Koninck turned to van de Velde; the latter was one of the most popular staffage painters in Holland and was frequently employed to adorn the landscapes of Jacob van Ruisdael, Meindert Hobbema, and Jan van der Heyden, among others.

In addition to painting pictures, Koninck owned and operated an inland shipping company. A prosperous member of the thriving Dutch middle class, he was acquainted with a number of Amsterdam's prominent citizens, including the poet Joost van den Vondel, for whom he painted several works. Despite his growing reputation as an artist Koninck apparently ceased to paint in the late 1670s.

RR

FIG. 41a
Philips Koninck, *Panoramic Landscape*, 1665, oil on canvas, 54½ x 65½ in. (138.4 x 166.4 cm), collection of the J. Paul Getty Museum, Malibu, California (85.PA.32).

Apollo and Phaëthon

GIOVANNI BATTISTA TIEPOLO
Italian (Venice), 1696–1770

c. 1731
Oil on canvas
25¼ x 18¾ in. (64.1 x 47.6 cm)
Gift of The Ahmanson Foundation
M.86.257

PROVENANCE:
Paris, Veil-Picard Collection, until c. 1960.
Switzerland, private collection.
London, sale, Sotheby's, 11 December 1985,
no. 19.
New York, Bob P. Haboldt & Co. (dealer).

SELECT LITERATURE:
Unpublished.

When Giambattista Tiepolo was called from his native Venice in 1730 by the Archinto family to decorate their palace in Milan, he was embarking on a career that would establish him as Europe's foremost decorative painter. Tiepolo had studied with Gregorio Lazzarini, but it was the vast ceiling paintings by Paolo Veronese, the sixteenth-century master, and the impressive altarpieces of Giovanni Battista Piazzetta, Tiepolo's contemporary, that had the most profound effect on his art. As early as 1726 Tiepolo was referred to as a "celebre Pittor" (by the Udine town council), and his fresco decorations, along with his sketches and easel paintings, were soon in high demand throughout Europe. He would enjoy an illustrious international career, working for the courts of Würzburg and Madrid before dying in Spain in 1770.

Apollo and Phaëthon is an extremely important record of Tiepolo's painting cycle at the Palazzo Archinto, which was destroyed by bombs in 1943. Unpublished and unknown to the scholarly community before it appeared at auction in 1985, the painting is directly related to a fresco that decorated the ceiling of one of the four reception rooms in the palace. It tells the story of the semidivine Phaëthon, who sought to prove his mother's assertion that he was the son of the god Apollo. He did this by coaxing Apollo into allowing him to drive the Chariot of the Sun, which the sun-god guided across the zodiac to usher in each new day. Apollo, who actually was Phaëthon's father, reluctantly agreed, but the young man, unable to control the feisty stallions in their charge across the sky, flew too close to the earth, scorching it and creating the deserts of Africa. The planet was spared total immolation by Jupiter, who halted Phaëthon's ill-advised ride by knocking him from the chariot with a thunderbolt.

Tiepolo did not paint the more commonly depicted episode in the story, Phaëthon's fall, but the earlier moment, when the youth begs his father's permission to lead the horses. In the center of the composition stands the radiant Apollo before his temple, his hand raised in protest to the entreaties of Phaëthon, who gestures to the grand chariot below. The fierce horses that pull it are barely kept in check by a number of nymphs and putti. Tiepolo clearly read his Ovid carefully, incorporating

its vivid description of what Phaëthon saw on Olympus, noting in particular the personifications of the four seasons, which he grouped at the right edge of the painting: "Here Spring appears with flow'ry Chaplets bound; here Summer in her wheaten Garland crown'd; here Autumn the rich trodden Grapes besmear; and hoary Winter shivers in the Rear" (*Metamorphoses* 2:23–30). In the left distance the zodiac arcs across the sky with Scorpio prominent in the center, alluding to a part of the story where Phaëthon drops the reins after being frightened by the scorpion. Saturn, the god of time, swoops into the scene at the top, his form seen in vertiginous foreshortening.

The fresco cycle to which *Apollo and Phaëthon* relates was commissioned by Alberico Archinto, an immensely urbane and well-traveled vice-legate to Pope Clement XII and a friend of the neoclassical painter Anton Raphael Mengs and the art historian J. J. Winckelmann. Tiepolo received the commission in 1730 and, as documented in a letter written by the artist, was still at work on it in April of the following year.

The cycle was dominated by a large *Allegory of the Arts* in the main salon, which was dated 1731. Three mythological scenes—*Perseus and Andromeda*, *Juno, Fortune, and Venus*, and *Apollo and Phaëthon*—decorated adjacent rooms, while a fifth, smaller fresco represented *Nobility*. An oil study for the *Perseus and Andromeda* is in the Frick Collection, New York (fig. 42a).[1] It is unclear how these various subjects were related, although it is probable that a unifying iconographic program was intended. One thought is that the scheme presented an allegory of fame, fortune, and the arts. It has also been suggested that *Juno, Fortune, and Venus* was painted to celebrate a marriage of one of the members of the Archinto family, although there is no proof of this.[2] The Scorpio prominent in the sky of *Apollo and Phaëthon*, quite apart from the role it plays in the story, was also Alberico's astrological sign, a personal reference that would have appealed to the sophistication and erudition of Tiepolo's patron.[3]

Judging from photographs of the Palazzo Archinto, it is clear that the museum's oil sketch differs little from the finished fresco. The sketch's high degree of finish and the exactitude with which it follows the composition of the final work (including the scalloped border) indicate that it is most likely not a preliminary study but a *ricordo*, a small-scale version done after the ceiling painting. As such it was intended as an autonomous work of art, painted for the private delectation of a connoisseur, probably Archinto himself. It is indeed similar in finish and execution to the oil sketch of *Allegory of the Arts* (Museu Nacional de Arte Antiga, Lisbon), which is considered a ricordo. By contrast, the Frick *Perseus and Andromeda*, which is painted on paper rather than canvas, differs considerably from the related fresco and is thus more likely an actual *modello*. The excellent condition of the Los Angeles painting preserves all the deftness of the artist's brush, the sure-handed construction of the human form, and the sparkling dashes of color that flicker across the composition. Many of these fine touches would have been lost in the fresco itself, and it is for that reason that Tiepolo's smaller versions were prized by eighteenth-century collectors.

The complex perspective and virtuoso foreshortening that are the salient features of *Apollo and Phaëthon*, however, would have been most effective on the ceiling

FIG. 42a
Giovanni Battista Tiepolo, *Perseus and Andromeda*, c. 1730, oil on paper affixed to canvas, 20⅜ x 16 in. (51.8 x 40.6 cm), copyright the Frick Collection, New York.

Notes

1. *The Frick Collection: An Illustrated Catalogue* (New York: Frick Collection, 1968), 2:243–46.

2. Guido Zelbi, "Quattro affreschi Tiepoleschi nel Palazzo della Congregazione di Carità di Milano," *La Città di Milano* 1 (September 1920): 336. See 335–36, 338, fig. 8, for *Apollo and Phaëthon*, which is misidentified as the *Triumph of Aurora*.

3. It has been suggested that the seven stars that appear in the Frick *Perseus and Andromeda* have similar astrological significance; see *The Frick Collection*, 2:246.

4. Antonio Morassi, *A Complete Catalogue of the Paintings of G. B. Tiepolo* (London: Phaidon Press, 1962), 231 (under 1731).

5. For information regarding all works related to the Archinto commission see Morassi, 3, fig. 242, 16, fig. 338, 25, figs. 239, 252, 264, 336–37, 34, fig. 251, 61, fig. 238, 66.

itself. Tiepolo's frescoes in the Palazzo Archinto, with their astounding mastery of illusionistic space, were singled out for praise in the 1737 edition of Lattuada's *Descrizione di Milano*: "Visitors admitted into the rooms of [the Palazzo Archinto] can enjoy many pictures by the most excellent masters, . . . as also the frescoes done in the vaults of the new rooms by the celebrated Venetian Tiepolo."[4]

There is an oil sketch (formerly Bruini Collection, Venice) that is similar in composition to the central area of the Los Angeles picture, but it probably dates to an earlier period. Two others, in the Bowes Museum, Barnard Castle, and the Akademie, Vienna, have also been associated with the *Apollo and Phaëthon* fresco.[5] While similar in certain details, the latter two differ considerably in composition from Tiepolo's final design. Moreover the viewpoint taken by the artist in each is better suited to an easel painting, to be hung on a wall, rather than an illusionistic ceiling painting, and it is likely that the sketches relate to another project altogether.

RR

Pastoral Landscape with a Mill

CLAUDE LORRAIN (CLAUDE GELLÉE)
French, 1600–1682

1634

Oil on canvas

23¼ x 32⅝ in. (59.1 x 82.9 cm)

Signed at lower right: 1634 S . . . N[?]V . . . ;
at lower left: Sc

Gift of The Ahmanson Foundation

M.86.259

PROVENANCE:

France, Filleul family.

New York, Wildenstein & Co. (dealer), 1975.

Princeton, Mr. and Mrs. J. Seward Johnson,
by 1980.

New York, Wildenstein & Co. (dealer).

SELECT LITERATURE:

Nature as Scene: French Landscape Painting from Poussin to Bonnard, exh. cat. (New York: Wildenstein & Co., 1975), no. 34.

Marcel Roethlisberger, "Additional Works by Goffredo Wals and Claude Lorrain," *The Burlington Magazine* 121, no. 910 (January 1979): 24, 26, fig. 39.

Marcel Roethlisberger, "Claude Gellée à Nancy," *La revue du Louvre* 31, no. 1 (1981): 52, n. 10.

H. Diane Russell, *Claude Lorrain, 1600–1682*, exh. cat. (Washington, D.C.: National Gallery of Art, 1982), 132, no. 22.

Claude Lorrain was one of the most significant landscape painters of seventeenth-century Europe. He defined and refined a tradition of ideal landscape painting that was to last until the second half of the nineteenth century.

Born in Chamagne, a village near Lunéville in the duchy of Lorraine, Claude went to Rome sometime between 1612 and 1620. Apart from a visit to Naples between 1619 and 1622, when he stayed with painter Goffredo Wals, and a brief trip to Nancy in 1625–26, he remained in Rome until his death. There he was a student of Agostino Tassi and was strongly influenced by other members of the community of Northern artists, such as Dutchmen Bartholomeus Breenbergh, Cornelis van Poelenbrugh, and Herman van Swanevelt, all of whom were inspired by the Roman *campagna*, with its poetic light and crumbling remnants of antiquity. Paul Bril had already begun this tradition as a Northern landscape painter specializing in Italianate scenes in the 1580s. A special intensity of observation and execution was brought by Adam Elsheimer, a German who worked in Rome during the first decade of the new century. Claude absorbed the example of all these artists as well as the grander, more classical or idealizing landscape style developed early in the century by the masters of the Bolognese school, Annibale Carracci and Domenichino (cat. no. 47).

By the early 1630s Claude was a well-established and increasingly successful painter in Rome, working for such distinguished patrons as Cardinal Bentivoglio, Pope Urban VIII, and King Philip IV of Spain. In addition to these patrons and other Roman customers he worked for French visitors to the Eternal City. In 1635 he began his *Liber Veritatis* (British Museum, London), a volume of drawings that recorded his paintings from that year onward. The drawings may originally have

been intended as a guard against imitation and forgery (a certain sign of success), but the two hundred sheets took on the meaning of an independent work of art for Claude by the end of his life.

Claude's artistic development moves from an early lyricism, with figures often in contemporary dress set in softly lit landscapes reminiscent of the hills at Tivoli and elsewhere around Rome, to, in the 1640s, more elevated biblical and mythological subjects in more idealized locations. From the 1650s to the end of his life he painted fewer but grander and costlier pictures and chose more rarified subjects, culminating in a group of scenes from Virgil's *Aeneid*, executed for a member of the noble Colonna family, where the landscapes became increasingly monumental and idealized.

Pastoral Landscape with a Mill is one of only a handful of dated landscapes from Claude's early maturity, just before he began the *Liber Veritatis*. It is typical of his early lyrical mode, presenting a quiet and intimate pastoral scene with figures in modern dress. The composition is carefully devised, with a water mill and sluice set against a dark group of trees on a hillside to the left and the landscape opening out to the right. A tall tree presents a mass of dark leaves at center right, a foil to the blue sky and its thin, hazy clouds. The landscape is bathed in a gently modulated atmosphere. Plants and rocks in the foreground are sharply delineated, while the rolling hills become less and less distinct as they recede delicately into the misty distance. Claude was famous in his day for his ability to control this type of aerial perspective with such subtlety. Also in the foreground a shepherd or goatherd pipes to his female companion, while his animals graze nearby. The little figures are strongly modeled with the brush and are brought into harmony with the landscape by their red and blue colors, which are more saturated versions of the tints found throughout the work, for example in the warm touches of sunlight and the cool blue of the far mountain. The trees are rich and dense in foliage. (The thinner foliage of the smaller trees at right anticipates the more ethereal trees of Claude's later landscapes.) From the lively foreground the eye wanders down to the river running along a shady valley to a bridge in the middle distance. At this important point, where the scale of the distance is measured, two tiny figures are caught in the light as they cross the bridge.

All these elements were gathered by Claude from the work of his teachers and immediate predecessors in Rome and turned by him into ideal landscapes such as this one. The clumped forms of the trees come from Tassi and Wals; the careful design of the landscape, articulated with horizontals and verticals and by the man-made forms of the mill buildings and bridge, is from the classically balanced landscapes of Annibale Carracci; the sensitive rendering of light derives from the lyricism of Elsheimer and other Northerners like Breenbergh and Poelenbrugh. Of course Claude also studied nature firsthand; hundreds of drawings have survived as evidence of this practice, and contemporary biographers tell of his frequent excursions into the countryside around Rome to sketch. Claude's landscapes are always unified by light, whose infinitely subtle variations he was able to control with consummate skill. In his use of light lies his personal poetry.

Claude's ideal world is drawn not only from artistic precedents but also from literary tradition, the arcadian and pastoral works of such ancient poets as Ovid and

Virgil or their Italian imitator in the seventeenth century, Sannazzaro. Nature and landscape were celebrated in literature for their peace and harmony, for being far from the bustle of the city and the intrigues of the court, a perfect place where man and beast and the minor deities of mythology lived in happy accord. Claude's piping goatherd is a descendant of one of Virgil's shepherds in the pastoral *Eclogues* or *Georgics*.

A few years later Claude would populate his ideal landscapes with classical figures, more strongly to evoke that idyllic antique past. *Pastoral Landscape with a Mill* already anticipates that arcadian pictorial world with its gentle rhythms, artfully balanced forms, and atmosphere of peace and repose. This is not nature as it is, but nature as it ought to be.

PC

Samson and Delilah

JAN STEEN
Dutch, 1626–79

1668
Oil on canvas
26½ x 32½ in. (67.3 x 82.6 cm)
Signed at lower right: JSteen 1668
Gift of The Ahmanson Foundation
M.87.64

PROVENANCE:

Amsterdam, J. Bruyn sale, 16 March 1724, no. 7.

Rotterdam, Wynand Coole sale, 6 August 1782, no. 65.

Rotterdam, Daniel de Jongh sale, 26 March 1810.

The Hague, N. Oosthuysen Collection.

Berlin, Oscar Huldschinsky Collection, 1898–1928.

Berlin, sale, Cassirer-Helbing Galleries, 10 May 1928, no. 36.

Amsterdam, L. van den Bergh sale, 5 November 1935.

The Hague, Bachstitz (dealer), 1938.

Confiscated by the Nazis, c. 1939–45.

The Hague, Bachstitz (dealer), c. 1945–51.

The Netherlands, private collection, 1951–87.

New York, Otto Naumann, Ltd. (dealer).

SELECT LITERATURE:

Albert Heppner, "The Popular Theatre of the Rederijkers in the Work of Jan Steen and His Contemporaries," *Journal of the Warburg and Courtauld Institutes* 3, nos. 1–2 (1939–40): 40–41.

Baruch D. Kirschenbaum, *The Religious and Historical Paintings of Jan Steen* (New York: Allanheld & Schram, 1977), 47, 49, 78–79, 97, 113, no. 10, 202, fig. 67.

Despite a prodigious output of at least four hundred pictures, very little is known of Jan Steen's life. He was born in 1626 in Leiden and, according to various sources, studied either with Nicolaes Knüpfer, Adriaen van Ostade, Jan van Goyen (whose daughter he married in 1649), or with more than one of these artists. He lived in Haarlem from 1661 until 1670, when he returned to Leiden after inheriting his father's house. Following his return to his native city and until his death in 1679, he played an increasingly active role in the Guild of Saint Luke, being elected its foreman twice and its dean once.

Steen is best known for his comic scenes, which center on raucous taverns or boisterous and ill-kempt households. These pictures, such as the museum's *The Twelfth Night* (fig. 44a), were painted with an eye toward exploiting the humorous implications of such environments and the outré behavior depicted within them. Such paintings, where physical appetite and whimsy win out over modesty and moderation, apparently fly in the face of Calvinist strictures against licentiousness, but it is generally acknowledged that Steen intended these works as warnings against pursuing such immoral behavior. There is little evidence, as Steen's early biographers have claimed, that the artist's own way of life is reflected in these paintings. In the 1670s Steen did in fact open a tavern, but it is not certain whether it was successful

nor is there any concrete evidence to support the old accusation that the artist was a profligate and a drunkard.

Less familiar are Steen's paintings based on biblical and literary subjects, of which *Samson and Delilah* is an outstanding example. While very different in subject matter from the comic scenes, these religious and historical pictures offered a similar satirical view of the world.

The subject of the painting is the betrayal of Samson, the legendary Nazarite hero, by his Philistine lover, Delilah, who tricked him into revealing the source of his immense strength (Judges 16:4–31). A latter-day Eve, Delilah conforms to the stereotype of the deceitful woman who uses her sexual allure to destroy her adversary. Here Steen presents the tension-filled moment when Delilah, having coaxed Samson to sleep with wine, calls for a barber to shear off the source of Samson's power, his seven locks of hair. In the background the clamoring guards are quieted by a maidservant who holds a finger to her lips; they await Delilah's signal, when she awakens Samson by saying, "The Philistines be upon thee."

After his capture Samson was blinded and sent to the prison at Gaza, where he was forced to turn a millstone. In prison his hair grew back, so that when he was chained to columns in the temple where the Philistines were feasting, he managed to pull down the structure, killing himself and more than three thousand of his enemies. The two columns that flank the middle ground of Steen's painting may allude to this final act of self-sacrifice. Steen also did a painting of Samson being mocked by the Philistines in the temple, a work now in the Wallraf-Richartz Museum in Cologne. Such images allude to Samson's role as a precursor of Christ.

The moment depicted in the Los Angeles painting was a common one in the history of art, and Steen would have had ample visual precedents to guide his own composition (there are examples by Rembrandt and Jan Lievens, among others). Steen seems to have been most influenced by a famous version by Rubens (National Gallery, London), which he probably knew through an engraving by Jacob Matham. Rubens's large painting could have suggested several motifs that appear in Steen's, especially the nervous Philistines outside the room and the billowing drapery overhead. There was a different, more likely, source for the museum's picture, however.

There is good reason to believe that Steen had in mind contemporary theatrical productions as much as the Bible when he composed the painting. *Samson and Delilah* is composed along a series of parallel planes, with the figures placed facing the viewer and elevated on a step, as if on a stage. The undulating orange-red curtain draped along the top of the composition completes the allusion to a proscenium, before which the actors play their roles. As scholars have often pointed out, the scene painted by Steen, in which the barber is called in to cut Samson's hair, was the high point of Abraham Koninck's popular play, *The Tragedy of Samson*, first produced in 1618.[1]

Steen is known to have been an aficionado of the stage, especially through the theatrical performances mounted by the *rederijkers* (rhetorician guilds) that flourished in most Dutch cities. These semiprofessional theater troupes frequently staged productions of true merit. The membership was drawn from the local arts and crafts guilds and often included famous painters of the period. Frans Hals (cat. no. 5) is the

FIG. 44a
Jan Steen, *The Twelfth Night*, c. 1666–67, oil on canvas, 26½ x 33¼ in. (67.3 x 84.5 cm), Los Angeles County Museum of Art, Marion Davies Collection (55.80.1).

most noted case; he was a member of one such group from 1616 to 1625. It is not certain whether Steen belonged (his name does not appear on the rolls), but his association with the rederijkers is clear enough; his uncle, Dirck Jansz Steen, was a member, and several of Jan Steen's paintings draw their subject matter from the life of the guild.[2]

Notes
1. Kirschenbaum, 113.
2. Heppner, 22–35.

As Baruch Kirschenbaum has written, by the mid-seventeenth century the influence and popularity of the rederijkers had been usurped by the professional theater inspired by the French, such as the company established at the Schouwburg Theater in Amsterdam. Steen's *Samson and Delilah*, like other historical paintings by him, probably drew inspiration more from these official productions than the popular drama of the guilds. Kirschenbaum has even suggested that in the setting of *Samson and Delilah* Steen sought to re-create the stage at the Schouwburg. It is not certain whether Koninck's play was performed in that theater, but the actions of the figures and the appearance of certain props in the museum's picture recall the professional acting troupe. The poses and gestures of the principal characters are curiously dramatized, their motions heightened and exaggerated, as if performed in full knowledge of a viewer before the canvas. This is most apparent in the exchange between Delilah and the acolyte at the far left, who lunges into the scene to hand the spotlit Delilah a pair of scissors. The obvious gesture of the maidservant in the center is another such clue, as are the impatient soldiers gathered just offstage, who are ready to rush in on cue. Certain props, such as the suspended drape and the rich, oriental carpet spilling over the front step, were common devices used at the Schouwburg, and they appear in several of Steen's historical paintings.

Steen used such theatrical conventions to fully exploit the dramatic possibilities of the biblical narrative. Like the Dutch customs and festivals he painted in his comic works, however, the great histories and legends of the past were viewed by Steen with the ironic eye of a satirist. Not only are the main characters exaggerations, but irreverent details, such as the two urchins at the right who tease a dog, further undermine the seriousness of the principal theme. In Steen's vision the pomposity and hubris of the historical genre is deflated, and its inhabitants are relegated to the flawed but entertaining realm of ordinary humanity.

RR

*Holy Family with Saint Francis
in a Landscape*

GIORGIO VASARI
Italian (Florence), 1511–74

1542
Oil on canvas
72½ x 49¼ in. (184.2 x 125.1 cm)
Gift of The Ahmanson Foundation
M.87.87

PROVENANCE:

Venice, Francesco Leoni, probably
commissioned for his private chapel,
December 1541.

Vienna, private collection, by 1975.

London and New York, Somerville & Simpson
(dealer).

SELECT LITERATURE:

Alessandro del Vita, *Il libro delle ricordanze di
Giorgio Vasari* (Arezzo: Dalla casa Vasari, 1927),
37–38.

Laura Corti, *Vasari: Catalogo completo* (Florence:
Cantini, 1989), 40–41, no. 23.

Giorgio Vasari is best remembered as the first great historian of Italian painting;
in effect he was the founder of European art history. His *Lives of the Artists*, which
first appeared in 1550 and was reissued in a second, revised edition in 1568, remains
to this day a valuable source of information, especially regarding those artists in the
Florentine tradition that he understood best, up to Michelangelo, the real hero of
his book. Vasari was also a great collector of drawings and tried to build a compre-
hensive collection that would illustrate the history of drawings in Italy from the late
Middle Ages to his own time.

A prolific painter, Vasari completed major cycles of frescoes in Florence and
Rome. Through the 1550s to the 1570s he oversaw most of the major architectural
and artistic programs of Florence, both secular and religious, for Cosimo de' Medici.
The frescoes at the Palazzo Vecchio, extolling the virtues of the Medici, were painted
in the 1550s, while he decorated the interior of the dome of Florence Cathedral in
the early 1570s. He made altarpieces for such major churches in Florence as Santa
Maria Novella and Santa Croce and supervised the design of Michelangelo's tomb
at the latter. In Rome he worked for Cardinal Alessandro Farnese in the Sala dei
Cento Giorni of the Palazzo della Cancelleria in 1546, producing a suite of scenes
celebrating the power of Pope Paul III Farnese, and also worked in the Sala Regia
of the Vatican during the 1570s on the cycle devoted to the rule of Pope Pius V
and that of Pope Gregory XIII.

Born in Arezzo, the artist, while still a youth, was in Florence absorbing the
lessons of Michelangelo and being trained in the circle of Andrea del Sarto and his
students Jacopo Pontormo and Rosso Fiorentino. He traveled widely, working in
Rome (1531–38), Bologna (1536–37), Venice (1541–42), and Naples (1545). In Rome,
Vasari had ample opportunity to study the works of Raphael and Giulio Romano
as well as Michelangelo's Sistine Chapel ceiling. From such examples of the High
Renaissance, Vasari developed quite an eclectic style. In his grandiose frescoes at
the Palazzo Vecchio and the Cancelleria he invented substantial figures and clear
narratives for his histories, while for the more intimate Studiolo of François I in the

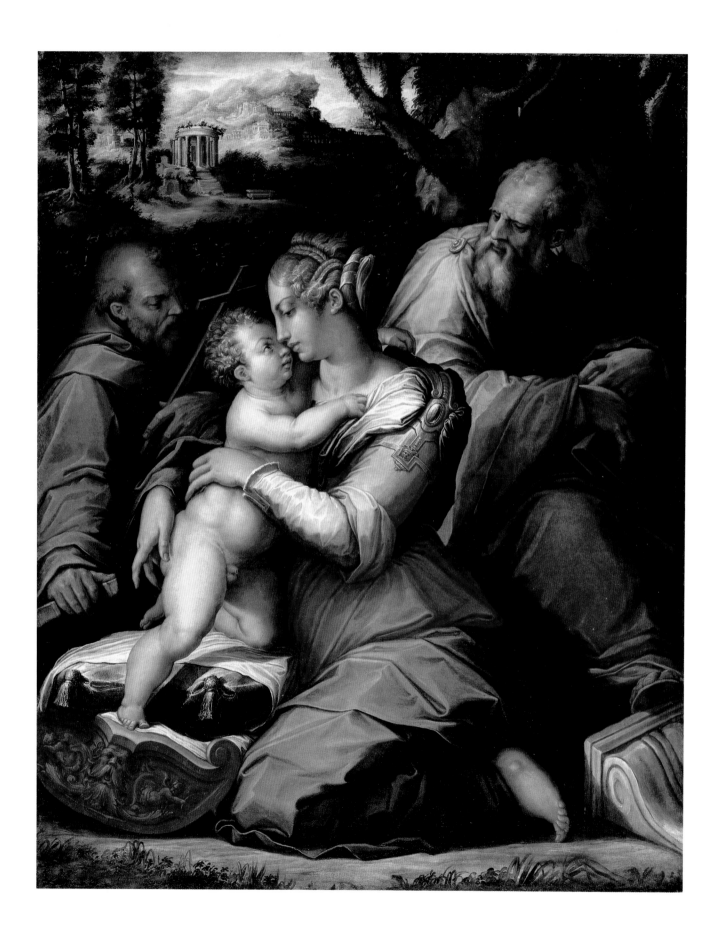

Palazzo Vecchio he deployed an elegance and self-conscious stylishness identified with mannerist art. His large altarpieces for Santa Maria Novella and Santa Croce are complex in iconography and design, but this type of ornate complexity was typical in mid-sixteenth-century Florence.

In addition to these multifarious activities Vasari also found time to paint a number of moving devotional works for private individuals. His *Holy Family with Saint Francis in a Landscape* is among the finest. While in Venice, Vasari stayed with Florentine banker Francesco Leoni, with whom he had corresponded on artistic matters during the 1530s. There is every reason to believe that the *Holy Family* was painted for Leoni. The artist described such a painting in his account books: "A large painting in oil on canvas of Our Lady on earth with her son in her arms and a full-length seated Saint Joseph with a Saint Francis."[1] The picture is the most important work to survive from Vasari's trip to Venice. Aside from this altarpiece there exists a handful of drawings for a theatrical presentation organized by Pietro Aretino, a dismembered ceiling decoration from the Palazzo Corner-Spinelli, and a decorative cycle begun by Vasari for the church of Santo Spirito in Isola (later completed by Titian).

The *Holy Family* reveals Vasari at his most accomplished and touching and conveys a personal air of tender devotion. As far as is known, the work does not appear in any early guidebooks to Venice, so the assumption must be that it remained hidden away in the private chapel of the Leoni house. It is also a significant indication of the painting's obscure history that no contemporary copies or replicas are known; generally Vasari's better-known paintings of this type were repeated in his day in one or more copies or variants.

The design is one of Vasari's most stable and classical and is heavily indebted to the art of Raphael. Specifically the grouping of Joseph, the Madonna, and the Christ Child and the way Jesus reaches and steps from an antique-looking crib are quite closely derived from Raphael's celebrated *Holy Family of François I* (Louvre, Paris, fig. 45a); Vasari substituted Saint Francis for Saint Anne in his picture, however. The monumental forms, especially of the Madonna, and the attention to details, such as the shoulder clasp of the Virgin and the architectural fragments, suggest Vasari's knowledge of the art of Giulio Romano at Mantua. Saint Joseph, in general type and contrapposto pose, recalls many a figure from Michelangelo's ceiling of the Sistine Chapel. It is as if Vasari in Venice felt he needed to emphasize his partisanship with the Florentine-Roman tradition of art. The clarity of his forms and the strong sense of drawn outlines also link his picture to this tradition and are pointedly different from the rich, painterly effects and loose, brushy broken outlines of Venetian art at this time. In his *Lives of the Artists* Vasari was to make an issue of this polarity between Florentine-Roman *disegno* and Venetian *colore*, entering a lively aesthetic debate that arose in the mid-sixteenth century and continued to be addressed by writers on art until well into the nineteenth century.

For all her monumentality, however, Vasari's Madonna is not without a hint of the elegance of contemporary mannerist art. Her elaborately braided hair, highly idealized features, and elegant hands suggest a knowledge of the art of Parmigianino. This feature is a reminder of Vasari's status as one of the principal exponents of *maniera*, the graceful style known today as mannerism, although at the moment he

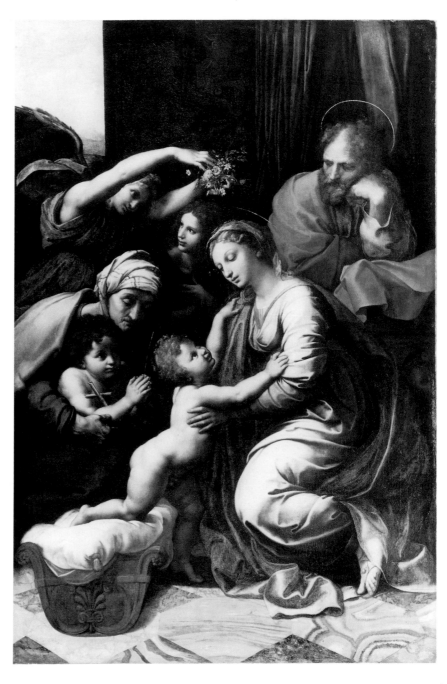

Notes

1. del Vita, 37–38.

painted his *Holy Family*, he was meditating more on the classical and monumental art of Raphael. A concession to contemporary Venetian taste is in the beautiful and carefully planned landscape background, with its trees, fantastic blue mountains, and almost spectral ancient city. The round antique temple is a variation on the so-called Temple of Vesta at Tivoli, a ruined ancient Roman structure that in Vasari's painting would stand as a symbol of the passing of the old pagan world before the rise of the new Christian era.

PC

Saint Augustine

PHILIPPE DE CHAMPAIGNE
Flemish (naturalized French), 1602–74

c. 1645–50
Oil on canvas
31 x 24½ in. (78.7 x 62.2 cm)
Gift of The Ahmanson Foundation
M.88.177

PROVENANCE:

Postmortem inventory of Philippe de Champaigne, 1674, no. 40.

Paris, Le Lorrain sale, 20 March 1758, no. 20.

Paris, Conti sale, 8 April 1777, no. 271.

Paris, Marcille sale, 16–17 January 1857, no. 419.

Monaco, sale, Sotheby's, 27 November 1986, no. 338.

Zurich, Bruno Meissner (dealer).

SELECT LITERATURE:

"Les peintres Philippe et Jean-Baptiste de Champaigne: Nouveaux documents et inventaires après décès," *Nouvelles archives de l'art français*, 3d series 8 (1892): 184, no. 40.

Bernard Dorival, "Recherches sur les sujets sacrés et allégoriques gravés au XVIIe et au XVIIIe siècle d'après Philippe de Champaigne," *Gazette des Beaux-Arts*, 6th period 80 (July–August 1972): 43–44 (as lost).

Bernard Dorival, *Philippe de Champaigne, 1602–1674* (Paris: Léonce Laget Libraire, 1976), 2:147–48, 222–23 (as lost).

Saint Augustine (A.D. 354–430) is revered as one of the four Latin Fathers of the Church, along with Ambrose, Gregory the Great, and Jerome. These theologians, writing in the early centuries of the rise of Christianity, debated and established many of the fundamental doctrines of the religion. During the Counter-Reformation of the sixteenth and seventeenth centuries Catholic theologians looked back with sharpened interest at such early teachers and formulators of Christian doctrine. This reconsideration and reassertion of the intellectual foundations of Catholicism brought not only a renewed study of the original authors of dogma but a concomitant revival of pictorial imagery celebrating them and their achievements.

Thus Philippe de Champaigne's image of Saint Augustine is a typical work of the Counter-Reformation in France. It shows the revered saint seated in his book-lined study, which is more sixteenth- or seventeenth-century than fifth-century in appearance. Augustine was Bishop of Hippo in North Africa so is depicted wearing episcopal vestments, with his miter on the table and pastoral staff leaning nearby. Edward Maeder, curator of costumes and textiles at the museum, has pointed out that Champaigne clothed Augustine in Spanish ecclesiastical robes of the mid- or late sixteenth century. Such garments would have been readily available during and after the Spanish rule of the Low Countries, Champaigne's native area, in the 1500s and 1600s. They are richly embroidered with images of the Evangelists and other saints. On the clasp band there is a head of Christ. Most likely Champaigne borrowed these robes from a church as artistic props; already in the mid-seventeenth century they may have given the painting a slightly archaic air. The Turkish carpet draped over the table was probably one of his own studio props, however. He used the same rug again in his great portrait of the contemporary lawyer *Omer II Talon* painted in 1649 (National Gallery of Art, Washington, D.C.).

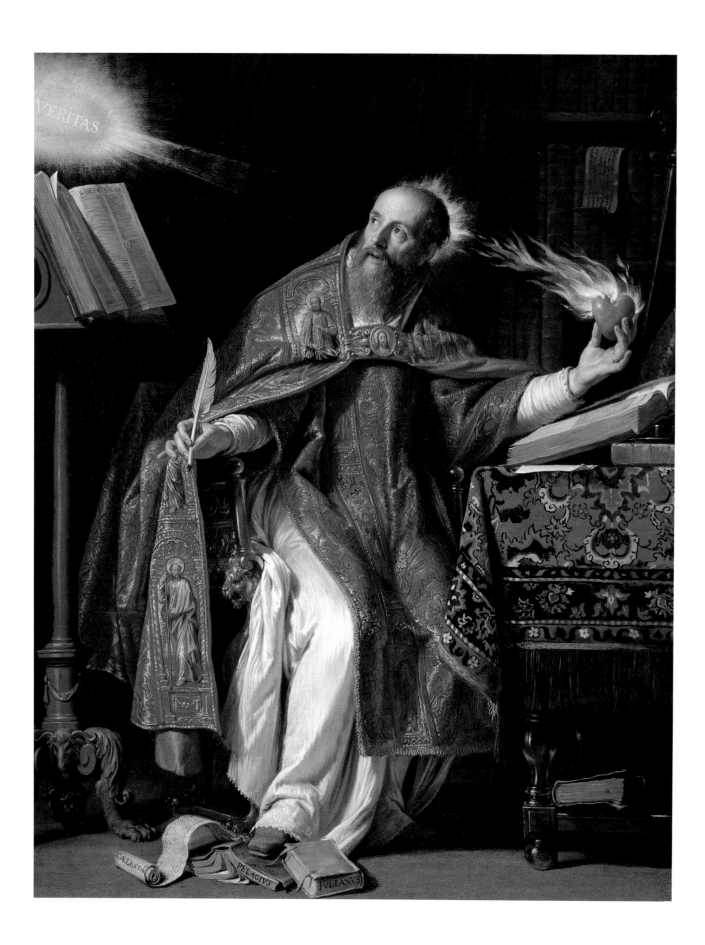

FIG. 46a
Philippe de Champaigne, *Saint Jerome*, c. 1645–50, oil on canvas, 31½ x 25 in. (80.0 x 63.5 cm), Galerie Bruno Meissner, Zurich.

Augustine pauses, quill pen in hand, to look over his shoulder for inspiration. He gazes at a blaze of divine light, bearer of *veritas*, which shines from above a copy of the divinely inspired *Biblia Sacra*, the written source of Truth. In his hand the saint holds a flaming heart, one of his traditional attributes, which denotes his religious ardor. X-radiographs reveal what is just visible to the naked eye in a good light, that Champaigne made changes here, for originally Augustine's left hand was turning the pages of the book on his table. Similarly the artist added a narrow strip of canvas at the bottom of the painting, so that he could show the two books and scroll scattered on the floor, trampled under Augustine's foot. The names on these texts refer to Celestius, Pelagius, and Julian of Eclanum. These three theologians were contemporaries of Augustine and engaged in acrimonious disputes with him over matters of doctrine. According to Augustine, Pelagius and his two supporters were promoters of heretical ideas that undermined the true faith by questioning the doctrines of original sin, divine grace, and the baptism of children. Needless to say, the theological arguments were extremely complex and convoluted and cannot be pursued here. Suffice it to observe that Augustine is shown, inspired by Truth and the Holy Bible, asserting his own doctrine and trampling the heretical texts underfoot.

The original owner of *Saint Augustine* is not known. Indeed its history is not firmly documented until its appearance at auction in 1986. The painting served as a model for an engraving, which was executed in exact detail and published in Paris by Nicolas de Poilly around the middle of the century.[1] A Latin legend under Poilly's print reads *Unde ardet, inde lucet* (The flame of love becomes light). Poilly's engraving was later copied by several other seventeenth-century engravers. The painting must date from the mid- to late 1640s; its meticulously detailed and superbly skillful execution can be compared with Champaigne's *Moses and the Ten Commandments* of 1648 (Milwaukee Art Museum).

In 1986 the painting was sold with a pendant *Saint Jerome* (fig. 46a). It is intriguing to note in the somewhat speculative provenance that a pair of paintings of *Saint Augustine* and *Saint Jerome* were noted in the inventory of Champaigne's estate after his death in 1674. These may be the same two paintings that were in the important collections of Le Lorrain in 1758 and the Prince de Conti in 1777 as well as the distinguished Marcille Collection in 1857. The quality of *Saint Augustine* is certainly worthy of such important collections of the eighteenth and nineteenth centuries.

After training in his native Brussels with landscape painter Jacques Fouquières, Champaigne moved to Paris in 1621, becoming a French citizen in 1629. He worked on decorations at the Palais du Luxembourg and in 1627 became *peintre de la reine mère*. He found favor with Louis XIII and Cardinal Richelieu, whose portrait he painted several times. He was a founding member of the Royal Academy in 1648, official painter to the magistrates of Paris, and a well-known portraitist. He also worked for several religious orders, including the Carmelites and the Carthusians. These official and semi-official positions enabled Champaigne to remain connected without trouble to the French Jansenists, who were confined to the Abbey of Port-Royal. This order, whose austere doctrines were influenced by Saint Augustine, was a center of political and religious controversy and opposed by the powerful Jesuits and other factions of the Catholic Church in Rome. Another image of Augustine

by Champaigne, showing the moment of the saint's conversion to Christianity, was engraved as the frontispiece to a volume of Augustine's famous *Confessions*, which was translated and edited in 1649 by Champaigne's friend Robert Arnauld d'Andilly, a leading member of the Port-Royal community.

Saint Augustine is thoroughly typical of Champaigne's style. While there is a certain austerity in its absolute clearness of observation and drawing, its strong color and fine technique place it in the traditions of Flemish painting. It seems to unite the rich saturated color of Flemish art with the rigorous clarity of French classical design. The saint is vividly characterized and every detail is sharply delineated: lectern, books, table, carpet, and, above all, the splendid bishop's vestments, whose richly colored embroidery contrasts with the creamy whites of the surplice. The whole image radiates with an intensity that reflects and expresses the passionate spirituality of the saint.

PC

Notes
1. Dorival, "Recherches," 43, no. 62.

*Saint Ignatius of Loyola's
Vision of Christ and God the
Father at La Storta*

DOMENICHINO (DOMENICO ZAMPIERI)
Italian (Bologna), 1581–1641

c. 1622
Oil on canvas
65⅜ x 38⅝ in. (166.1 x 98.1 cm)
Gift of The Ahmanson Foundation
M.89.59

PROVENANCE:
Rome, Cardinal Odoardo Farnese, probably commissioned for his private chapel at the Gesù, c. 1622.
Private collection.
London, Matthiesen Fine Art Limited (dealer).

SELECT LITERATURE:
Richard E. Spear, *Domenichino* (New Haven: Yale University Press, 1982), 1:308, no. 117, 2: pl. 432.

This tall altarpiece was painted almost certainly in 1622 for the Cappella Farnesiana, the chapel of Cardinal Odoardo Farnese in the Casa Professa of the Gesù, mother church of the Jesuit order in Rome. It was replaced soon after by a good but slightly stilted copy, probably by an artist from Domenichino's studio; the copy remains in the chapel to this day. Why and by whom the original canvas was removed is not known, but most likely the switch occurred shortly after the death of the patron in 1626. The first picture was probably sold simply for profit. It is not recorded in any subsequent Farnese inventories, according to M. Bertrand Jestatz, who has studied these archives extensively.[1] It appeared on the art market in 1981, just in time to be included as an addendum to Richard Spear's catalogue of Domenichino's works.

Odoardo Farnese was one of the most prolific art patrons of early seventeenth-century Rome. The most famous work he commissioned was the decoration of the Gallery of the Palazzo Farnese by Annibale Carracci and his studio between 1595 and 1604. The young Domenichino came to Rome from Bologna to work on this project and became a leading member of Annibale's team. It was to be one of the seminal works of seventeenth-century painted decoration. Shortly after the completion of the Farnese Gallery, Odoardo commissioned Domenichino to decorate the chapel of Saint Nilo at the Abbey of Grottaferrata, where the cardinal was Comendatario. These frescoes were completed between 1608 and 1610. The Farnese family was closely linked with the Gesù, not least because it had been Odoardo's great uncle, Cardinal Alessandro Farnese, who had overseen its construction by architect Giacomo Vignola from 1568 onward. Odoardo was responsible for the construction of a sacristy and new Casa Professa behind the church, which was undertaken by architect Girolamo Rainaldi from 1599 to 1623. These buildings incorporated the Camere di Sant'Ignazio, rooms inhabited by Ignatius of Loyola from 1544 to 1556, and the new chapel. Given these involvements with the Gesù and the fact that Odoardo clearly admired Domenichino's refined classical style of painting, it would not be surprising if, when the artist returned to Rome in 1621 from a four-year stay

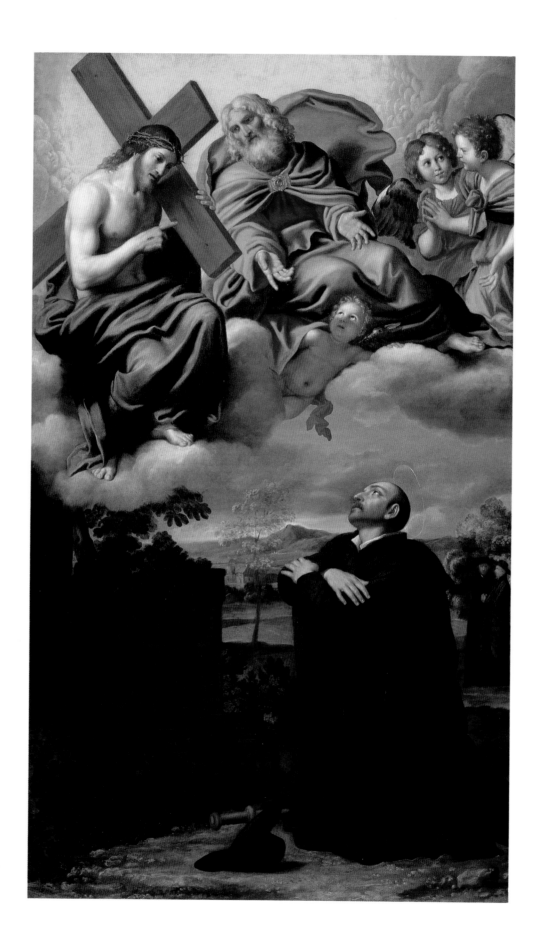

in Bologna, he should receive the commission for the new altarpiece.

Although the painting is not dated, the early 1620s would be right from the point of view of Domenichino's stylistic development. Not only did he return to Rome in 1621, but on March 12, 1622, Ignatius was canonized. It seems likely that the painting was ordered to mark the canonization and to coincide with the completion of the building programs at the Gesù.

The painting shows a decisive moment in the life of Saint Ignatius. With two traveling companions, Jaime Laynez and Pierre Lefèvre, both seen in the background, he journeyed in 1537 from Paris, where he founded the Society of Jesus in 1534, to Rome, where he was to seek papal confirmation of his order. At La Storta, on the road from Siena to Rome, the three stopped to pray at an abandoned wayside chapel. There Ignatius had a vision of God the Father presenting to him the resurrected Christ carrying the cross; pointing to the cross, which was to become the symbol of the Jesuit Order, Christ uttered the words: "I will help you on your way to Rome," thereby condoning the mission of Ignatius.

Domenichino shows the saint, dressed in black with his hat and pilgrim's staff on the ground beside him, kneeling in rapt adoration before the heavenly vision. His brightly lit face is isolated against the sky, and the air of passive adoration is enhanced by his folded arms; he is not gesturing toward the vision nor in any other way overtly drawing attention to it. Clouds and a cherub support Father and Son, while two mischievous-looking angels to the right comment on what is taking place. A host of other cherubs' faces stud the clouds of heaven. In common with other Italian baroque altarpieces of this period, where earthly people have heavenly visions, the saint is firmly planted on the ground as a sort of intermediary between the spectator in the chapel and the divine personages inhabiting the spiritual upper realm of the painting. Both Christ and God are beautiful idealized types, whose perfectly modeled forms and draperies look back through Annibale Carracci to the works of Raphael and High Renaissance Rome. Ignatius has the somewhat idealized features of the man who had died about sixty-six years before Domenichino painted this picture. Everything about the saint's pose, attitude, and features speaks of his earnest devotion. Domenichino was also a noted landscape painter in a tradition established for Italian artists by Annibale Carracci. The lovely landscape stretching behind Ignatius is among the finest examples of the painter's ability in this genre.

The museum's canvas is in a perfect state of preservation. There are some pentimenti, notably in the right hand of Christ and the position of the cross, showing that Domenichino made slight revisions to the design as he worked. Three preparatory drawings exist: one for the whole composition, close to the finished picture but slightly wider in proportion (fig. 47a); one for the figure of Christ (fig. 47b), probably done from a studio model (where the artist has yet to idealize the form); and a third for the kneeling saint (fig. 47c).[2] At one time there were probably others, for Domenichino carefully worked out his compositions with drawings of the whole and its parts. This type of working procedure was normal for an artist in the classical tradition. The practice had been revived and encouraged by the Carracci at their academy in Bologna, where Domenichino had received some of his training, and Annibale continued it in Rome; hundreds of drawings survive from the planning of the Farnese Gallery.

FIG. 47a
Domenichino, *Vision of Saint Ignatius of Loyola*, c. 1622, red chalk on paper, 6³/₁₆ x 4⅝ in. (15.7 x 11.7 cm), Windsor Castle, Royal Library. Copyright 1990 Her Majesty Queen Elizabeth II.

FIG. 47b
Domenichino, *Study for Christ*, c. 1622, . black chalk heightened in white on paper, 12⅞ x 8³/₁₆ in. (32.7 x 20.8 cm), Windsor Castle, Royal Library. Copyright 1990 Her Majesty Queen Elizabeth II.

FIG. 47c
Domenichino, *Study for Saint Ignatius of Loyola*, c. 1622, black chalk heightened in white on paper, 11⁵/₁₆ x 8 in. (28.7 x 20.3 cm), Windsor Castle, Royal Library. Copyright 1990 Her Majesty Queen Elizabeth II.

Notes

1. M. Bertrand Jestatz, conversation with author, 26 April 1989.

2. The saint in the Windsor drawings was erroneously identified as Philip Neri in John Pope-Hennessey's *The Drawings of Domenichino in the Collection of His Majesty the King at Windsor Castle* (London: Phaidon Press, 1948), 104–5, nos. 1250, 1252.

Saint Ignatius is a mature work, painted when the artist was at the height of his powers, in his early forties. The invention of the design probably came easily to him, and in any case, it is relatively simple in conception. Indeed the clear and straightforward presentation of the subject is one of the work's charms and is characteristic of Domenichino's approach as an artist. He invests the scene with a calm and noble simplicity, which matches the emotional directness of Saint Ignatius's experience of his vision. Domenichino does not indulge in extravagant gestures and virtuoso effects of illusion, foreshortening, and dramatic lighting, which were becoming common artistic devices to convey spiritual and ecstatic states of mind in Italian art at the time.

Domenichino's training with Annibale Carracci, especially his involvement with the Farnese Gallery, would have taught him a great deal about the need for clarity in narrative, one of the hallmarks of his teacher's approach. The sculptural solidity and beautifully idealized individual figures of Domenichino also derive from Annibale's concept of form.

By the time he painted *Saint Ignatius*, Domenichino had a well-established reputation in Rome as the leading painter in the Carraccesque classical manner. In addition to his work in the Farnese Gallery in the first decade of the century Domenichino had painted a seminal fresco in a chapel at the church of San Gregorio Magno in 1609 representing the *Flagellation of Saint Andrew*, which was to be a major inspiration for Nicolas Poussin and other classicizing artists later in the century. He had also completed two grand cycles of frescoes, the aforementioned *Life of Saint Nilo* at Grottaferrata in 1608–10 and the *Life of Saint Cecilia* in San Luigi dei Francesi in 1612–15; a major altarpiece for Saint Peter's, *The Last Communion of Saint Jerome*, in 1614; and a major mythological painting, *Diana and Her Nymphs*, which was delivered to the great collector and patron Cardinal Scipione Borghese in 1617. After a time in Bologna and Fano, Domenichino returned to Rome to begin his greatest decorative cycle, scenes from the *Life of Saint Andrew* (1622–27) in the apse vault of Sant'Andrea della Valle, just down the street from the Gesù. Thus *Saint Ignatius*, painted at this same moment of Domenichino's return to Rome, dates from one of the most creative periods of his career.

PC

Mercury and Argus

CAREL FABRITIUS
Dutch, 1622–54

c. 1645–47

Oil on canvas

28¹⁵/₁₆ x 40¹⁵/₁₆ in. (73.5 x 104.0 cm)

Signed at left center: Carolus Fabritius

Gift of The Ahmanson Foundation

M.90.20

PROVENANCE:

Paris, sale, Lebrun, 19 June 1764, no. 20.

Naples and Moscow, De Lebzeltern Collection, then by descent.

Monaco, sale, Sotheby's, 22 June 1985, no. 147.

New York, Richard L. Feigen & Co. (dealer).

SELECT LITERATURE:

Christopher Brown, "'Mercury and Argus' by Carel Fabritius: A Newly Discovered Painting," *The Burlington Magazine* 128, no. 1004 (November 1986): 797–99, fig. 18.

As a result of his unfortunate death at the age of thirty-two and the parallel loss of his studio, the extant oeuvre of Carel Fabritius is extremely circumscribed. *Mercury and Argus* is one of only twelve paintings securely attributable to his hand. Nevertheless among these is a striking diversity of subjects, testifying to what must have been a remarkable production: one biblical scene, two mythological subjects, six portraits, a genre scene, a perspectival townscape, and an unusual picture of a goldfinch standing on its perch. The recent rediscovery of *Mercury and Argus* is thus of paramount importance in tracing the development of Fabritius's career. Already a painting in Boston, *Mercury and Aglauros* (fig. 48a), formerly ascribed to Govaert Flinck, has been reattributed to Fabritius on the basis of its similarity to the Los Angeles picture.[1]

Fabritius was the son of Pieter Carelsz, a Calvinist schoolteacher in Midden-Beemster, a rich agricultural community on the northern outskirts of Amsterdam. Pieter was himself an amateur painter; it is likely that Fabritius's first lessons in art were from his father. Carel's younger brothers, Barent and Johannes, were also painters. During his youth in Midden-Beemster, Fabritius worked as a carpenter, but by 1641 he and his wife had moved to Amsterdam, where he became an assistant in Rembrandt's studio.

It is unclear how long he spent working with Rembrandt, but in 1643 he was recorded living again with his parents; given the proximity of Midden-Beemster to Amsterdam, there is no reason to believe that Carel did not have continued contact with Rembrandt. By 1650 Fabritius was listed as residing in Delft, where he joined the Guild of Saint Luke in 1652. The artist was killed when his studio was destroyed by the explosion of the town arsenal on October 12, 1654, thus prematurely ending the career of the most talented and original painter to emerge from the circle of Rembrandt. In a poem published in 1667 the Delft bookseller Arnold Bon lamented, "So died the greatest artist that Delft or even Holland had ever known."[2]

There can be no doubt that *Mercury and Argus* is by Fabritius. The thick, deliberate application of paint, the narrow range of palette, limited mostly to earth tones and

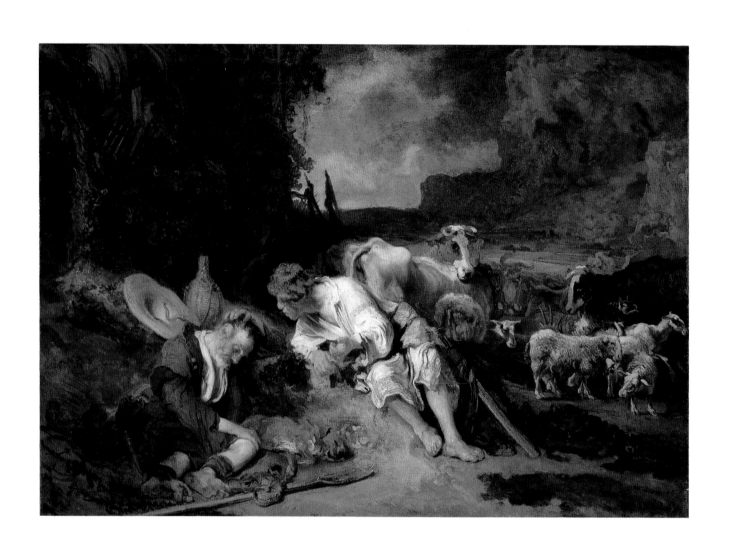

FIG. 48a
Carel Fabritius, *Mercury and Aglauros*,
c. 1645–47, oil on canvas, 28½ x 35¹³⁄₁₆ in.
(72.4 x 91.0 cm), Martha Ann Edwards
Fund, courtesy Museum of Fine Arts, Boston
(03.1143).

olive greens, and especially the probing streams of light, which pick out certain areas while throwing others in shadow, are fully characteristic of Fabritius's early style, as revealed in his large *Raising of Lazarus* (Museum Narodowe, Warsaw). Indeed when the Los Angeles painting was cleaned the artist's signature was revealed on the embankment behind Argus at the left edge. Christopher Brown dates *Mercury and Argus* to the years immediately following the *Raising of Lazarus*, around 1645–47, when the artist had returned home to Midden-Beemster.

The history of *Mercury and Argus* before its reappearance in 1985 is unclear. It is not known whether the picture was painted on commission, although the fact that Fabritius signed his name in its full Latin form might suggest a patron steeped in classical literature. In the eighteenth century the picture was in Paris, where it was copied by Jean-Honoré Fragonard in a painting now in the Louvre (fig. 48b). It is tempting to identify the Fabritius with a painting of "Argus being lulled to sleep by Mercury," supposedly by Rembrandt, which sold in Paris on June 19, 1764. At a time when Fabritius was very little known, it would not have been unusual for the signature to have been painted over and the picture passed off as a Rembrandt. The painting in the Paris sale was paired with a second "Rembrandt," *Medea and Jason*, but this picture is still to be identified.[3]

It is not difficult to imagine Fragonard thinking he had copied a Rembrandt. In style Fabritius's painting bears a superficial resemblance to a number of Rembrandt's works of the 1640s, such as the *Bathsheba Bathing* of 1643 (Metropolitan Museum of Art, New York) or the famous *Night Watch* of 1642 (Rijksmuseum, Amsterdam). Most of all, the haunting panoramic landscape that Fabritius painted in the right background is influenced by Rembrandt prototypes.[4] The technique and treatment of subject matter, on the other hand, are entirely characteristic of Fabritius. The paint is laid on in a rich impasto, the careful application of each brushstroke giving the paint a grainy texture. The physical and tactile nature of Fabritius's handling of paint complements the radically earthy treatment of the classical theme.

The story of Mercury and Argus was in fact a very popular one in Rembrandt's circle. Versions exist by Ferdinand Bol, Gerbrand van den Eeckhout, Flinck, Cornelis Bisschop, and Barent Fabritius, among others. Although no paintings of the subject by Rembrandt have surfaced, he did treat the theme several times in drawings similar to the composition of the Los Angeles painting, suggesting that Fabritius had continued contact with his mentor after leaving Amsterdam.

Ovid, in his *Metamorphoses* (1:568–688, 713–22), recounts the tale of the beautiful nymph Io, who was loved by Jupiter. To conceal her from his jealous wife, Juno, Jupiter turned Io into a white heifer. Juno, however, was aware of her husband's deception and ordered the shepherd Argus, who possessed a hundred eyes, to watch over Io. In turn Jupiter dispatched Mercury to steal Io away from Argus. Disguising himself as a goatherd, Mercury coaxed Argus to sleep with the soothing tones of his flageolet and then decapitated him. The furious Juno reclaimed Argus's eyes, inserting them into the tail of her peacock. These last two episodes were incorporated in a print by an unknown engraver made in 1589 after a design by Hendrick Goltzius (fig. 48c).

Fabritius's painting depicts the moment Argus has drifted into unconsciousness and Mercury leans over to ascertain that he is in fact asleep. A sense of torpor

FIG. 48b
Jean-Honoré Fragonard, *Mercury and Argus*,
c. 1764, oil on canvas, 23¼ x 28¾ in.
(59.0 x 73.0 cm), Louvre, Paris. Photo:
Cliché des Musées Nationaux.

FIG. 48c
After Hendrick Goltzius, *Mercury Killing Argus*,
1589, engraving, 7 x 10 in. (17.8 x 25.4 cm),
Los Angeles County Museum of Art, Graphic
Arts Council Fund (M.71.76.19).

Notes

1. Frederik J. Duparc, "A 'Mercury and
Aglauros' Reattributed to Carel Fabritius," *The
Burlington Magazine* 128, no. 1004 (November
1986): 799–802, fig. 21.

2. Christopher Brown, *Carel Fabritius: Complete
Edition with a Catalogue Raisonné* (Oxford:
Phaidon Press, 1981), 159–60. See also 13–23.

3. Brown, " 'Mercury and Argus,' " 799.

4. More precisely, it resembles quite closely
the *Great Mountain View* by Hercules Seghers
(c. 1631, Uffizi, Florence), which Rembrandt
in fact owned. The author is grateful to
Frederik Duparc for this information.

pervades the scene. Save for the rambunctious play of two of the goats, the movements and attitudes of the principal figures and animals are sluggish: a heavy-lidded cow rests its head on Io's back, Argus sleeps, his chin on his chest, his dog snoring beside him; even Mercury's movements are slow, deliberate, as if through his own music he has hypnotized himself.

The artist was attentive to the setting and details of Ovid's text, including the goats that accompanied Mercury and the bank beside a shady tree where the unwitting Argus invited Mercury to join him. These elements appear in most representations of the scene. (Another print after Goltzius depicts the same moment painted by Fabritius.) Indeed Fabritius was not adverse to borrowing motifs quite directly from earlier visual sources; the unusual perspective of Io, seen from behind, is drawn straight from the engraving of *Mercury Killing Argus*. Completely new in the Los Angeles painting, however, is the uncompromisingly rustic and naturalistic treatment of the theme. Mercury appears as a ruddy swain, near unidentifiable as a god. The crude behavior of the goats parallels Jupiter's lust for Io. Io herself is not the looming white cow that is normally present, but is in fact rather indiscreetly turned from the viewer, her head in shadow.

The downfall of Argus lay in the fact that he did not recognize Mercury, who, as Ovid relates, had disguised himself as an ordinary goatherd. Fabritius's Mercury is hardly godlike: his features are coarse, he is stripped of his attributes, his unruly hair falls over his face. He has little in common with Goltzius's half-naked god or with the figure in Fabritius's own *Mercury and Aglauros*, who sports the traditional winged shoes and carries the caduceus. Indeed Mercury's identity in the Los Angeles painting is revealed only by the sword at his side and the recorder in his hands. Fabritius's metamorphosis of Mercury renders him nearly as unrecognizable to the viewer as he was to Argus.

Such stylistic innovation and iconographic subtlety are particular to Fabritius. From his few remaining pictures one senses an idiosyncratic interpretation of subject matter, an enigmatic quality unique among Rembrandt's followers. Fabritius's last years are felt to have had a decisive influence on the development of certain artists in Delft, particularly Jan Vermeer, with whom he may have worked. Vermeer, who owned two of Fabritius's pictures, would have been drawn to Fabritius's precise and rich technique and the absorptive quietude that pervades much of his work, qualities fully present in *Mercury and Argus*.

RR

The Last Supper

PEDRO BERRUGUETE AND WORKSHOP
Spanish, c. 1450–1503/4

c. 1495–1500
Distemper on linen
74⅝ x 130¼ in. (189.5 x 330.8 cm)
Gift of The Ahmanson Foundation
M.90.171

PROVENANCE:

Buenos Aires, Souza-Lage Family Collection.
Geneva and Rome, Enzo Costantini (dealer).

SELECT LITERATURE:
Unpublished.

According to the Gospels (for example, Matthew 26), the Last Supper took place during the feast of Passover, on the night of Christ's betrayal to the Romans by his disciple Judas. We see Jesus gathered with the Twelve; on the table are the paschal lamb, salt, bitter herbs, unleavened bread, and wine. Two important events happened during this meal. With the words "Verily I say unto you, that one of you shall betray me," Jesus dismayed and perturbed his disciples with the foreknowledge of his fate. He also instituted the ritual that would become the most significant in the Christian Church, the sacrament of the Eucharist. At the moment he broke the bread, Christ said: "Take, eat; this is my body," and when he poured the wine he added, "Drink ye all of it; for this is my blood of the new testament, which is shed for many for the remission of sins." Christ is shown holding the Eucharistic wafer, the ritualized representation of his body. The disciples are presented in lively groups, gesturing as they discuss the meaning of Christ's words. Isolated at the right end of the table sits Judas; he is grim-faced and clutches a purse containing the thirty pieces of silver, his bribe for the betrayal. Judas also has a black halo in contrast with the gold ones of the loyal disciples.

An unusual feature of *The Last Supper* is the presence of Mary Magdalene, who, her face streaming with tears, wipes Christ's feet with her hair before anointing them with ointment from the jar next to her. (The vessel, however, may be a later, sixteenth-century addition to the original painting. It is drawn in a different style, and its shadow is cast to the left, which is inconsistent with the lighting of the rest of the scene. It was presumably added to clarify the identity of the Magdalen.) Matthew relates that this episode took place a day or two earlier at another meal in the house of Simon the Pharisee (see also cat. no. 31). This unusual conflation of the two stories seems to have been peculiar to Spanish art at the end of the fifteenth century; two other examples from this time are also known.[1] The reason for this local variation on traditional iconography needs further study. The artist initially thought of placing the Magdalen to the right of center facing left. The dark outline of this first underdrawing can just be perceived by the naked eye, showing through the tablecloth in the right half of the painting. Its presence there is confirmed in examination by infrared reflectography.

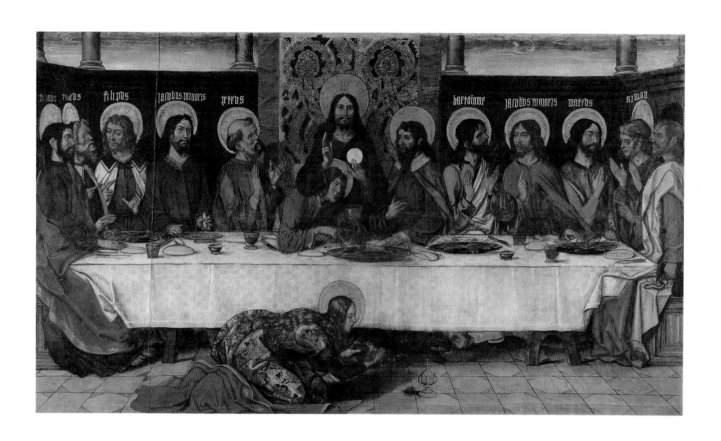

Further research will be required to discover the original location of *The Last Supper*. The theme was normally depicted in the refectories of monasteries, and it is safe to assume that this example was painted for one of the thousands of abbeys that existed in Spain at the end of the fifteenth century. The story was considered an appropriate subject for decoration, because when the monks sat down together each day to eat, they would be reminded of Christ's sacrifice, the mission of the disciples to spread his teachings, and their own devotion to Jesus and the continuance of his ministry. It would have hung fairly high up, well above the heads of the monks seated at their long tables. The perspective was designed to be seen from below.

Detail

The Last Supper is a painting of the type known in Spain as a *sarga*, executed in a water and glue-based paint (distemper) on a very large, fine linen support. It bears comparison in scale, technique, and style with a set of four equally large (but vertical) sargas generally attributed to Berruguete in the Prado, Madrid, which may originally have served as organ shutters. Two of them represent Saints Peter and Paul, while the other pair shows the Adoration of the Magi. The rather dry surface quality of distemper on linen, which would not have been varnished (fortunately neither the Prado sargas nor the Los Angeles one have been varnished subsequently), approximates the grainy dryness of fresco painting, a common technique for large-scale mural decorations. The similarity of effect may have been intentional.

The supports of the Madrid and Los Angeles paintings are made of the same type of linen, and the pieces stitched together to make up all five large works were woven on a loom of the same width, which suggests that they could have come out of the same workshop. The most recent literature states that the Prado paintings originally came from the church of San Pedro, Avila.[2] As noted above, the early provenance of *The Last Supper* is not known, but Avila is a likely source. For stylistic reasons one must conclude that the Los Angeles painting was executed in the southern part of Castile, the region northwest of Madrid between Avila and Palencia, which, along with Toledo, was the principal area of activity of Berruguete and his school. In the Prado *Adoration of the Magi* (fig. 49a) the characterization of two of the kings (figs. 49b and 49c) is very similar to some of the figures in *The Last Supper*, notably Philip (third from left), who is perhaps the most beautifully drawn and modeled character, as well as Peter, Christ, the sleeping John, and Simon (second from right; he is harder to read and is a little damaged). The style of drawing of the faces and hands of these figures is very close, as are the general disposition of the hands and the rhythms of their gestures.

Born in 1440 or 1450 (the latter is the more commonly accepted date) and dying probably in December of 1503 or January of 1504, Pedro Berruguete is among the most poorly documented of famous artists and one whose overall output has not been very clearly defined nor agreed upon by modern scholars.[3] He was born in Paredes de Nava, near Palencia, and in the earlier part of his career, about 1470–75,

FIG. 49a
Pedro Berruguete, *Adoration of the Magi*, c. 1490,
distemper on linen, 137¹³/₁₆ x 81²/₁₆ in. (350.0 x
206.0 cm), Prado, Madrid. Photo: Amplia-
ciones y Reproducciones Mas.

executed the high altar retable in the church of San Juan in his native town. His
other masterpieces to survive more or less intact are the high altar retable in Santa
Eulalia, Paredes de Nava, of the 1480s, and two high altar retables in Avila, one from
the early 1490s in the church of Santo Tomás, the other in the Cathedral. This last
work was begun in 1499, toward the end of Berruguete's life, continued in 1504 after
his death by Diego de la Cruz, and completed after 1508 by Juan de Borgoña.

On the basis of a legal document (first published in 1822 and not seen since)
Berruguete may have been the "Pietro Spagnuolo" working at the court of Federico
da Montefeltro in Urbino in 1477. It is generally accepted that he collaborated with
the Flemish artist Joos van Ghent on a series of twenty-eight panels representing
famous men that decorated the study of the duke (now divided between the Palazzo
Ducale, Urbino, and the Louvre, Paris). He probably spent some years in Italy from
the early or mid-1470s to 1483, when he is recorded in Toledo a year after the death
of Federico. He is documented in Toledo through the 1480s and 1490s, working
mainly in the Cathedral, but most of these paintings have been destroyed. He
certainly worked elsewhere at this period, for example in Avila, but his movements
are not recorded.

Although nothing is known of his training, Berruguete issued from the mid-
fifteenth-century Hispano-Flemish tradition of painting, and his art retained many
of its characteristics. In his panel paintings he reveals a sharp eye for realistic detail,
beautifully observed and modulated light, and a love of richly patterned gold
brocade for garments or for the cloths of honor that often hang behind his principal
figures. The visit to Italy seems confirmed by the style of Berruguete's mature
works, for more than any other Spanish painter of the late fifteenth century, he
could create a convincingly deep pictorial space, conceive monumental figures with

FIG. 49b
Pedro Berruguete, *Adoration of the Magi* (detail).
Photo: Ampliaciones y Reproducciones Mas.

FIG. 49c
Pedro Berruguete, *Adoration of the Magi* (detail).
Photo: Ampliaciones y Reproducciones Mas.

fully modeled draperies, and give his personages strong individual characterizations. It was above all Berruguete who brought the dignified figures and measured spaces of the Italian Renaissance to Spanish art.

The Last Supper has both Hispano-Flemish and Italianate features but also a bold style of draftsmanship and gritty, intense characterization that make it very distinctive. The vividly observed features of the weeping Magdalen, the rich gold brocade of her costume and the cloth behind the head of Christ, and the gentle light that bathes the scene are all features of the Hispano-Flemish tradition. The Italianate architecture, the way the tiled floor is employed to create perspective, and the grouping of the disciples around the table suggest that the painter was aware of Italian renditions of the Last Supper, such as the one by Andrea del Castagno in the refectory at Sant'Apollonia, Florence, dating from the late 1440s.

By their nature sargas were broadly and rapidly executed works that were regarded as relatively ephemeral decorations in contrast with fresco or panel paintings. As a consequence of this less painstaking preparation and execution *The Last Supper* and the Prado sargas seem awkward in terms of space and draftsmanship when compared with Castagno's fresco or with more carefully designed and highly wrought panels painted in oil or tempera by Berruguete, such as his *Annunciation* in the Cartuja de Miraflores, Burgos, or the *Clothing of Saint Thomas Aquinas as Novice* in the high altar retable of Santo Tomás, Avila.[4] This last panel painting, with its clear space and hard, sharp observation, represents a relatively unfamiliar subject that needed to be legible from afar. By contrast *The Last Supper* was of a familiar subject and was designed to serve as decoration for a dining hall.

More than one scholar has suggested that *The Last Supper* may have been painted by Berruguete in collaboration with one of his assistants, or that it may even be by one or more of the many artists trained in his large workshop.[5] Rather little is known about studio practice in Spain in the fifteenth and sixteenth centuries, but it would have been perfectly normal for an artist as famous and in demand as Berruguete to employ a sizable studio of assistants and very likely that several of them would collaborate on larger projects under the supervision of the master. The degree of his personal involvement might depend on the prestige of the commission. The hands of several of Berruguete's assistants and followers have been distinguished, even if their names are not always known. Thus, Berruguete-like works have been convincingly assigned to different hands now called the Paredes Master, the Riofrío Master, and the Tránsito Master, to mention but three.[6] All of these artists were heirs to the Hispano-Flemish tradition, but even if they were not privileged with a visit to Italy, they would have absorbed some of the lessons of Italian art from their master.

Samuel K. Heath has pointed out that in *The Last Supper*, in contrast with Saints Philip, Peter, John, and Simon and Christ, compared above with figures in the Prado sargas, some of the other disciples are drawn in a more schematic and less subtly modeled way, suggesting that more than one painter was at work. Several of the disciples are drawn in a bold and almost caricatural manner, such as Thomas and Thaddeus at the extreme left and Judas at the extreme right. Their style strikes Heath as being similar to that of the Paredes Master. For example, a comparison can be made with a figure such as Saint Luke in the predella panel of the Paredes Master's altarpiece at Santa María, Paredes de Nava.[7] Heath has also noted that

Notes

1. Ronda Kasl (conversation with author, 10 July 1990) drew attention to a representation of the Last Supper with the Magdalen at Christ's feet in the lower register of the carved high altar retable by Gil de Siloë in the monastery of Miraflores, Burgos; there is another on the choir stall carved by Hanequin de Bruselas in the monastery of Belmonte, Cuenca (María González Sánchez-Gabriel, "Los hermanos Egas, de Bruselas, en Cuenca. La sillería de Coro de la Colegiata de Belmonte," *Boletín del seminario de estudios de arte y archeología*, fasc. 13–21 (1936–39): 21–34, pl. 19.

2. María de los Santos García Felguera, ed., *Pedro Berruguete*, Cuadernos de arte de la Fundación Universitaria, no. 4 (Madrid: Fundación Universitaria Española, 1985), 80–81, nos. 147–50. The attribution was first made by Juan Lafora, "De Pedro Berruguete," *Arte Español* 8 (1926): 163–69. *Saint Peter* and *Saint Paul* are illustrated in Chandler Rathfon Post, *A History of Spanish Painting* (Cambridge: Harvard University Press, 1947), 9: pt. 1, 73, fig. 12.

3. A recent overview of Berruguete and the attributions to date is Felguera 1985. The standard work in English remains Post 1947. (All references are to volume nine, part one.) See Post, 17–161.

4. Post, 38, fig. 4, 106, fig. 27.

5. In addition to Kasl (see note 1), opinions have been offered by Pilar Silva Maroto (conversation with author, 12 July 1990), Judith Berg Sobré (letters to author, 1 June 1990 and 6 July 1990), Samuel K. Heath (letter to author, 7 January 1991), and Chiyo Ishikawa (conversation with author, 9 February 1991), all of whom have only seen photographs so far. William B. Jordan, who has seen the painting in its unrestored state, is in favor of Berruguete as author, perhaps with a collaborator, and stresses the conditioning factors of its support and technique (conversation with author, 3 March 1991).

6. Post, 354–66, 383–502, identifies the different hands among Berruguete's followers. He tentatively attributes a *Last Supper* fresco in the refectory of Santa Isabel de los Reyes, Toledo, to the Paredes Master, suggesting a lost work by Berruguete may have inspired it (see 378–80, fig. 125).

7. Post, 443, fig. 156. Heath has also drawn attention to a group of large sargas in the church of San Pedro, Avila, painted by the Riofrío Master (for information on this artist see Post, 383–93).

some of the disciples are less individualized than others. For example, James the Lesser and Matthew have similar physiognomies as do James the Greater and Andrew (the disciple seated to the proper left of Christ; his name has been worn away). This supports the notion of collaboration in *The Last Supper*, for Berruguete's own characters are normally highly individualized.

Spanish painting in this period still remains relatively unstudied, but eventually the different hands at work may be attributed with more certainty. The total production of Berruguete's workshop would have been enormous, and although the vicissitudes of time and history in Spain have taken a heavy toll, a good many works by these fascinating but little-studied artists await rediscovery in the dark corners of obscure churches and monasteries. *The Last Supper* is not only a beautiful and moving image of one of the profoundest moments in the New Testament but also a major document in the history of Spanish Renaissance art. It is to be hoped that its rediscovery and publication will lead to further research in this neglected field.

PC

The Baptism of Christ

ANTOINE COYPEL
French, 1661–1722

c. 1690
Oil on canvas
53⅝ x 38⁷/₁₆ in. (136.2 x 97.6 cm)
Gift of The Ahmanson Foundation
M.90.154

PROVENANCE:

Paris, collection of the artist, then by descent to Charles-Antoine Coypel.

Paris, Coypel sale, April 1753, no. 88.

Paris, Monsieur de Saint-Philippe.

Paris, Ange-Laurent de La Live de Jully sale, 5 March 1770, no. 64.

Paris, François Guillaume Ménageot.

London, P. & D. Colnaghi & Co. Ltd. (dealer).

SELECT LITERATURE:

Ange-Laurent de La Live de Jully, *Catalogue historique* (1764) and *Catalogue raisonné des tableaux* (1770), introduction and concordance by Colin B. Bailey (New York: Acanthus Books, 1988), *Catalogue historique*: 1, *Catalogue raisonné*: 35, no. 64.

Hébert, *Dictionnaire pittoresque et historique de Paris et de ses environs avec le catalogue des plus célèbres artistes anciens et modernes et leurs vies* (Paris: 1767), 1:118.

Antoine Schnapper, *Au temps du Roi Soleil: Les peintres de Louis XIV*, exh. cat. (Lille: Palais des Beaux-Arts, 1968), 46, under no. 46.

Nicole Garnier, *Antoine Coypel (1661–1722)* (Paris: Arthena, 1989), 111, under no. 43.

Antoine Coypel was one of the leading history painters of the period of transition in French art from the end of the reign of Louis XIV through the *régence* and into the reign of Louis XV. His father, Nöel Coypel, was also an esteemed history painter in the classical tradition, much influenced by the style of Nicolas Poussin, and was director of the French Academy in Rome from 1673 to 1675. Thus early in his career Antoine was able to absorb the rich and varied lessons of Italian art and also the more classicizing approach of the French academic tradition. He became a member of the Royal Academy in 1681 and thereafter pursued an exemplary official career working for the Church and the Crown.

In 1685 Coypel became official painter to Monsieur, duc d'Orléans, the brother of Louis XIV. He remained close to this family and later became *premier peintre* to Philippe, the son of Monsieur, later to become duc d'Orléans and Regent of France from 1715 to 1723, during the minority of Louis XV. For the Palais-Royal, the Orléanses' palace in Paris, Coypel painted in 1723–26 one of his major works, a magnificent ceiling for the main gallery, known as the Galerie d'Énée after its themes based on Virgil's story of Aeneas (destroyed at the end of the eighteenth century). His other major scheme of decoration was the ceiling of the royal chapel at Versailles, painted in 1709 and representing God the Father announcing the coming of the Messiah and scenes of angels carrying the instruments of Christ's Passion. He was made director of the Royal Academy in 1714 and *premier peintre du roi* in 1716.

Coypel's style is typical of the late years of Louis XIV and the transition to the new century. Less rigorously classical than that of Poussin or even the more colorful and ornamental official grand manner of Charles Le Brun, Coypel's art is quite eclectic, drawing on a variety of sources, including the French classical tradition, the Italian baroque, and the more coloristic art of Rubens. If the Academy in the seventeenth century generally upheld the values of classical draftsmanship and composition associated with the grand manner that runs from Raphael to Poussin, nevertheless French painters could not ignore the more decorative and illusionistic baroque art they saw in Rome nor the rich coloristic example of Rubens, whose great cycle of paintings celebrating the reign of Marie de' Medici had been present in Paris at the Palais du Luxembourg since the 1620s. Coypel and his older contemporary Charles de la Fosse were the two painters who best reconciled these tendencies and formed the transition from the more ponderous style of art associated with the reign of Louis XIV to the more elegant, light, and coloristic styles of the regency and the age of Louis XV.

The Baptism of Christ perfectly illustrates the way that Coypel could draw eclectically on the artistic traditions mentioned above and reconcile them in a moving work of art that is in itself a beautiful and complete expression of a major aesthetic tendency of the 1690s. The painting is an autograph replica, only six inches less in height and three in width, of Coypel's altarpiece painted for the Chapel of Saint John the Baptist in the abbey church of Saint-Riquier, Somme, and still in place today. The artist must have been especially proud of this altarpiece, because not only did he engrave it himself (probably from the museum's version), but he kept the present picture in his own collection and bequeathed it to his son Charles-Antoine Coypel, a painter no less important in his generation than Antoine had been in his.

According to Antoine-Joseph Dezallier d'Argenville, when Charles d'Aligre, the abbot of Saint-Riquier, commissioned the leading religious painters of Paris to paint a series of altarpieces for his recently renovated church, he organized a competition among them to stimulate their best efforts.[1] The prize of a gold medal and two hundred livres went to Jean Jouvenet for his *Louis XIV Healing Those Afflicted with Scrofulous in the Presence of Saint Marcoul*.[2] Along with Coypel the other artists involved with this important provincial commission to Parisian painters were Bon Boullogne (*Saint Angilbert Receiving the Habit of Saint Benedict from Symphorian, Abbot of Saint-Riquier*), Louis de Boullogne (*The Annunciation*), Claude-Guy Hallé (*Christ Giving the Keys to Saint Peter*), and Antoine Paillet (*The Obeisance of Saints Maurus and Placidus in Saint Benedict's Hands*). All the altarpieces, except Louis de Boullogne's, which is lost, remain in situ in the church of Saint-Riquier. In 1712 the Abbé Molé commissioned two further altarpieces, *The Exhumation of Saint Angilbert's Remains* and *Saint Michael Archangel*, from Louis de Silvestre to complete the series.

While some of the subjects chosen for this commission, such as Coypel's *The Baptism of Christ*, are quite conventional, others are rather obscure, such as those by Jouvenet, Bon Boullogne, and Paillet. This is because they reflect aspects of local devotion and ecclesiastical history. For example, Saint Marcoul, a sixth-century Norman abbot, was venerated locally for his healing powers, hence his presence as the king's companion in Jouvenet's picture; Saint Angilbert, a son-in-law of

Notes

1. Antoine-Joseph Dezallier d'Argenville, *Abrégé de la vie des plus fameux peintres* (Paris: de Buré l'âiné, 1762), 4:345.

2. Antoine Schnapper, *Jean Jouvenet* (Paris: Léonce Laget Libraire, 1974), 95–97, 193, no. 45, fig. 37.

Charlemagne, died as abbot of Saint-Riquier in A.D. 813; and not only was Saint Maurus said to have introduced Benedictine rule into France, but the abbey of Saint-Riquier, under the direction of Abbé d'Aligre, had adhered to the so-called Maurist reform since 1659.

In Coypel's painting John the Baptist, dressed in homespun camel hair garments, is baptizing Jesus in the river Jordan. John, who lived and preached in the wilderness of Judea, prophesied the coming of Christ and urged repentance through the act of baptism. Coypel depicts the scene in an open landscape, with Christ standing in the waters of the Jordan. The account in Matthew 3:16–17 is followed quite closely, with God the Father blessing the proceedings, angels and cherubim in attendance, and the dove, representative of the Holy Spirit, appearing in a glory of divine light: "And, lo, the heavens were opened unto him, and he saw the Spirit of God descending like a dove, and lighting upon him: And lo a voice from heaven, saying, This is my beloved Son, in whom I am well pleased."

As noted above, *The Baptism of Christ* is a slightly smaller autograph version of the altarpiece at Saint-Riquier. It was a common practice of the day for an artist to keep just such a replica of a particularly important commission in his studio after the original had been dispatched to the client. Such a painting was not a preparatory sketch, but a finished replica of the original. If the colors of Coypel's work owe much to Italian baroque art of the late seventeenth century and the hovering angel in the left foreground, descended from the angels of Correggio, could have flown in from some Roman baroque altarpiece of the 1670s or 1680s, nevertheless his study of Rubens is paramount. Coypel was very familiar with Rubens's great Medici cycle at the Palais du Luxembourg. The general composition of *The Baptism of Christ* seems to have its origin in *The Birth of Marie de' Medici*, while a direct quotation from Rubens is the face of the small angel holding a white cloth behind the head of Christ, which was taken from the second *amore* on the chariot in *The Marriage of Henry IV and Marie de' Medici*. This sort of creative eclecticism is absolutely typical of French painters of Coypel's time. Moreover the lightness and elegance of his design and the sweetness of the religious sentiment look forward to the approach of eighteenth-century painters, culminating in such works as François Boucher's *Nativity* (Musée des Beaux-Arts, Lyon) painted for Madame de Pompadour's chapel at Bellevue in 1750.

PC

A Glory of the Virgin with the Archangel Gabriel and Saints Eusebius, Roch, and Sebastian

SEBASTIANO RICCI
Italian (Venice), 1659–1734

c. 1724–25
Oil on canvas
44¹¹/₁₆ x 25 in. (113.5 x 63.5 cm)
Gift of The Ahmanson Foundation
M.90.155

PROVENANCE:
London, P. & D. Colnaghi & Co. Ltd. (dealer).

SELECT LITERATURE:
*A Collectors Miscellany: European Paintings
1600–1800*, exh. cat. (London: P. &
Colnaghi & Co. Ltd., 1990), 28–29, pl. 4.

Sebastiano Ricci was the leading decorative painter of late seventeenth- and early eighteenth-century Venice, the artist who revived for his own time the great sixteenth-century Venetian tradition of decoration that is associated mainly with Paolo Veronese (cat. nos. 6–7). Ricci took Venetian painting into its final burst of energy and glory in the eighteenth century and was followed by other Venetian decorative painters such as his nephew and collaborator, landscape painter Marco Ricci; the great *vedutisti* Bernardo Bellotto and Antonio Canaletto (cat. no. 27); Gianantonio Pellegrini; and Giambattista Tiepolo (cat. no. 42). All these artists soon established international reputations and led extraordinarily itinerant careers all over Europe, working more for clients outside Venice than for local patrons. Ricci was no exception, painting throughout northern Italy, as far south as Florence and Rome, and also in Vienna, where he worked at the Schönbrunn Palace. In 1712 he traveled with Marco to England, where he spent four years. He later returned to Venice via Paris, where he had a considerable influence on French decorative painting.

Ricci executed impressive cycles of frescoes for churches and palaces as well as altarpieces, smaller devotional paintings, and mythological works. The most important source for his art was Veronese, whose masterpieces he studied in Venice. From Veronese he learned his use of color and handling of paint and how to organize a large and complex composition into a clear and legible design without sacrificing dynamism or decorative effect. Of course Ricci also assimilated the rich handling and dramatic, illusionistic techniques of Italian baroque painting of the seventeenth century.

The museum's painting is a work of Ricci's full maturity and is the *modello* for an altarpiece described by Jeffery Daniels as "one of Ricci's most splendid and luminous," *A Glory of the Virgin with the Archangel Gabriel and Saints Eusebius, Roch, and Sebastian*, completed by 1725 for the chapel of the Venaria Reale, a royal hunting lodge on the outskirts of Turin.[1] During the last decade of his life Ricci received a number of important commissions from the House of Savoy in Turin for over-doors, large historical paintings, and altarpieces. He painted these works in Venice because

he was not allowed to visit Turin owing to a youthful indiscretion over a woman. Ricci's altarpiece for the Chapel of Saint Hubert at the Venaria Reale is arguably the greatest picture he did for Turin. It was placed in the left transept chapel, dedicated to the Virgin, facing an altarpiece in the right chapel by Francesco Trevisani, the *Immaculate Conception with Saint Louis of France and the Blessed Amadeus of Savoy*.[2] Two other altarpieces were provided by Sebastiano Conca, the *Madonna and Child with Saint Carlo Borromeo* and the *Madonna and Child with Saint Francis of Sales*.[3] The paintings are now located in the main hall of the University of Turin, although the original placement of Ricci's work is recorded in an old photograph.[4] The chapel of the Venaria Reale had been renovated by the architect Filippo Juvarra during the early 1720s, and the commission of the altarpieces must have been part of that program. The accounts of the royal household, kept in the Archivio di Stato, Turin, show that on March 21, 1725, Ricci received payment for an "incona . . . rappresentante la Vergine, l'angelo Gabriele, S. Rocco, S. Sebastiano e S. Eusebio con coro d'angioli, per uno di due altari laterali della Reale cappella della Venaria" (altarpiece representing the Virgin, the angel Gabriel, Saint Roch, Saint Sebastian and Saint Eusebius with a choir of angels, for one of two lateral altars of the Royal chapel of the Venaria).[5] The altarpiece is rich in color and was, in the original location, complemented by a surround of polychrome marble, designed by Juvarra to strike a vibrant chromatic note in the general whiteness of the chapel. Ricci's altarpiece was greatly admired by the eighteenth-century travel writers Charles-Nicholas Cochin and Jean-Jacques Lalande as well as the Abbé de Saint-Non, one of the great amateurs of painting of the day, who called it "un très beau tableau."[6]

An altarpiece of this type does not depict an event from religious history (as does Antoine Coypel's *The Baptism of Christ*, cat. no. 50) but rather serves to focus the mind and emotions of the spectator on a doctrinal truth. Ricci's altarpiece is a glorification of the Virgin and her Annunciation. At the top of the painting, in the holiest sphere, the Virgin is shown surrounded by adoring angels and cherubim in a glory of light, the light of heaven. Below, the vision is pointed out by the flying figure of the Archangel Gabriel, who is carrying a lily, symbol of the Virgin's purity, and addressing the three saints positioned on the ground. Shown are Saint Sebastian, the third-century Christian martyr, who is tied to a column, his side pierced by an arrow; the fourteenth-century Saint Roch, accompanied by his dog and traveler's staff (the sore on his leg refers to his work in ministering to victims of the plague; his presence in the altarpiece may refer to the terrible epidemic that had ravaged Marseille in 1722); and Saint Eusebius, the fourth-century Bishop of Vercelli, who is seated at left in his splendid ecclesiastical robes. By their presence the three saints confirm the important doctrinal idea of the virgin birth of Christ, as Mary learns that she is to bear the divine child. From the three saints through the figure of Gabriel to the scene of the Annunciation the spectator's gaze is drawn up from the real world (the chapel) through ascending levels of divinity. The companion altarpiece by Trevisani affirms a related doctrine, that of the Immaculate Conception, the Virgin's own virgin birth.

The Los Angeles modello differs from the finished altarpiece in several minor respects, such as the position of Saint Roch's dog, the flooring in the foreground, and the glory of angels around the Virgin, but in essence the design is the same.

Notes

1. Jeffery Daniels, *Sebastiano Ricci* (Hove: Wayland Publishers, 1976), 126–27, no. 441, fig. 281.

2. Frank R. DiFederico, *Francesco Trevisani: Eighteenth-Century Painter in Rome* (Washington, D.C.: Decatur House Press, 1977), 61–62, no. 81, pl. 67.

3. *Sebastiano Conca (1680–1764)*, exh. cat. (Gaeta: Palazzo De Vio, 1981), 154–55, cat. nos. 32a, 32b.

4. Andreina Griseri and Giovanni Romano, *Filippo Juvarra a Torino. Nuovi progetti per la citta*, exh. cat. (Turin: Cassa di Risparmio, 1989), 218–19, pl. 55.

5. *A Collectors Miscellany*, 29.

6. Daniels, 126; Pierre Rosenberg and Barbara Brejon de Lavergnée, *Saint-Non, Fragonard: Panopticon Italiano (Un diario di viaggio ritrovato, 1759–1761)* (Rome: Edizioni dell'Elefante, 1986), 76.

There are pentimenti that reveal Ricci's sources and thoughts in creating the image. On the right above Saint Sebastian it is evident that Ricci originally intended to show one or perhaps two full columns, a pictorial idea that can be traced back to one of Titian's most famous altarpieces, *The Pesaro Madonna* in the Venetian church of Santa Maria dei Frari. The final solution with the broken column was inspired by Veronese's equally celebrated *Saint Sebastian* altarpiece at San Sebastiano in Venice. Indeed the design of Ricci's altarpiece is rather like a baroque version of the Veronese, a moving testament to his great sixteenth-century predecessor.

PC

View at La Ferté-Saint-Aubin,
near Orléans

CONSTANT TROYON
French, 1810–65

c. 1837
Oil on canvas
50 ¹³/₁₆ x 75 ¹⁰/₁₆ in. (129.0 x 192.0 cm)
Signed lower left: C. Troyon
Gift of The Ahmanson Foundation
M.91.36

PROVENANCE:
France, private collection.
Monaco, sale, Sotheby's, 16 June 1990, no. 623.
Zurich, Bruno Meissner (dealer).

SELECT LITERATURE:
Unpublished.

Constant Troyon was born at Sèvres, where his parents were decorative painters for the famous porcelain manufactory there. He was destined to follow in their footsteps, and part of his training consisted of sketching the wooded countryside around the communities of Sèvres, Saint-Cloud, and Meudon. The point of such exercises was to train the hand and eye in drawing from nature and to stock sketchbooks with landscape motifs for porcelain decoration. Troyon's background meant that he was technically proficient as a draftsman and watercolorist at an early age. His employment at the Sèvres factory continued through the early 1830s, giving him the opportunity to travel extensively in search of decorative landscape ideas. It is not known what motivated him to become something more than an anonymous china painter, but his turn to professional painting did coincide with a general rise of French interest in the genre of landscape painting.

During the 1830s Troyon increasingly associated with artists who were independent landscape painters. Such individuals as Camille Roqueplan, Paul Huet, Camille Flers, Louis Cabat, and especially Jules Dupré were his friends and companions in the open air and the studio. These and other artists came to be known as "the generation of 1830," after the democratic July Revolution of that year. Many such young French painters, in a spirit of artistic revolution, wished to express their vision of nature without the constraining pictorial conventions of the old academic system. Ever since the fall of Napoleon in 1815, when cross-Channel cultural relations opened again after a quarter-century of hostilities following the French Revolution, many artists had been looking for alternatives to the tired academic tradition. Some of them found inspiration in the example of the English, who had developed a distinctive national school of landscape painting. The artist most admired by these young Frenchmen was John Constable, who took advantage of French Anglomania in the 1820s and sent several important works for exhibition to the Paris Salon. One of these was *The Hay Wain* (National Gallery, London), the veritable icon of English landscape naturalism, which Constable exhibited in Paris in 1824 along with another monumental canvas, *View on the Stour near Dedham*

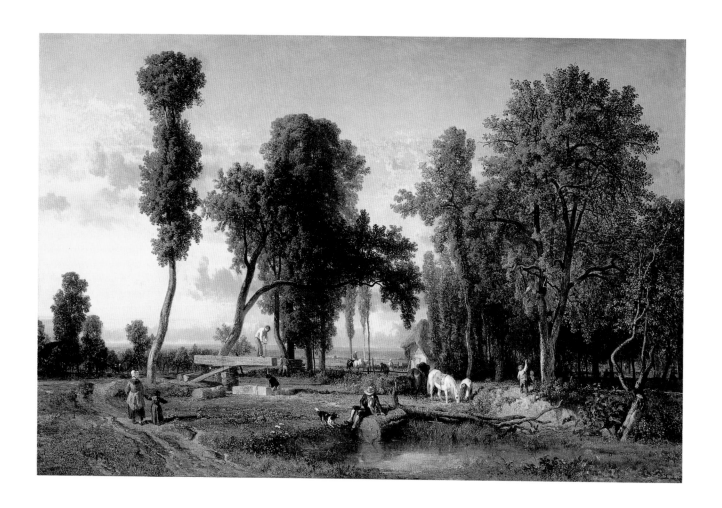

FIG. 52a
John Constable, *View on the Stour near Dedham*, 1822, oil on canvas, 51 x 74 in. (129.5 x 188.0 cm), Henry E. Huntington Library and Art Gallery, San Marino, California (25.18).

(Henry E. Huntington Library and Art Gallery, San Marino, California, fig. 52a). These two admired canvases remained in France for many years: *The Hay Wain* was back in England by 1838, while *View on the Stour near Dedham*, sold in Paris in 1830, was not recorded again in England until 1845.[1] The continued presence of these works in France through the 1820s and 1830s must have had an effect on French artists, but this has never been as apparent as it is now with the recent rediscovery of this painting by Troyon.

It is impossible to look at the *View at La Ferté-Saint-Aubin, near Orléans* without thinking of Constable's example. Presented is a humble site of no particular historical or topographical consequence, whose simple natural beauties and characteristic rural activities are revealed by the artist. The magnificent trees are the most arresting feature of the scene, along with the warm light that plays on them and suffuses the panoramic distance. Two men, one standing in a trench to facilitate the use of a saw, are squaring off a tree trunk into a large beam. A woman and child pass by and observe the scene. A man walking his dog rests and contemplates the depths of a pond. One child is feeding a horse, while other youths gather nuts from an autumnal tree. At the right the shadowy figure of a huntsman moves through the woods, while on the left a couple can be seen approaching a cottage. In the distant fields tiny figures are at work. This last detail recalls one of Troyon's freshest and most calligraphic oil sketches, *Fields outside Paris* (Museum of Fine Arts, Boston, fig. 52b), which, of all French oil sketches of the nineteenth century, is the one that is closest in feeling to the sketches of Constable. It probably dates from the late 1830s, around the time Troyon painted the museum's picture, and is most likely a product of his open-air sketching activities.

Further research will be required to establish why the village of La Ferté-Saint-Aubin was of such interest to Troyon that he painted it several times. Pierre Miquel has suggested that *View at La Ferté-Saint-Aubin, near Orléans* is one of two or three paintings of this subject that Troyon submitted for exhibition to the Salon of 1837.

FIG. 52b
Constant Troyon, *Fields outside Paris*, late
1830s, oil on paperboard, 10⅝ x 17⅞ in.
(27.0 x 45.4 cm), Henry C. and Martha B.
Angell Collection, courtesy Museum of Fine
Arts, Boston (19.117).

Notes

1. Graham Reynolds, *The Later Paintings and
Drawings of John Constable* (New Haven: Yale
University Press, 1984), 1:67–69, no. 21.1,
99–100, no. 22.1, 2: plates 213, 334.

2. Miquel is cited in the Sotheby's auction
catalogue, 34. See also Pierre Miquel, *Le
Paysage français au XIXe siècle, 1824–1874:
L'École de la nature* (Maurs-la-Jolie: Editions
de la Martinelle, 1975), 2:324–25; *Explication
des ouvrages de peinture*, exh. cat. (Paris: Musée
Royal, 1837), 186, nos. 1741–42; *Explication des
ouvrages de peinture*, exh. cat. (Paris: Musée
Royal, 1840), 175, no. 1564.

3. Daniel Wildenstein, *Claude Monet: Biographie
et catalogue raisonné* (Lausanne: La Bibliothèque
des Arts, 1974), 1:419, no. 1.

It is very likely the same work as the large *View near Orléans* he exhibited at the Salon of 1840.[2] The museum's landscape is carefully constructed and balanced, not only to create a convincing space but also to convey a sense of pastoral calm. While it is invested with the monumental grandeur of a landscape by Nicolas Poussin or Claude Lorrain, it also betrays careful observation and a true feeling for the immediate experience of nature reminiscent of Constable. The scale of the work especially evokes the large canvases that Constable called his "six-footers," such as the aforementioned *View on the Stour near Dedham*. Troyon was imitating Constable's idea of exhibiting a monumental image of an aspect of nature that traditionally would have been considered insignificant or banal. The way the cottages nestle under the lovingly depicted trees and the affectionate observation of everyday rural life could almost have been painted by the English artist. Troyon's color also invokes the example of Constable, with its variety of fresh greens, the flecked highlights that enliven the surface, and the saturated reds and blues that draw attention to some of the figures and add vivid notes to the landscape. Finally, Troyon's debt to the English master is palpable in the handling of the paint, which is expressive of the rude and undistinguished nature that is his subject. The clearly visible, textural character of his brushwork boldly conveys the rustic character of the scene.

It was not only their apparently ordinary subject matter but also their forthright and painterly way of expressing it that caused Troyon and other realist painters of the 1830s to have problems with the artistic establishment. Traditionally landscape painters were expected to show a carefully finished and highly idealized image of nature, or at least a site famous for its beauty, sublimity, or associations, not an ordinary place treated in a naturalistic way. The pictorial and ideological struggle between the old academic tradition and realism would continue into the 1840s with the Barbizon School, of which Troyon became a prominent member. The artists of this school, taking their group name from the village of Barbizon in the Forest of Fontainebleau (where they often lived and worked from the 1840s through the 1870s), issued from the "generation of 1830." Along with Narcisse Virgile Diaz, Théodore Rousseau, Jean-François Millet (cat. no. 23), and Charles-Emile Jacque, Troyon was one of the best-known Barbizon painters and specialized in large panoramic landscapes with cattle or more closely focused scenes of livestock or huntsmen with their hounds.

Quite apart from its inherent beauty as one of the great Salon landscapes of the early nineteenth century and its significance vis-à-vis the influence of Constable in France, Troyon's *View at La Ferté-Saint-Aubin, near Orléans* prepared the way for impressionism in its feeling for light and nature and free, painterly handling. It is significant that Claude Monet, not long after arriving in Paris from Le Havre in May of 1859, visited Troyon and sought the older painter's advice.[3]

PC

INDEX OF ARTISTS

This index lists the beginning page number of each artist's entry or entries.